THE SOURCE BOOK

KODAK EKTAGRAPHIC
SLIDE PROJECTORS

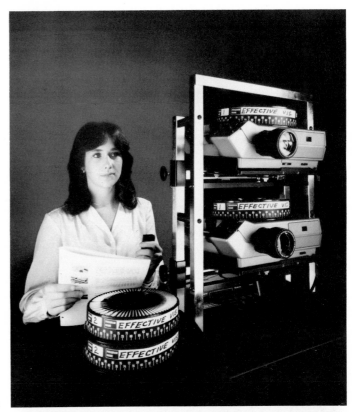

THE SOURCE BOOK — *KODAK EKTAGRAPHIC* SLIDE PROJECTORS
(SECOND EDITION)

© Eastman Kodak Company, 1984
Second Edition, First Printing
International Standard Book Number 0-87985-335-2
Library of Congress Catalog Card Number 81-69536

Table of Contents

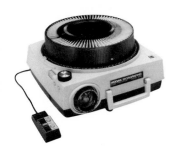

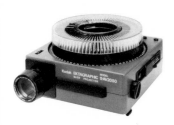

**KODAK EKTAGRAPHIC III Projectors are used widely in large multi-image
presentations.**

Introduction

Most professionals in audiovisual communications today accept the performance of *KODAK EKTAGRAPHIC* Slide Projectors as an international standard. Why? Because *EKTAGRAPHIC* III and *EKTAGRAPHIC* Slide Projectors do what they are supposed to do with unsurpassed simplicity, flexibility, and reliability. As a consequence, they are found in almost any situation where 2 x 2-inch (50 x 50 mm) mounted transparencies (slides) are used to communicate—in nursery schools for basic skills training and entertainment (kids love seeing their drawings on *KODAK EKTAGRAPHIC* Write-On Slides projected life-size); in elementary schools, high schools, and college classrooms for the study of virtually any subject; in hospitals for patient and staff training; in corporate boardrooms for new product introductions, product performance reviews, and strategic planning and employee training; for point-of-purchase applications (*EKTAGRAPHIC* Slide Projectors are used to help promote a product or service where the sale is made); for museum use to communicate an historical or technical message; on the film chains of many cable and closed-circuit television operations, and so forth. They are everywhere, and their popularity continues to grow.

To make your efforts as a professional communicator easier and more effective, we have assembled in *The Source Book* virtually all we know about these versatile slide projectors—how they came about, which models are available today, what you can do with out-of-the-box projectors, how they can be modified for special projection requirements, available Kodak accessories, methods for increasing the effectiveness of your AV programs, taking care of your projectors, and much more.

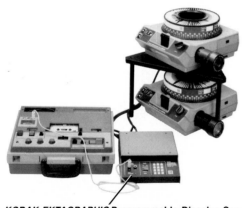

The *KODAK EKTAGRAPHIC* Programmable Dissolve Control, Model 2, can be used with a wide variety of *KODAK* Slide Projectors and audiovisual tape recorders to produce and present sophisticated sound-slide programs.

The Source Book is divided into nine parts:

Part I, "The Evolution of *KODAK EKTAGRAPHIC* Slide Projectors," is a basic chronology of the 135-format Kodak slide projector—from the *KODASLIDE* Projector introduced by Kodak in 1937 to the current *KODAK EKTAGRAPHIC* III Projectors introduced in August 1981.

Part II, "The *KODAK EKTAGRAPHIC* Slide Projector Line Today," begins on pages 10 and 11 with a Projector Summary Chart that shows—at a glance—the distinguishing features of each projector model. We then explain the basic controls, functions, and capabilities of each model in each of the three separate lines or classes of *KODAK EKTAGRAPHIC* III and *EKTAGRAPHIC* Slide Projectors currently manufactured.

In **Part III**, "Kodak Slide Projector Accessories," you'll find basic information about the accessories Kodak supplies to make your audiovisual presentations more professional.

Part IV, "Techniques for Better AV Programs," contains nine helpful "how-to" articles.

Part V, "Adapting Your *KODAK EKTAGRAPHIC* Slide Projector," gets you inside our projector. We cover the internal electrical controls, wiring, and operation of *EKTAGRAPHIC* III and *EKTAGRAPHIC* Slide Projectors. We also show you the "hardware" (plugs, sockets, and receptacles, etc) that you must have to adapt your projector for special requirements.

Part VI, "Detailed Plans for Helpful Home-Built AV Projects," provides plans for making blimps, a shelf unit for your AV hardware, and a movable projection table to hold stacks of projectors. We also show you how to construct a wooden or a metal two-projector piggyback stand for simple dissolve projection.

Part VII, "Projector Remote Control," contains schematic diagrams for making your own portable remote-control box for remotely controlling slide projectors and motion picture projectors. For projector exhibit use, we discuss push-button start and automatic shutoff of *EKTAGRAPHIC* Slide Projectors.

In **Part VIII**, "Maintenance and Care of *KODAK* AV Equipment and Slides," we cover the prevention of temperature and voltage extremes that can lead to projector deterioration. You are shown how to examine Kodak slide trays for damage, how to clean them, how and where to get replacement parts, and how to fix them. There is also a discussion of damage-resistent packaging.

Part IX, "Offbeat Applications for *KODAK* Slide Projectors," cites a few instances where our projectors were used unconventionally—but imaginatively—for research, pain-relief, and pleasure.

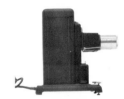

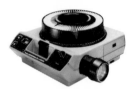

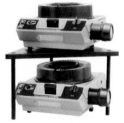

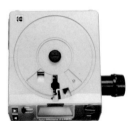

Text Boxes

You will find a number of "Text Boxes" placed throughout *The Source Book.* You may ask, "What's a text box?" It is a short fact-filled discussion of specialized subjects of importance to AV communicators. They provide additional details that complement the main narrative. For example, in the text box entitled "Don't Do a Slow Burn," you learn how to stop high-intensity (xenon) slide projectors from scorching glass-mounted silver-image slides. Or in the one entitled "Focusing on Lenses," we explain why a good camera lens costs much more than a Kodak slide projector lens.

The Source Book covers the inside and outside of *EKTAGRAPHIC* III and *EKTAGRAPHIC* Slide Projectors in great detail, and it provides invaluable techniques for presenting better AV programs. Armed with this knowledge, you should be able to improve the effectiveness and impact of your AV presentations.

For your convenience, here is a list of the text boxes appearing in *The Source Book.*

PART I
The Evolution of *KODAK EKTAGRAPHIC* Slide Projectors

The ubiquitous *KODAK EKTAGRAPHIC* Slide Projector. It has matured through the last several decades into a highly professional AV tool used by communicators the world over. Since the debut of the 135-format *KODASLIDE* Projector in 1937, over 200 improvements have been made in the various models, bringing us to the current *EKTAGRAPHIC* III Projector line.

We thought you projector buffs would enjoy a capsule look at the evolution of the *EKTAGRAPHIC* Slide Projector, so we have produced a time-line chart highlighting the most significant design changes that have occurred over the past 45 years.

1937 to 1940
***KODASLIDE* Projector**

The first Kodak slide projector to project slides in the 2 x 2-inch (50 x 50 mm) format. Using the so-called "douser" method, each glass-mounted transparency was inserted into a metal gate at the top of a slide holder, then "gravity-fed" by lowering and raising a lever at the side.

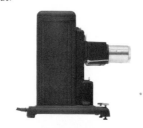

1947 to 1951
***KODASLIDE* Projector, Model 1A**

The Model 1A Projector offered a much brighter, sharper screen image than earlier models. Improvements included a new 150-watt lamp (vs 100 watts on older models), an advanced optical system with a 4-inch *KODAK* Projection *f*/3.5 *LUMENIZED* Lens, and single-element heat-absorbing glass for added transparency protection.

1951 to 1956
***KODASLIDE* Merit Projector**

This projector adapted an earlier slide-feeding principle. Slides were inserted one-by-one from the top of the unit.

1937

1939 to 1947
***KODASLIDE* Projector, Model 1**

This projector was designed with side-to-side slide-changing action, as opposed to its predecessor that had a top-to-bottom action. Each slide was simply loaded from one side, and as it entered the gate it pushed the preceding one out. It was the most compact projector of its time, measuring only 2 7/8 x 5 1/4 x 4 5/8 inches. It was also the first model to accept *KODACHROME* transparencies in *KODASLIDE READY-MOUNTS*, which were introduced in 1939.

1947 to 1956
***KODASLIDE* Projector, Master Model**

The Master Model was the first Kodak slide projector specifically designed for use in large lecture halls and auditoriums. It offered a wide range of lamps (ranging from 500 watts to 1000 watts), and a selection of projection lenses (ranging from 5 inches to 11 inches). All of the lens elements in the optical system were treated to reduce internal reflections and to increase illumination. This projector was also provided with a powerful blower for maximum cooling.

1952 to 1955
***KODASLIDE* Highlux III Projector**

Similar in function to the *KODASLIDE* Merit Projector, the Highlux III Projector featured two especially notable additions: an extra-bright 300-watt lamp and a blower system in the base to provide increased lamp cooling.

1954 to 1958
***KODASLIDE SIGNET* 500**
Projector, Models 1, 2, and 2F

The *SIGNET* 500 Projector provided brighter images than earlier designs (except for the Master Model) with a 500-watt lamp system. It also had a smoother, faster automatic slide take-up changer and it offered three different ways of changing slides: drop-through, push-through, and a changer with magazines. A remote control was also available. It was the first Kodak slide projector to permit projecting filmstrips (with an adapter). Another convenient feature was a receiver bin that automatically stacked projected slides in their original order.

1958 to 1960
***KODAK* 500 Projector**

This was one of the most portable projectors built by Eastman Kodak Company, featuring a self-contained carrying case and weighing less than 9 pounds. Customers had a choice of two slide-handling systems: a *KODAK READYMATIC* Changer that held up to 36 slides and automatically projected each grouping, or an automatic magazine changer that showed and stored up to 30 slides in its metal magazine.

1961 to 1966
***KODAK CAROUSEL* Projector,**
Model 550

The *CAROUSEL* Projector was a revolutionary addition to the 2 x 2 slide market. The concept of the linear slide tray was discarded by Kodak design engineers as being too limiting, and the idea of a circular tray rotating over a stationary bottom plate evolved. The *CAROUSEL* Projector was designed to accept a new circular tray with 81 compartments—enough space for each slide to drop through one at a time by gravity, as rapidly as one slide every second. The round tray offered easier access to slides for editing and changing sequences. The projector itself was equipped with an illuminated control panel at the back. Automatic slide changing at 5-, 10-, or 20-second intervals; high and low lamp settings from a 500-watt lamp; remote forward, reverse, and focus; and improved slide cooling from an efficient impeller-type blower were also provided.

1958 to 1962
***KODAK CAVALCADE* Projector,**
Models 500, 510, 500C, and 520C

The *CAVALCADE* Projector was the first Kodak slide projector equipped with a linear (straight) tray. It provided three ways of projecting slides: automatically cycled at 4-, 8-, or 16-second intervals; push-button control on the projector remote control; or manual rotation of a handwheel on the side (for either forward or reverse). There was also a built-in movable pointer that could superimpose a silhouetted arrow on the screen to highlight important areas in the slide.

1959 to 1962
***KODAK CAVALCADE* Repeating**
Projector, Model 540

This model had all the functions of the *CAVALCADE* 500 Projector. In addition, it was designed to index its 40-slide tray automatically to repeat a program over and over for continuous playback in retail stores, conventions, etc. It also permitted the showing of synchronized sound-slide programs with a tape recorder, and its "shutter-hold" feature kept the screen dark between tray changes and whenever a slide in a metal holder was removed from the tray.

1964 to 1972
***KODAK CAROUSEL* 800 Projector**

This projector featured a more reliable slide-change mechanism that reduced slide jamming as well as a reduction in size by almost half and in weight from 18 pounds (8.2 kg) to 12 pounds (5.4 kg). A seven-pin control receptacle was also provided that accepted a *KODAK CAROUSEL* Dissolve Control plug.

1967 to 1969
KODAK EKTAGRAPHIC Slide Projector

The first *EKTAGRAPHIC* Slide Projector offered a number of professional features not found on projectors: more accurate horizontal slide registration for precise superimposition of screen images from two projectors, a permanently attached three-wire power cord, and a manual shutter control that permitted fraction-of-a-second flashing of slides for tachistoscopic effects. (A tachistoscope is an apparatus used

1969 to 1971
KODAK EKTAGRAPHIC Slide Projector, Model AF, Model E, and Model B

The Model AF Projector provided all the features of its predecessor, plus automatic focusing. After the first image was focused, either at the projector or the remote control, an electronic device monitored the position of each transparency; if it shifted, the lens automatically adjusted to maintain image focus. In

1971 to Present
KODAK EKTAGRAPHIC Slide Projector, Models E-2, B-2, AF-2, and AF-3

In addition to retaining the professional features of earlier *EKTAGRAPHIC* Slide Projectors, evolutionary improvements upgraded their already high standard of performance. For example:

In 1971: a locking lever was added to make the heat-absorber/condenser-lens assembly more secure, and a long-life ANSI Code ELH lamp (for bright images with less heat) was introduced.

1972: the fan impellers were made black to reduce light spill from the projector; heavy-duty motors were introduced for cooler operation and greater durability.

NOTE: The *EKTAGRAPHIC* Slide Projectors listed and briefly discussed from this point on are covered more thoroughly later in *The Source Book.*

1967

for the brief exposure of visual stimuli in the study of learning, perception, and attention.) Numerous models of *CAROUSEL* Slide Projectors (including some with autofocus capability and several 50/60 Hz models) continued to be supplied to the amateur market and, in fact, are still available.

addition, a built-in timer provided automatic slide-changing intervals of 5-, 8-, or 15-seconds. The Model E offered precise horizontal and vertical slide registration so that screen images (using carefully mounted transparencies) from two projectors could be exactly superimposed. Slides could be flashed on the screen using a manual control. The same control permitted skipping of unwanted slides. The Model B included the features of the Model E; in addition, a remote control was packed with the projector.

1975: the Model AF-3 was introduced. It incorporated all the features of the AF-2 Projector and also offered remote control of the projector power on/off function.

1976: a locking and extracting lever was developed for the projection lamp; a ridge was added to the reverse button on the remote control to distinguish it from the forward button—a useful feature in a darkened room.

1977: an autofocus on/off switch was added so that when projecting a mix of slide mounts, the autofocus mechanism could be bypassed; in addition, lighter-and-stronger glass-fiber-reinforced polycarbonate housings were adopted.

1978: an automatic dark-screen shutter was provided to prevent irritating screen glare from the projection lamp when the projector gate contained no slide.

1980 to 1983
KODAK EKTAGRAPHIC Slide Projector, Model S-AV2030

The Model S-AV2030 is also a multi-national model. It provides for a selection of four different voltage settings. Additionally, this projector features a built-in, self-starting, self-operating zero-position circuit that automatically returns the slide tray to "O" one slide slot at a time over the shortest route; a quick-cut circuit for special effects that can be actuated by a switch control through a 12-pin contact plug (optional accessory); and a quick-change, dual-lamp device that allows the user to move a replacement lamp quickly into position whenever the lamp burns out.

1979 to Present
KODAK EKTAGRAPHIC Slide Projector, Model B-2AR

The world-wide growth of slide use encouraged Kodak to introduce the Model B-2AR, which automatically sets itself for the frequency and voltage range (110 to 130 V, or 220 to 240 V, 50 or 60 Hz) according to the type of power available when the projector power cord is plugged into the power outlet and the projector is turned on.

1981 to Present
KODAK EKTAGRAPHIC III Projectors

That brings us to the most recent addition to the professional line of performance-proven Kodak Projectors—the *EKTAGRAPHIC* III Projector. Representing the latest advance in the original circular slide-tray concept, this series of projectors meets the needs of any professional communicator—from those interested in sophisticated multi-image presentations to the majority who are working with one- and two-projector shows.

1975 to Present
KODAK EKTAGRAPHIC Slide Projector, Model AF-2K

The Model AF-2K Projector is similar to the Model AF-2 and is the first version of an *EKTAGRAPHIC* Slide Projector designed to operate on power at 110 to 130 V, 50 or 60 Hz.

PRESENT

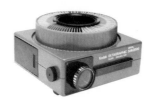

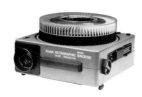

1976 to Present
KODAK EKTAGRAPHIC Slide Projector, Model AF-1

The Model AF-1 Projector incorporates all the features of the B-2 Projector, except for remote focusing. It also offers automatic focusing, with autofocus on off capability.

1979 to 1980
KODAK EKTAGRAPHIC Slide Projector, Model S-AV2000:

The Model S-AV2000, made by Kodak AG in Stuttgart, West Germany, was the first German-made *EKTAGRAPHIC* Slide Projector to be imported and sold in the U.S. Earlier models similar to the line of *KODAK CAROUSEL* S-AV Projectors had been manufactured in Germany beginning in 1964, but were sold only in 50 Hz countries (Australia, Mexico, Europe, Asia, and Latin America). Features that distinguished the S-AV2000 Projector included a range of voltage settings for 110, 130, 220 to 230, and 240 to 250 V, 50 or 60 Hz, which enabled the "world traveler" to use the projector virtually anywhere.

1982 to Present
KODAK EKTAGRAPHIC Slide Projector, Model S-AV2050

The Model S-AV2050 Projector—also made by Kodak AG in Stuttgart, West Germany—has most of the features, functions, and maintenance requirements of the Model S-AV2030, plus a slide-cycling time that is faster than the Model S-AV2030 (equal to the slide-cycling speed of *KODAK EKTAGRAPHIC* Slide Projectors and *EKTAGRAPHIC* III Projectors); it also has the versatility to accept lenses made in the U.S. and Germany.

PART II
The *KODAK EKTAGRAPHIC* Slide Projector Line Today

For your convenience, the basic features of all these projectors are summarized in the *"EKTAGRAPHIC* Slide Projector—Summary Chart" shown on the next page.

In the pages that follow, the simplest model in each projector line will be thoroughly described. Subsequent discussions of increasingly more sophisticated projector models will be limited to the respective distinguishing features or operational requirement.

This part of *The Source Book* covers the basic controls, functions, and capabilities of the three lines of professional *EKTAGRAPHIC* Slide Projectors, as listed below:

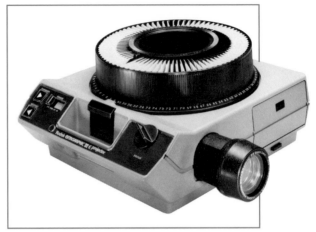

The *KODAK EKTAGRAPHIC* III Projector
(Models E, ES, B, A, AS, and AT).

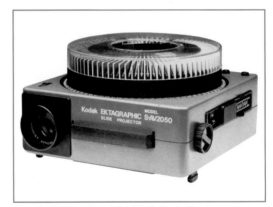

The *KODAK EKTAGRAPHIC* Slide Projector
(Model S-AV2030 and Model S-AV2050),
manufactured in West Germany.

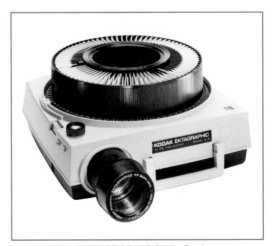

The *KODAK EKTAGRAPHIC* Slide Projector
(Models E-2, B-2, B-2AR, AF-1, AF-2, and AF-2K).

EKTAGRAPHIC SLIDE PROJECTOR—SUMMARY CHART

	EKTAGRAPHIC III						EKTAGRAPHIC						
	E	ES	B	A	AS	AT	E-2	B-2	B-2AR	AF-1	AF-2	AF-2K	S-AV2050
Projector Power Requirements 110-125 volts, 60 Hz only	●	●	●	●	●	●	●	●		●	●		
110-130 volts, 50 or 60 Hz									●			●	●
220-240 volts, 50 or 60 Hz									●				●
110, 130, 220-230, 240-250 volts, 50 or 60 Hz													●
Focus: Remote			●			●	●		●	●	●		●
Remote and automatic						●				●	●		
Automatic				●	●	●				●	●	●	
Autofocus ON/OFF switch				●	●	●				●	●	●	
Solid-state variable timer: 4 to 15 sec											●	●	
Solid-state variable timer: 3 to 22 sec						●							
Increased illumination	●	●	●	●	●	●							
Improved center-to-corner brightness uniformity	●	●	●	●	●	●							
Rear lamp module removal	●	●	●	●	●	●							
Slide tray select without power	●	●	●	●	●	●							
Elevation 16°	●	●	●	●	●	●							
Elevation 6°							●	●	●	●	●	●	●
Built-in viewing screen		●				●							
"Go" condition LED for dissolve mode	●	●	●	●	●	●							
Reading light	●	●	●	●	●	●							
Special-application receptacle (8-contact)	●	●	●	●	●	●							
Improved EMI suppression	●	●	●	●	●	●	●	●	●	●	●	●	●
HIGH/LOW lamp capability	●	●	●	●	●	●		●	●	●			
Manual quick lamp change	●	●	●	●	●	●							●
Dark-screen shutter	●	●	●	●	●	●	●	●	●	●	●	●	
Rack and spiral lens mount													●
Zero-position switch	●	●	●	●	●	●							
Rear leveling adjustment	●	●	●	●	●	●	●	●	●	●	●	●	*
Tray alignment mark	●	●	●	●	●	●							
Spare lamp storage	●	●	●	●	●	●							●
Threaded sockets in base	●	●	●	●	●	●							
Illuminated control panel	●	●	●	●	●	●							
Power-cord retainer	●	●	●	●	●	●							
Safety features: Thermal fuses	●	●	●	●	●	●	●	●	●	●	●	●	†
10-foot attached 3-wire power cord	●	●	●	●	●	●	●	●	●	●	●	●	‡
Accessories KODAK EKTAGRAPHIC Programmable Dissolve Control, Model 2	●	●	●	●	●	●	●	●	●	●	●	●	
KODAK EKTAGRAPHIC Filmstrip Adapter	●	●	●	●	●	●	●	●	●	●	●	●	
KODAK CAROUSEL Projector Case, Model E	●	●	●	●	●	●	●	●	●	●	●	●	●
KODAK EC Sound-Slide Synchronizer	●	●	●	●	●	●	●	●	●	●	●	●	
KODAK EC Automatic Timer, Model III	●	●	●	●	●	●	●	●	●	●	●	●	
KODAK EC Stack Loader	●	●	●	●	●	●	●	●	●	●	●	●	
KODAK EC Lamp Module	●	●	●	●	●	●							
KODAK EC Projector Dust Cover	●	●	●	●	●	●							
KODAK Remote Control: EC Model No.	1	1	2	1	1	3	1	2	2	1	3	3	§
KODAK EC Remote Extension Cord, 25-foot	●	●	●	●	●	●	●	●	●	●	●	●	
UL Listed	●	●	●	●	●	●	●	●	●	●	●	●	
CSA Approved	●	●	●	●	●	●	●	●	●	●	●	●	●

*Combined front leveling and elevation feet.

†Automatic resetting circuit breaker plus overload fuses.

‡Detachable three-wire power cord.

§Uses KODAK EKTAGRAPHIC S-AV Remote Control.

KODAK EKTAGRAPHIC III PROJECTORS

INTRODUCTION

The information presented in this section covers the controls and functions for all currently manufactured models of the *KODAK EKTAGRAPHIC* III Projector—as well as the basic setup, preparation, use, shutdown, and maintenance procedures for each projector.

As shown in the Projector Summary Chart earlier (page 11), the *EKTAGRAPHIC* III E Projector is the most basic model and therefore will be described first. The III ES, B, A, AS, and AT Projectors (which follow in that order) have the same basic features as the III E Projector, plus other features that make them appropriate for specific projection requirements and environments. Only features unique to each model (after the III E) will be noted.

GENERAL PROJECTOR FEATURES AND DIMENSIONS

The *EKTAGRAPHIC* III Projector is noticeably different in size and shape from the *EKTAGRAPHIC* Slide Projector, Models E-2, B-2, AF-1, AF-2, etc, or the German-made *EKTAGRAPHIC* Slide Projector, Model S-AV2030 or Model S-AV2050.

The controls for the *EKTAGRAPHIC* III Projector are located on the right side of the projector (as viewed from behind the machine), and are easy to use (even in a dark room) because the built-in illuminated control panel keeps them visible. The sloping panel makes viewing and operating the controls easier from either the side or the back of the projector.

Three "sight lines" are built into the projector to aid the operator in aligning the projector with the screen—without turning the projector on: the edge of the handle, the top of the control panel, and the groove down the center of the housing on the left side are all parallel to the optical axis of the projector, which makes preliminary alignment easy even in a lighted room.

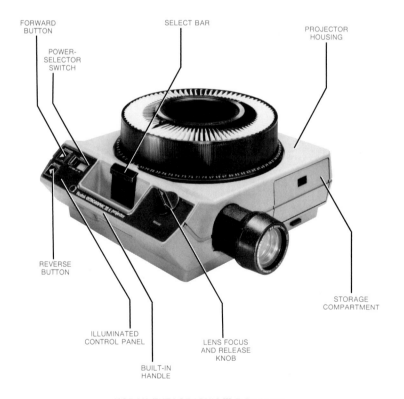

KODAK EKTAGRAPHIC III E Projector

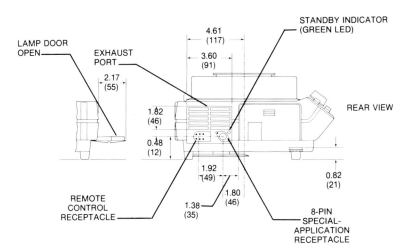

TOP VIEW

SPECIAL-
APPLICATION
RECEPTACLE

EXHAUST

REMOTE-
CONTROL
PLUG

12.93
(328)

11.11
(282)

5.55
(141)

AUTOFOCUS
ON/OFF
SWITCH

3.30
(84)

FRONT VIEW

6.81
(173)

STORAGE
DOOR

4.51
(114)

4.88
(124)

2.87
(73)

1.45
(37)

0.94
(24)

5.75
(146)

4.52
(115)

CORD WRAP

PULL-OUT
HANDLE ONLY
ON MODELS WITH
BUILT-IN SCREEN

TRAY
CENTERLINE

TIE-DOWN
POINT
(ACCEPTS
1/4 x 20
BOLTS)

8.71
(221)

8.73
(222)

BOTTOM VIEW

4.34
(110)

5.75
(146)

1/4-20 THREADED
TIE-DOWN HOLE—
REMOVAL OF LEVELING
FOOT REQUIRED

4.23
(107)

LAMP DOOR
OPEN

EXHAUST
PORT

2.17
(55)

4.61
(117)

3.60
(91)

STANDBY INDICATOR
(GREEN LED)

REAR VIEW

1.82
(46)

0.48
(12)

1.92
(49)

1.80
(46)

0.82
(21)

REMOTE
CONTROL
RECEPTACLE

1.38
(35)

8-PIN
SPECIAL-
APPLICATION
RECEPTACLE

Dimensional Line Drawings for *KODAK EKTAGRAPHIC* III Projectors

Shown at the left are dimensional line drawings for the *KODAK EKTAGRAPHIC* III Projector for anyone wishing to build projection shelves, piggyback stands, etc, for these projectors.

Power Required: 110 to 125 V, 60 Hz, 400 W; UL listed for normal and unattended information display use; CSA approved.

Dimensions apply to any model *EKTAGRAPHIC* III Projector.

KODAK EKTAGRAPHIC III E PROJECTOR

The Controls and Their Functions

Remote-Accessory Receptacle

The seven-contact remote-accessory receptacle accepts a control plug from a number of remote-control devices, such as the *KODAK EKTAGRAPHIC* Programmable Dissolve Control, Model 2, the *KODAK* EC Sound-Slide Synchronizer, and the *KODAK* EC-1 Remote Control, which are described later in the "Accessories" section of *The Source Book*. Many dissolve controls and accessories from other manufacturers can also be connected to the remote-accessory receptacle.

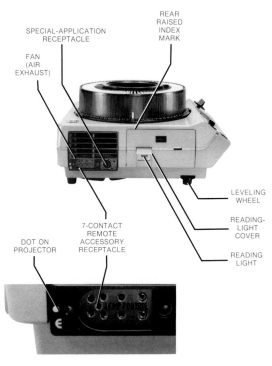

SPECIAL-APPLICATION
RECEPTACLE

REAR
RAISED
INDEX
MARK

FAN
(AIR
EXHAUST)

LEVELING
WHEEL

READING-
LIGHT
COVER

READING
LIGHT

DOT ON
PROJECTOR

7-CONTACT
REMOTE
ACCESSORY
RECEPTACLE

KODAK EKTAGRAPHIC III E Projector

If you are using the optional *KODAK* EC-1 Remote Control, plug it into the remote-accessory receptacle so the yellow orientation dot on the plug of the remote control is at the left, next to the dot on the projector. The yellow dot on the plug of the *KODAK* EC-1 Remote Control denotes the three-conductor cord assembly for the *EKTAGRAPHIC* III E Projector. (The plug has five pins, two of which are not used.)

Please note that the interchanging of remote controls between a III E Projector and other *EKTAGRAPHIC* III models is not recommended; it will not damage your projector; however, it will not add remote-focusing capability.

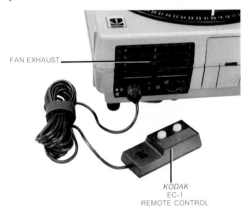

FAN EXHAUST

KODAK
EC-1
REMOTE CONTROL

The projector cord on the *KODAK EKTAGRAPHIC* Programmable Dissolve Control, Model 2, has a seven-pin plug that fits into the seven-contact remote-accessory receptacle of the projector. Many dissolve controls from other manufacturers have similar seven-prong plugs and, hence, are compatible with *EKTAGRAPHIC* III Projectors.

Power-Selector Switch

When the power-selector switch is set at OFF, neither motor nor lamp operates, nor can they be turned on by an accessory controller. When the power-selector switch is set at FAN, the projector's cooling fan operates. The projection lamp is lighted only if a dissolve control or other external control is switched on. (The lamp will not go on if the switch is set at the OFF position. This avoids potential overheating caused by having the lamp on but fan off.) Set the power-selector switch at the FAN position when connecting two or more projectors to a dissolve control. For single-projector use, move the switch to LO to obtain maximum lamp life or HI for maximum image brightness.

NOTE: The *EKTAGRAPHIC* III Projector exhaust fan is run a bit faster than those in US-made *EKTAGRAPHIC* Slide Projectors to compensate for the projector's greater slide illumination and consequent heat generation capability. The configuration of fan exhaust resembles that of *EKTAGRAPHIC* Slide Projectors— exiting from the back at about a 45-degree angle toward the left side (as viewed from behind the projector).

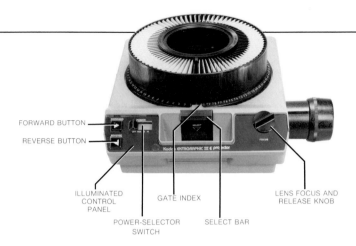

FORWARD BUTTON

REVERSE BUTTON

ILLUMINATED CONTROL PANEL

GATE INDEX

LENS FOCUS AND RELEASE KNOB

POWER-SELECTOR SWITCH

SELECT BAR

KODAK EKTAGRAPHIC III E Projector

Lens Focus and Release Knob

Focus the image by turning the lens focus and release knob in either direction. If you are using a zoom lens, adjust image size by rotating the lens barrel and then refocus.

To install or remove a projection lens, push the lens focus and release knob up (toward the center of the projector) as you insert or withdraw the lens.

Also, when inserting the lens, position the threaded rack of the lens barrel toward the lower left to engage the pinion of the focus-knob shaft.

Forward and Reverse Buttons

Briefly press the forward button or reverse button to change your slides one slide space at a time. Holding either button down will change slides rapidly.

Select Bar

The select bar enables you to rotate or remove the slide tray at any time, whether the power is on or off. With the power on, pressing the select bar down will stop the slide-advance cycle at midpoint, with the slide-lift lever raised, so the tray can be manually turned to any position. To rotate the tray to another position (or remove it from the projector) with the power on, press the select bar and hold it down while turning the tray to the desired slide (or to slide slot "O" for removal). Push the select bar all the way down to its lowest position if the tray is to be rotated with the projector power-selector switch set at the OFF position.

NOTE: To prevent improper interaction between the powered and manual select function, there is a mechanical interlock to prevent operation of the power-off select feature when the power switch is at the FAN, HI, or LO lamp position. **If you wish to remove the tray when the projector is not receiving power, the projector power-selector switch must be set at the OFF position.** The tray will not rotate with the power-selector switch set at FAN, LO, or HI if the projector is not powered.

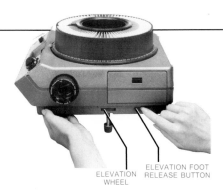

ELEVATION WHEEL
ELEVATION FOOT RELEASE BUTTON

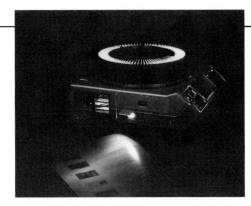

Elevation Foot-Release Button

To raise your projector for vertical image adjustment (up to 16 degrees), lift the front of the projector to the desired height and then press the elevation foot-release button. The foot will drop into position and remain there once you have released the button.

Elevation Wheel

For more precise image positioning, turn the elevation wheel. (The foot must be resting on the table surface for the wheel to adjust the leg.)

FAN (AIR EXHAUST)

SPECIAL-APPLICATION RECEPTACLE

READING LIGHT COVER

CONTACT REMOTE ACCESSORY RECEPTACLE

STANDBY LIGHT

LEVELING WHEEL

Leveling Wheel

Turn the leveling wheel to raise or lower the right side of the projector, which permits you to align the projected image horizontally.

Standby Light

The standby light glows green to indicate a "go" condition for the start of a presentation. When you use two or more *EKTAGRAPHIC* III Projectors with a dissolve control, the standby light on each projector will glow to indicate the following:

• The projector is receiving power.

• The power-selector switch is set at FAN.

• The projection lamp is properly installed, not burned out, and ready to light.

• The standby light itself is working.

• Both thermal fuses are functional.

The standby light dims noticeably as the intensity of the projector lamp fades in and out for each dissolve cycle; the light goes out completely when the power-selector switch is set at HI (for single-projector use). A very slight glimmer may be visible at LO.

Reading Light and Illuminated Control Panel

The reading light and illuminated control panel make projecting your slides in a darkened room easier. To use the reading light, lift the cover from the reading light and place your script or notes under the light. The projector lamp must be on for the reading light and illuminated control panel to be lighted. (The projector light *is* the reading light.) The reading light is not effective during a dissolve presentation because it fades off and on with the projection lamp.

The illuminated control panel may be dimmed, if desired, by sliding a shutter—located on the right side of the projector's lamp module—to the left. The control panel is edge-lighted by a "light pipe" from the projection lamp that runs from a small opening on the right side of the lamp module up to the back of the control panel. (For access to the lamp module, see "Replacing the Projection Lamp" on page 20.)

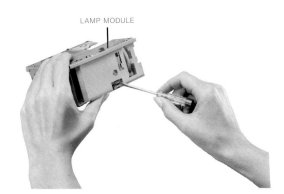

LAMP MODULE

Special-Application Receptacle

The special-application receptacle (next page) accepts eight-pin plugs as well as DIN-type plugs with three or five pins at 180 degrees. The receptacle provides 22.5 V low-voltage power (isolated from the main power line of the projector), so you have an easily accessed power source for special uses. The receptacle also provides access to your projector's circuitry for additional external control and programming capability. Functions include forward and reverse slide change, sensing of the zero tray position when the shutter is closed, and electrical grounding.

Possibilities for additional accessories that could be built by other manufacturers or do-it-yourselfers include but are not limited to

• Low-voltage electric pointers

• Remote-controlled filmstrip adapters

• Relays to switch the projection lamp on or off

• Pilot lights labeled "Push to start program"

• Remote controls for lens zoom

Pin-Number Configurations for the Special-Application Receptacle of the *EKTAGRAPHIC* III Projector

Shown below are the functions controlled by each pin-number configuration for the special-application receptacle:

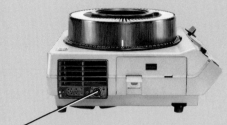

Special-application receptacle (contact identification as seen from the back of the *EKTAGRAPHIC* III Projector).

Contacts Required	Function	Description
1&3	Zero-Position Switch	Connects to an internal single-pole single-throw normally open switch. Contacts are closed when the projector slide tray is at any position other than zero. These leads connect only to the switch terminals. Do not exceed a switching load of 1 A at 30 V ac.
4&5	Shutter Switch	Connects to an internal single-pole single-throw normally closed switch. Contacts are open when a slide is in the projector gate and the shutter is open. These leads connect only to the switch terminals. Do not exceed a switching load of 1 A at 30 V ac.
7&8	Low-Voltage Supply	For operating external equipment. The current is supplied by a secondary winding on the main motor, isolated from the voltage power, and is available whenever the main projector motor is running. Supply is 25.5 V, 500 mA (1/2 A) maximum. Contact number 8 is common (return) for the remote-control circuit. Contact number 7 is the "hot" lead and is used with a slow-blowing fuse. (Replacement requires disassembly of the projector by a qualified technician.)
6&8	Forward-Tray Cycle	Connects to the forward tray advance circuitry in the projector. These contacts are connected internally to the remote-accessory receptacle and an electrical connection made at either receptacle will result in a forward cycle.
2&8	Reverse-Tray Cycle	Connects to the reverse-tray advance circuitry in the projector. These contacts are connected internally to the remote accessory receptacle and an electrical connection made at either receptacle will result in a reverse cycle.
Shell	Plug Ground	If a plug with a connecting shell is used, it is connected to the projector frame (chassis) through the special-application receptacle and to earth ground through the projector's power cable.

CAUTION: All equipment, cables, and connectors used with the special-application receptacle must be assembled by qualified electronics personnel. All circuits connected electrically to the projector through the receptacle must also comply with the Underwriters Laboratories, Inc., low-voltage, limited-energy circuit requirements. (For safety reasons, there is a fuse limiting the amount of current that can be drawn.) Low-voltage, limited-energy circuit requirements may be found in UL-122, *Photographic Equipment,* available from Underwriters Laboratories, Inc., 333 Pfingsten Rd., Northbrook, IL 60062.

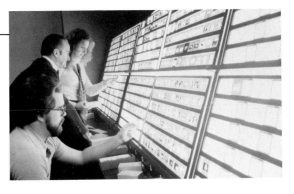

COVER

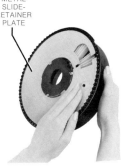
METAL
SLIDE-
RETAINER
PLATE

Latch shown
out of locked position.

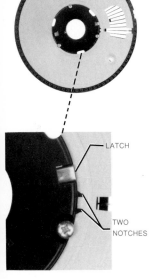
LATCH

TWO
NOTCHES

Setting Up Your Projector

Loading the Slide Tray for Front-Screen Projection

First, arrange your slides on an illuminator so that all the images are right-side up, with words and images reading correctly from left to right, and in correct projection sequence (in the order that you want them to appear in the show). Then rotate each slide so that all the images are *upside down* (do *not* flip the slide around so that the opposite side of the film faces you). Then number each slide mount consecutively in the upper right-hand corner. **(Do not skip this step.)**

NOTE: Avoid using "sticky labels" to number the mounts. Projector heat may eventually loosen them, causing the slides to jam in the projector gate. Also, most felt-tip pen ink smears when the mount is handled. Use a permanent-ink pen, such as a Schwan-Stabilo Pen No. 76P Medium or a Sanford's Sharpie" No. 3000.

Remove the lock ring or cover of the tray by turning it counterclockwise. Before you load the *EKTAGRAPHIC* Universal Slide Tray, Model 2, *EKTAGRAPHIC* Universal Deluxe Covered Slide Tray, or *CAROUSEL TRANSVUE* 80 Slide Tray, be sure that the bottom metal slide-retainer plate is locked correctly with the latch. The formed end of the latch should be positioned in the two notches. If it is not, turn the bottom metal plate until it locks into position. (The Deluxe Covered Slide Tray has only one notch.)

Insert the first slide of the program into slot number 1 of the tray, the second slide into slot number 2, etc. Remember that the correct orientation of each slide for front-screen projection is with the image upside down and the correct-reading side of the film facing toward the next higher number in the tray (inserted into the tray in exactly the same orientation as you arranged them on the illuminator). When the tray is loaded and held right-side up in front of you, the mount numbers should be positioned next to the outside circumference of the tray and visible as the tray is turned 360 degrees.

After all slides are in the tray, replace the lock ring or cover, turning it clockwise until tight. This locks the ring to the tray and prevents the slides from falling out if the tray is inverted (turned over) accidentally.

For instructions on loading the tray for rear-screen projection, refer to the text box entitled "Front-Screen Projection versus Rear-Screen Projection" at right.

Front-Screen Projection versus Rear-Screen Projection

Rear-screen projection usually requires different slide orientation in the tray slots (depending on whether mirrors are used in the projector light path, and if so, the number and arrangement of the mirrors).

FRONT PROJECTION SCREEN

REAR PROJECTION SCREEN

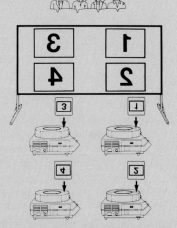

Correct slide orientation for front-screen projection versus rear-screen projection (without mirrors in the light paths of the projectors).

To adapt any slide program for rear-screen projection, put the first slide in the projector gate in different positions until the image projects right-side up on the screen (from the viewing position of the *audience*—not the projectionist) and reads correctly from left to right.

Then orient all the other slides in the set the same way, by reinserting them so that all the slide mounts in the tray are positioned the same way—for example, all mount numbers facing the lamp in the projector, etc)

Rehearse the show to be sure all slides are correctly oriented.

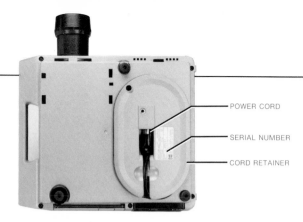

POWER CORD

SERIAL NUMBER

CORD RETAINER

Installing the Slide Tray on the Projector

Place your loaded slide tray on the projector so that the hole in the center of the tray fits over the center post. Then turn the tray until the "O" slide slot is at the gate index and the tray drops into position. If the tray doesn't drop easily, check the slide retainer plate of the tray to be sure it is locked in the "O" position.

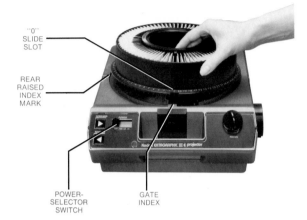

"O" SLIDE SLOT

REAR RAISED INDEX MARK

POWER-SELECTOR SWITCH

GATE INDEX

The rear raised index mark on the back of the projector can be used in conjunction with the numbers embossed on the rim of the tray (or with a mark placed on the tray that aligns with the raised index mark) to set the tray at the proper program starting point. This is especially helpful when the gate index on the side of the projector cannot be seen easily (such as in a dark room). For example, if the program starts on slide number 1 (as most audiovisual programs do), a user positioned in back of the projector can verify that the tray is properly set at the number 1 slide position by checking to see that slide number 21 (visible from the back of the projector) is aligned with the raised-index mark. However, if the program actually starts at slide number 8, slide number 28 is then aligned with the rear raised index mark. (The rear raised index mark is especially helpful when checking all tray starting positions for a large multi-image presentation.) *KODAK EKTAGRAPHIC* Tray Bands can also be used to help identify the specific slide in the projector gate quickly and easily. (See page 57.)

Operating the Projector
Simple Start-Up Procedure

The *EKTAGRAPHIC* III E Projector enables the user to project 2 x 2-inch slides in a wide range of transparency sizes—including 126, 135, 828, 127, and 110. Follow the instructions below to set up and operate your *EKTAGRAPHIC* III E Projector.

• Unwind the required length of power cord from the cord retainer located on the bottom of the projector and plug it into a 110 to 125 V, 60 Hz power outlet.

For *EKTAGRAPHIC* Slide Projectors (Models E-2, B-2, AF-1, etc.) equipped with cord compartments, remove the entire length of the power cord to prevent overheating due to reduced ventilation. This precaution is not necessary with *EKTAGRAPHIC* III Projectors because the cord retainer and ventilation system are totally independent.

• Place a loaded slide tray on the projector with the "O" slide slot at the gate index.

• Move the power-selector switch to LO or HI.

NOTE: (If light from the projection lamp spills onto the screen when the projector is first turned on, the automatic dark-screen shutter in the projector is not engaged. To engage the shutter, simply press the select bar on the projector once. The shutter will engage and the projection lamp light will be blocked.

• Briefly push the forward button on the projector to project the first slide.

• Elevate the projector as required; align the image and then focus it with the lens focus and release knob.

• If the program is in the dissolve mode (two projectors attached to and controlled by a dissolve control, with their images superimposed), be sure the projector power-selector switches are set at the FAN position.

• Proceed with your program.

If the Slide Tray Jams
(Won't Advance or Reverse)

If the slide-changing mechanism will not operate because a defective slide is caught in the gate, you will need to remove the tray as follows to correct the problem.

• Turn the coin-slotted tray-removal screw as far as possible in either direction and hold it there while lifting off the tray.

• Remove the jammed slide from the projector gate by pressing the select bar and then pull the slide out.

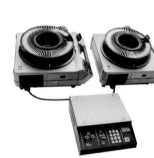

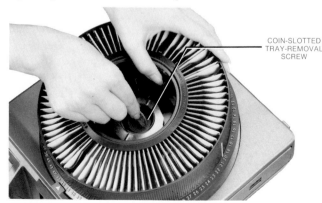

COIN-SLOTTED TRAY-REMOVAL SCREW

- Check that the lock ring or cover on the tray is tight; then invert the tray and turn the bottom plate of the tray until it locks into position. (For the 140 Tray, it is necessary to release the latch and turn the bottom plate until the index hole is at the index notch.)
- Turn the tray upright and remove the lock ring or cover. If the slide is undamaged, return it to the tray. Replace the lock ring or cover; return the tray to the correct slide position and resume your program.
- You can also turn projector power off and press the select bar all the way down to aid in unjamming the slide.

Alternative Projection Methods

Three alternative ways of projecting your slides are possible:

- You can show slides without using a slide tray. A single slide can be shown by inserting it, correctly oriented ("right-reading" from left to right, and then inverted) into the projector gate. Simply press the select bar or slide-advance button to remove each slide.

- You can use the *KODAK* EC Stack Loader (page 56) for fast review of up to 36 slides in thin cardboard or plastic mounts (in the forward projection mode only).
- Slides can be shown with the tray but without the tray lock ring. By leaving the lock ring off, slides can be inserted or removed for easy editing. Extra care is necessary when handling the tray to avoid spilling the slides.

KODAK EC Stack Loader

NOTE: Be sure the slide mounts are consecutively numbered.

(The *EKTAGRAPHIC* Universal Deluxe Covered Slide Tray is handy for editing this way because the lower tray sidewall exposes the slide corners.)

Long-Run Applications

In normal use, the parts of the projector that are subject to wear have about equal life expectancy and require no special maintenance. However, if you expect to run your projector for an exceptionally long period of time, you must observe these precautions:

- **Provide for unrestricted air flow to and from the openings in the projector housing.**

- **If the projector is to be used in a small, enclosed area such as a cabinet, furnish an exit for warm air released from the rear grill vent. In some cases, additional forced-air ventilation may be needed.**
- **Keep air circulating through the projector. Air at normal room temperature is satisfactory.**

Shutdown

You should adopt a standard shutdown procedure after each presentation, similar to the one that follows. This procedure will help you be ready for the next show and will also help provide proper care for the projector.

- Rotate the tray to the "0" position while pressing the select bar.
- Turn off all power to the projector by moving the power-selector switch to OFF.

NOTE: Rapid cooling of an *EKTAGRAPHIC* III Projector or *EKTAGRAPHIC* Slide Projector after each use is not necessary nor recommended.

Pulling cool air over the lamp and glass parts may cool them too fast and increase the chance for breakage. Also, it's too easy to forget and leave the fan running, which shortens projector motor life. However, if the projector must be handled immediately after the show, or if the projection lamp has burned out and needs to be rapidly cooled before being exchanged for a new lamp, the fan can be run to speed up cooling. (A spare *KODAK* EC Lamp Module can also be used to speed up lamp replacement. See page 21.) The right-rear corner of your projector may be warm for several minutes after you switch off the power. The maximum temperature reached, however, will be well below the danger point for the projector, lamp, slide tray, slides, and the operator's fingers.

- Remove the slide tray. If the projector is unplugged, simply move the projector power switch to OFF, depress the select bar all the way down, and rotate the tray to the "0" position. Then remove the tray.

If the projector will not be moved before the next show

- Retract the elevation foot and leveling wheel.
- If desired, remove the projection lens. (Release it by pushing *up* the lens focus and release knob. Then grasp the projection lens and pull it out.)
- Unplug the remote control, if used.
- Disconnect the power cord and wrap it around the cord retainer underneath the projector.
- Place the projector in a storage or travel case for protection.

Serial Number

The projector serial number is printed on the label affixed to the cord wrap retainer underneath the projector. Record this number—as well as the model identification and the date and place of purchase—for future reference.

Planning Ahead for Multiple Slide Presentations

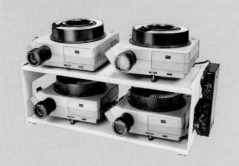

If you intend to leave your equipment in place for a repeat performance do the following:

- Lock the door to the projection area, if possible.

- When leaving an unenclosed projection area, make a sign such as "Do Not Move Projectors" and place it near your equipment. If you are not using projector "piggyback" stands or multiple-projector "stacking" stands (which hold projectors tightly in position), you can place a piece of masking tape under each projector foot and trace the location of each foot on the tape. If the projectors are moved accidentally, they can easily be replaced in the correct position.

- If you remove the slide trays from the projectors, keep them in order so they can be placed back onto the projectors quickly and in correct sequence. *KODAK EKTAGRAPHIC* Tray Bands (see page 57) provide a good method of identifying and organizing your slide trays.

- If you leave the equipment set up and trays on projectors, return trays, audiotapes, and other controls to the starting position and, if possible, turn off all equipment with a master switch. It is also helpful to prepare a detailed "Program Start Checklist" so that your presentation starts correctly and runs smoothly every time.

***KODAK EKTAGRAPHIC* Tray Bands**

Projector Maintenance

Before doing any projector maintenance or cleaning of your projector, *be sure it is cool.* Disconnect the power cord from its outlet. It is also a good practice to remove the slide tray plus the remote control and any other cables.

Replacing the Projection Lamp

Be careful! The lamp may be hot. If you are in a hurry, run the fan until the lamp and lamp module are cool, or use a cotton cloth to protect your fingers when you handle the warm lamp module and lamp.

To replace a burned-out lamp, open the lamp door by pressing down on the latch.

ANSI Code EXR and EXW projection lamps for *EKTAGRAPHIC* III Projectors

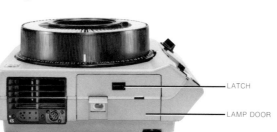

Grasp the small pull-out handle on the lamp module and pull slowly until the lamp module stops.

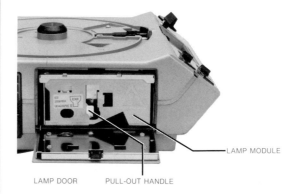

Press down on the stop latch on the lamp module, so that the lamp module can be pulled all the way out of the projector.

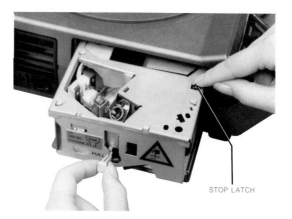

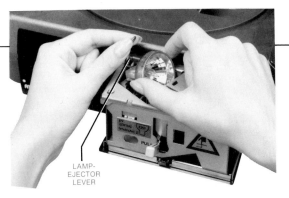

Push the lamp-ejector lever down and away from you so that it clears the retaining clip; then raise the lamp-ejector lever and remove the lamp.

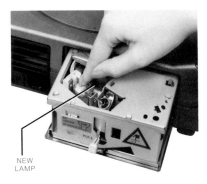

Insert a new lamp tightly into the two slots of the lamp socket.

NOTE: Do not touch the small bulb. If you accidentally get fingerprints on the bulb, remove them with a soft cloth moistened with rubbing alcohol.

Relatch the lamp-ejector lever. Press down on the lamp base until it is properly seated. Then push the lamp module back into the projector and close the lamp door.

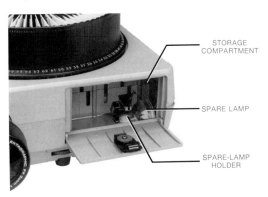

A spare lamp can be kept in the spare-lamp holder of the storage compartment in the front of the projector.

NOTE: A longer lamp-to-gate path in the *EKTAGRAPHIC* III Projector combines with the new ANSI Code EXR lamp to produce more uniform image brightness from center to corners. (This more uniform illumination is especially important in multi-image programs that contain wide-screen panoramas.)

Some Advantages of a Separate Lamp Module

KODAK EC Lamp Module

All *KODAK EKTAGRAPHIC* III Projectors are provided with the lamp module described earlier under "Replacing the Projection Lamp," on page 20. The lamp module offers some not-so-obvious benefits for single-projector as well as multi-image presentations.

Since it contains a projection lamp, mirror, heat-absorbing glass, and coated condenser lens, AV professionals can replace a burned-out lamp with a spare module (equipped with a new lamp) in a matter of seconds—*without disturbing critical projector alignment and without losing the attention of the audience.*

This quick lamp-change capability reduces the need to "relamp" before important multi-image programs and thus avoids the accumulation of expensive half-used projection lamps. It also simplifies the cleaning of optical parts and helps to prevent burned fingers.

The lamp module—complete with condenser optics and heat-absorbing glass—is available as an accessory from most dealers in Kodak audiovisual products. Refer to *KODAK* EC Lamp Module, CAT No. 145 0154, for pricing and ordering information.

Cleaning the Projection Lens

Remove the projection lens by pushing the lens focus and release knob *up* as you withdraw the lens. Blow off any loose grit. Then wipe both surfaces of the lens with *KODAK* Lens Cleaning Paper, or with a clean cloth moistened with a single drop of *KODAK* Lens Cleaner. Fingerprints reduce the brightness and clarity of screen images; a little dust does not.

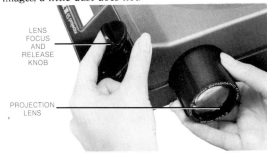

Cleaning Condenser Optics

CAUTION: The heat-absorbing glass could shatter unexpectedly. Always wear safety glasses.

Allow the glass to cool before handling. Be careful!
Anytime the glass is exposed, keep it covered with a cloth to confine potential shattering; handle the glass gently.

Open the lamp door and remove the lamp module as described on page 20. Next, loosen the small retaining screw and raise the hinged bracket. Then carefully lift out the condenser lens and heat-absorbing glass and place them in a soft cloth.

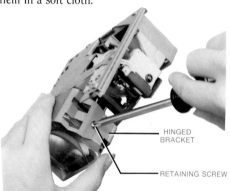

HINGED BRACKET

RETAINING SCREW

CAUTION: Damage to both the slides and the projection lens can be expected if the projector is operated without the heat-absorbing glass in place.

Wipe the condenser lens and heat-absorbing glass with either *KODAK* Lens Cleaning Paper or a clean, soft, lintless cloth.

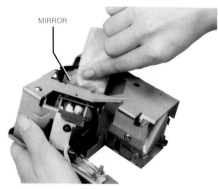

MIRROR

Do not leave fingerprints on the surfaces. Use a soft cloth to replace the lens and glass. Lower the bracket and tighten the retaining screw.

Invert the lamp module to reach the mirror through the opening. (The mirror is permanently aligned and should not be moved.) Wipe the mirror surface as described above for the optics.

Slide the module back into the projector as described earlier; then close the lamp door.

If You Modify the Projector

If you modify your projector, obliterate the UL and CSA labels. Modified equipment must conform to electrical and other appropriate codes and to safety requirements.

Allowing Proper Ventilation

If you use your projector in a confined or dusty area—particularly where a wall or partition blocks the fan exhaust—*poor ventilation may cause overheating.* If the built-in thermal fuses open and the projector stops, contact a Kodak Equipment Service Center or other competent repair service to have the fuses replaced and, if necessary, your projector repaired.

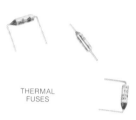

FAN (AIR EXHAUST)

Thermal Fuses

Your projector has two thermal fuses—one at the motor and one at the projection lamp—to prevent dangerous overheating in case of ventilation blockage, exhaust fan failure, or motor failure. If overheating causes the fuses to open, this indicates that the projector has been hot enough to cause possible damage. The projector should be checked and repaired, if necessary, by a qualified service technician at a Kodak Equipment Service Center or other competent repair service.

THERMAL FUSES

The Purpose of Thermal Fuses in *KODAK EKTAGRAPHIC* III and *EKTAGRAPHIC* Slide Projectors

Q. What is a thermal fuse? How is it different from other electrical fuses?

A. A thermal fuse works like an ordinary household fuse, except that it is sensitive to temperature rather than current. In other words, the thermal fuse opens a circuit and shuts off the electricity when the temperature is too high.

Q. Why are there thermal fuses in *KODAK EKTAGRAPHIC* Slide Projectors?

A. They are there for safety. Their purpose is to shut off electricity in the projector before the temperature rises high enough to be a fire hazard.

Q. Do the thermal fuses shut off the projector before high temperatures can shorten projector life or damage slides?

A. No, that is a common misconception. Temperatures may become too high for optimum motor life or maximum slide life, but the thermal fuses won't open, so the projector will keep running.

Q. Then why not use thermal fuses that open at a lower temperature—so the projector and slides will be protected?

A. It is not practical. Operating a motor even at a low temperature will eventually wear it out; and projecting a slide, even at a low temperature, might eventually cause some dye changes in the transparency.

Q. **Then why use thermal fuses at all in** *EKTAGRAPHIC* **Slide Projectors if the fuses don't protect the projector and slides?**

A. As we said, the thermal fuses are used to avoid hazards to surroundings—*not* to avoid high temperature operation of the projector. Sometimes people operate slide projectors in hot or dusty environments harmful to slide or projector life. But the user may feel that the reduction in slide and projector life is worthwhile because the presentation is important and effective. However, if the thermal fuses opened whenever the air temperature is higher than ideal, the presentation would be ruined.

Q. **Why aren't the thermal fuses user replaceable?**

A. Because a burned-out fuse indicates that there may be a projector problem that needs correction before the projector is used again. Experience indicates that replacing a thermal fuse without correcting the *cause* often results in another fuse burn-out.

Q. **What causes thermal fuses to burn out?**

A. It could be projector wear-and-tear from very long use, dirt in the ventilating air, an electrical short, low or high power source voltage, or other conditions that cause motor overload and projector overheating.

Q. **You mean, external conditions such as restricted airflow, paper piled up against projector air intakes, or blocked projector-exhaust airflow?**

A. Yes. Even if these conditions are corrected after a thermal fuse has opened, the projector should be thoroughly checked by a competent technician because the projector has been overheated, possibly causing more projector damage.

Q. **I have heard of people who wire across the thermal fuse contacts and say they have no trouble.**

A. That is courting trouble. It is similar to putting a penny in an old-fashioned fuse holder. A "bypassed" thermal fuse in a slide projector usually causes reduced projector and slide life because of too much heat. Of course, defeating a safety feature means increased danger for yourself, other people, your environment, and your property.

Q. **Well, if the projector thermal fuses are not intended to protect the projector and slides from overheating, what can** *EKTAGRAPHIC* **III and** *EKTAGRAPHIC* **Slide Projector owners and users do to provide such protection?**

A. Usually no problems will occur if you follow the instructions in the "User's Instruction Manual" packed with every *EKTAGRAPHIC* Slide Projector.

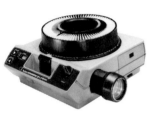

Microfiche Service Library

A comprehensive microfiche reference library that provides complete and up-to-date service information on all current Kodak amateur and professional audiovisual equipment, including *EKTAGRAPHIC* and *EKTAGRAPHIC* III Slide Projectors, is available from Eastman Kodak Company. The microfiche cards can be viewed on any microfiche reader. Further information on this microfiche library and other service plans is available from

> Eastman Kodak Company
> Parts Services
> 800 Lee Road
> Rochester, New York 14650
> Phone (716) 722-7087

A printed service manual for *KODAK EKTAGRAPHIC* III Projectors is also available as a special service to owners of *EKTAGRAPHIC* III Projectors: *Service Manual for the KODAK EKTAGRAPHIC III Projectors—Autofocus Models* (*KODAK* Publication No. S-81-1). This publication is a supplement to the microfiche service library described above. It does not replace the microfiche service library. The microfiche service library is updated as changes occur and is, therefore, the recommended source of current service information.

The printed manual can also be ordered from the address below for $15.00. (Be sure to include $2.95 with each order to help defray the handling and shipping charges, and enclose remittance (check, money order, or purchase order payable to Eastman Kodak Company) with your order:

> **Eastman Kodak Company**
> **Department 454**
> **343 State Street**
> **Rochester, New York 14650**

You can also order by telephone toll-free at **1-800-445-6325, Ext 206,** in the continental U.S.A., 8:30 a.m. to 4:30 p.m. EST, Monday through Friday. Have the code number ready when you call. Use this phone number **for credit card ordering only.**

☐ VISA^R ☐ Master Card™

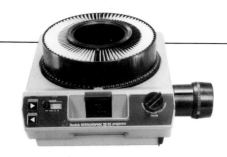

KODAK EKTAGRAPHIC III ES PROJECTOR

The *KODAK EKTAGRAPHIC* III ES Projector has all of the features, functions, and maintenance requirements of the III E Projector discussed earlier, plus one additional feature: a built-in viewer.

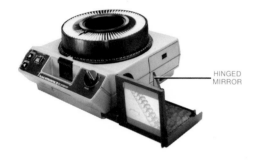

HINGED MIRROR

The Controls and Their Functions

Built-in Viewer

The built-in viewer is especially convenient for projecting your slides in a fully lighted or darkened room to either preview them alone or present them to a small group. It also offers a quick, easy way of slide editing.

CAUTION: Before attempting to use the built-in viewer, first remove the projection lens. (If the lens is not removed, the projector may be damaged.)

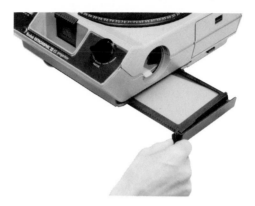

Grasp the viewer handle and pull it all the way out from under the projector to open the viewer. A built-in 2.09 inch (53 mm) *f*/4.2 lens—designed only for use with the built-in screen—moves into position as you pull out the viewer. The screen itself measures 3³/₄ x 3³/₄ inches (95.2 x 95.2 mm). Pull the screen out until it is almost an inch beyond the front of the projector so the image will be properly centered, and the lens will be properly coupled to the focusing mechanism.

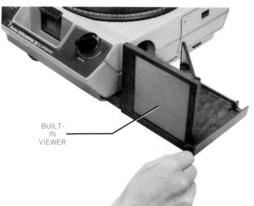

BUILT-IN VIEWER

To close the viewer, press the hinged mirror gently against the screen. Then lower the screen and mirror together into the viewer base and slide the viewer back into the compartment beneath the projector.

Operating the Projector

Operation of the *EKTAGRAPHIC* III ES Projector is exactly the same as the III E Projector with the addition of the built-in viewer described on page 24.

KODAK EC-1 REMOTE CONTROL

Shutdown and Projector Maintenance

Refer to the *EKTAGRAPHIC* III E Projector instructions on pages 19-22 for detailed shutdown and maintenance procedures. The viewer mirror and screen on the *EKTAGRAPHIC* III ES Projector can be cleaned the same way as the internal projector optics of the III E Projector. Normally, the internal projection lens will not need cleaning, but if it does, the front surface can be cleaned with a cotton swab. The back surface can be cleaned with a short cotton swab, held in the gate area by a pair of tweezers or needle-nose pliers. To see what is being done, turn the projector on, and release the shutter by pulling the pressure pads back in the gate; view from the front obliquely (i.e., not looking directly into the lens).

KODAK EKTAGRAPHIC III B PROJECTOR

The *KODAK EKTAGRAPHIC* III B Projector has all of the features, functions, and maintenance requirements of the III E Projector, plus remote focusing as well as remote forward and reverse slide-change capability, using the *KODAK* EC-2 Remote Control packed with the projector.

The Controls and Their Functions

The Remote Control and Plug

The colored dot on the plug of the *KODAK* EC-2 Remote Control for the *EKTAGRAPHIC* III B Projector is red. Plug the remote control into the remote-accessory receptacle so the red orientation dot on the plug is at the dot on the projector. Then briefly press either the forward or reverse button on the remote control to cycle the projector.

The focus lever on the remote control focuses the image as does the lens focus and release knob on the projector. Simply press the focus lever on the remote control forward or back to adjust image focus on the screen. If you use a zoom lens, first adjust image size by rotating the lens barrel, and then refocus.

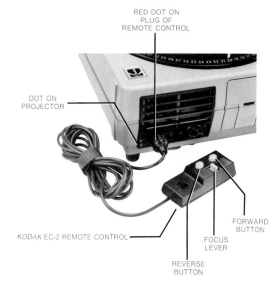

RED DOT ON PLUG OF REMOTE CONTROL

DOT ON PROJECTOR

FORWARD BUTTON

KODAK EC-2 REMOTE CONTROL

FOCUS LEVER

REVERSE BUTTON

Operating the Projector

Operation of the *EKTAGRAPHIC* III B Projector is exactly the same as the III E Projector with the addition of the remote focus and remote forward and reverse slide-change capabilities described above.

Shutdown and Projector Maintenance

Refer to the *EKTAGRAPHIC* III E Projector instructions on pages 19-22 for detailed shutdown and maintenance procedures.

REMOTE-
ACCESSORY
RECEPTACLE

KODAK EKTAGRAPHIC III A PROJECTOR

The *KODAK EKTAGRAPHIC* III A Projector has all of the features, functions, and maintenance requirements of the III E Projector, plus automatic focusing of similarly mounted slides (autofocus capability). It also has an autofocus on/off switch as well as remote forward and reverse slide-change capability.

AUTOFOCUS ON/OFF SWITCH

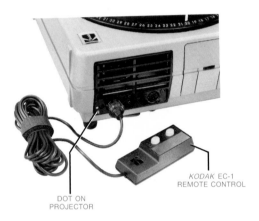

DOT ON
PROJECTOR

KODAK EC-1
REMOTE CONTROL

The Controls and Their Functions

Autofocus On/Off Switch

A built-in electronic autofocus mechanism monitors the position of each transparency in relationship to the lens. It is controlled by the autofocus on/off switch. After the first slide is focused by the user, the mechanism automatically maintains the distance between the lens and the front surface of the next slide, near the center. The front surface is film in an open-frame mount and glass (instead of film) in a glass-mounted slide.

For slides mounted the same way (all glass, or all plastic, etc), focus the first one and then leave the autofocus switch on to maintain focus.

Leave the switch off when your slides are a mix of open-frame (cardboard or plastic) and glass or if the divisions on some multiaperture slides or matte-surface write-on slides make the autofocus mechanism motor run continuously. With some mixed open-frame and glass mounts, one or the other may be out of focus; you can refocus for each type when necessary or determine and set an acceptable overall focus.

You may also wish to keep the autofocus switches of your projectors at the OFF position when presenting dissolve or multi-image programs.

The Remote Control and Plug

The colored dot on the plug of the *KODAK* EC-1 Remote Control (supplied with the projector) for the *EKTAGRAPHIC* III A Projector is yellow. Plug the EC-1 Remote Control into the remote-accessory receptacle so the yellow orientation dot on the plug is at the dot on the projector. Then briefly press either the forward or reverse button on the remote control to cycle the projector.

Operating the Projector

Operation of the *EKTAGRAPHIC* III A Projector is the same as the III E Projector, with the addition of the remote-control forward and reverse slide-change capability and autofocus capability.

Shutdown and Projector Maintenance

Refer to the III E Projector instructions on pages 19-22 for detailed shutdown and maintenance procedures.

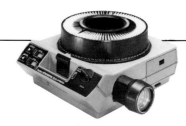

KODAK EKTAGRAPHIC III AS PROJECTOR

The *KODAK EKTAGRAPHIC* III AS Projector has all of the features, functions, and maintenance requirements of the III A Projector plus one additional feature: a built-in viewer.

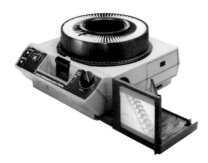

The Controls and Their Functions

Built-in Viewer

Refer to the *EKTAGRAPHIC* III ES Projector instructions (page 24) for detailed information on how to use the built-in viewer.

Operating the Projector

Operation of the *EKTAGRAPHIC* III AS Projector is exactly the same as the III A Projector with the addition of the built-in viewer, described in the III ES instructions (page 24).

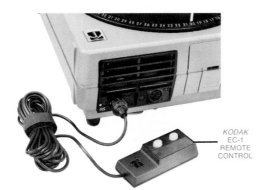

KODAK EC-1 REMOTE CONTROL

The *EKTAGRAPHIC* III AS Projector uses the **KODAK EC-1 Remote Control.**

Shutdown and Projector Maintenance

Refer to the *EKTAGRAPHIC* III E Projector instructions (pages 19-22) for detailed shutdown and maintenance procedures.

KODAK EKTAGRAPHIC III AT PROJECTOR

The *KODAK EKTAGRAPHIC* III AT Projector has all of the features, functions, and maintenance requirements of the *EKTAGRAPHIC* III A Projector plus remote-focus capability and a variable electronic timer. The variable electronic timer provides a choice of preset automatic slide-change intervals ranging from about 3 to 22 seconds.

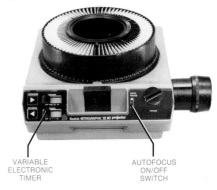

VARIABLE ELECTRONIC TIMER

AUTOFOCUS ON/OFF SWITCH

The Controls and Their Functions

The Remote Control and Plug

The colored dot on the plug of the *KODAK* EC-3 Remote Control for the *EKTAGRAPHIC* III AT Projector is white. Insert the plug of the remote control into the remote-accessory receptacle so the white orientation dot on the plug is at the dot on the projector. Then briefly press either the forward or reverse button on the remote control to cycle the projector in the desired direction.

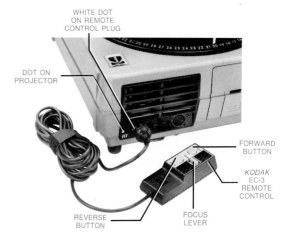

WHITE DOT ON REMOTE CONTROL PLUG

DOT ON PROJECTOR

FORWARD BUTTON

KODAK EC-3 REMOTE CONTROL

REVERSE BUTTON

FOCUS LEVER

The focus lever on the remote control performs the same function as the lens focus and release knob on the projector. Simply move the lever forward or back to adjust image focus on the screen. Until released, the focus lever on the remote control overrides the autofocus mechanism.

Autofocus On/Off Switch

The autofocus mechanism as well as the autofocus on/off switch for the *EKTAGRAPHIC* III AT Projector perform the same functions as described for the III A Projector (page 26). The remote focus continues to work even if the autofocus mechanism is switched off.

VARIABLE
ELECTRONIC
TIMER

AUTOFOCUS
ON/OFF
SWITCH

Variable Electronic Timer

The variable electronic timer on the *EKTAGRAPHIC* III AT Projector provides continuous variable automatic timing of slide-change intervals ranging from about 3 seconds at the fast end (F) to about 22 seconds at the slow end (S). Place the slider control at the desired position. Your slides will cycle automatically at any interval from 3 to 22 seconds when the projector is on. The three-point interval scale below the slider control is roughly linear so that a setting at the center dot will result in intervals between automatic slide advances of about 13 seconds.

Operating the Projector

Operation of the *EKTAGRAPHIC* III AT Projector is exactly the same as the III A Projector (page 26) with the addition of the remote-control focus capability and the variable electronic timer described above.

Shutdown and Projector Maintenance

Refer to the *EKTAGRAPHIC* III E Projector instructions (pages 19-22) for details on shutdown and maintenance procedures.

Answers to Some Common Questions about the *KODAK EKTAGRAPHIC* III Projectors

Q. Will the larger size of the *EKTAGRAPHIC* III Projector create more keystoning?

A. It's not likely. The actual increase in projector size is not great. The difference in minimum spacing from one projector to the next one is inconsequential at ordinary projection distances, with the projection lenses ordinarily used.

Q. Will the 16-degree elevation capability of the *EKTAGRAPHIC* III Projector cause keystoning when fully used?

A. Anytime the lens axis is not at right angles to the projection screen, there will be keystoning. Increasing the elevation angle will increase keystoning on a vertical screen. Usually, keystoning caused by an approximately 16-degree-projection angle is not objectionable for single image use (one projector, or a dissolve control with two projectors).

Q. Why doesn't the image fill the built-in viewer (screen) on the *EKTAGRAPHIC* III ES and AS Models?

A. There is some space around the image when using smaller slide formats so the popular 24 x 36 mm horizontal format can be seen either as a horizontal or a vertical image. If super slides are used, the image fills the screen.

Q. What happens if the high-output EXW lamp intended for the *EKTAGRAPHIC* III Projector is used in a *CAROUSEL* 4000 or 5000 Series projector?

A. The *CAROUSEL* Projector will overheat. The safety thermal fuse in the lamp area could open, shutting off the projector.

Q. We've been told that the *KODAK* EC Lamp Module supplied with the *EKTAGRAPHIC* III Projector is available as a separate product. Can it be used in *CAROUSEL* 4000 and 5000 Series projectors?

A. Yes, but that still doesn't permit using the high-output EXW lamp. The cooling of the *CAROUSEL* 4000 and 5000 Series projectors is not sufficient for the lamp, and the thermal fuse could open.

KODAK EKTAGRAPHIC SLIDE PROJECTORS

INTRODUCTION

The information presented in this section covers the controls and functions for all currently manufactured models of the *KODAK EKTAGRAPHIC* Slide Projector—as well as the basic setup, preparation, use, shutdown, and maintenance procedures for each projector.

As shown on the Projector Summary Table on page 11, the *EKTAGRAPHIC* Slide Projector, Model E-2, is the most basic model and hence will be described first. Models B-2, B-2AR, AF-1, AF-2, and AF-2K (which follow in that order) have the same basic features as the Model E-2 plus other features that make them appropriate for specific projection requirements and environments. Only features unique to each model (after Model E-2) will be noted.

GENERAL PROJECTOR FEATURES AND DIMENSIONS

The *KODAK EKTAGRAPHIC* Slide Projector—Models E-2, B-2, B-2AR, AF-1, AF-2, and AF-2K—is designed to meet the demanding needs of the professional user and incorporates many special features for multi-image applications. It has precise, repeatable horizontal and vertical slide registration, heavy-duty motor, and a dark-screen shutter. Some models are equipped with an autofocus on/off switch. All models are equipped with a varistor and a capacitor to extend clutch-spring contact life and reduce projector-generated interference with tape players and AV programmers—a potential cause of audio "popping" and unwanted slide changes.

The condenser lens in *EKTAGRAPHIC* Slide Projectors is coated to reduce internal reflectance—giving you approximately eight percent more light output.

Shown at the left are dimensional line drawings for the *EKTAGRAPHIC* Slide Projector—to assist people who need this information for use in the design and construction of projection shelves, piggyback stands, carrying cases, etc.

In general, allow approximately 2 inches (51 mm) behind the projector for plug connections and about 3 inches (176 mm) clearance above the slide tray for tray removal.

IMPORTANT: Do not obstruct air intake and exhaust areas located at the slide gate, lamphouse, underneath, and rear surface of the projector.

Elevation: Approximately 1 inch results in a 6½-degree upward angle.

Projector Weight: Ten lb (4.5 kg); exception: *EKTAGRAPHIC* Slide Projector, Model B-2AR, 14 lb (6.4 kg).

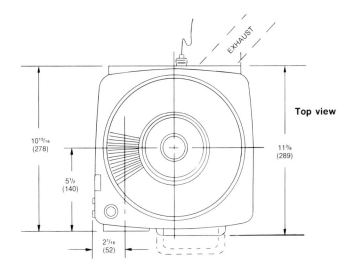

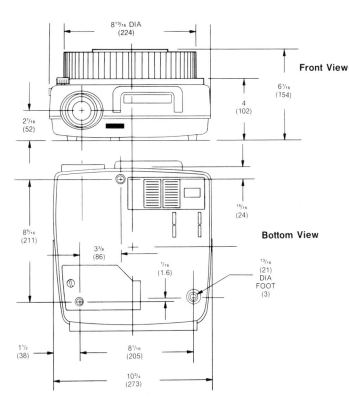

Dimensional line drawings for the KODAK EKTAGRAPHIC Slide Projector, Models E-2, B-2, B-2AR, AF-1, AF-2, and AF-2K.

KODAK EKTAGRAPHIC SLIDE PROJECTOR, MODEL E-2

The Controls and Their Functions

Remote-Accessory Receptacle

The seven-contact remote-accessory receptacle of the *EKTAGRAPHIC* Slide Projector, Model E-2, accepts the control plug from a number of remote-control devices, such as the *KODAK EKTAGRAPHIC* Programmable Dissolve Control, Model 2, the *KODAK* EC Sound-Slide Synchronizer, the *KODAK* EC Automatic Timer, Model III, and the *KODAK* EC-1 Remote Control, plus the plugs of many other dissolve controls and projector-control devices from other manufacturers.

Leveling Wheel

Turn the leveling wheel clockwise to raise and counterclockwise to lower the left side of the projector (and therefore, the left side of the projected image). This feature is important for alignment and superimposition of multiple images in dissolve and multi-image presentations.

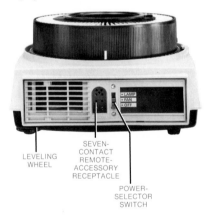

LEVELING WHEEL

SEVEN-CONTACT REMOTE-ACCESSORY RECEPTACLE

POWER-SELECTOR SWITCH

EKTAGRAPHIC Slide Projectors are equipped with a built-in three-wire grounding power cord, as required by many industrial and institutional safety codes.

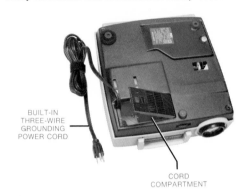

BUILT-IN THREE-WIRE GROUNDING POWER CORD

CORD COMPARTMENT

Remote Control

A *KODAK* EC-1 Remote Control is not supplied with the Model E-2 Projector. However, in case you should obtain one separately, its features are discussed here. To change slides with the EC-1 Remote Control, insert the plug of the remote control into the remote-accessory receptacle of the projector. Then briefly press either the remote-control forward or remote-control reverse button to rotate the slide tray in the desired direction one space (slide position) at a time. (Holding either button down will change slides rapidly.)

NOTE: The interchanging of a *KODAK* EC-1 Remote Control between a Model E-2 Projector and other models of *EKTAGRAPHIC* Slide Projectors is not recommended.

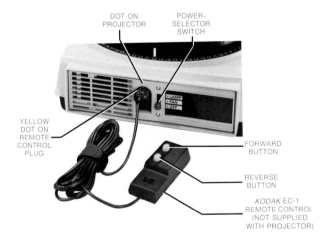

DOT ON PROJECTOR

POWER-SELECTOR SWITCH

YELLOW DOT ON REMOTE CONTROL PLUG

FORWARD BUTTON

REVERSE BUTTON

KODAK EC-1 REMOTE CONTROL (NOT SUPPLIED WITH PROJECTOR)

Power-Selector Switch

When the power-selector switch is set at the FAN position, the projector's cooling fan will operate but the projection lamp will not be lighted (unless the projector is connected to a dissolve control or other control device, such as a multi-image computer programmer). When connecting two or more slide projectors to a dissolve control, set the power-selector switches of each

projector at the FAN position. For conventional single-projector use, set the power-selector switch of the slide projector at the LAMP position; the projector fan will run and the lamp will be lighted. (A 300 W ELH lamp, supplied with the projector, has a rated average life of 35 hours at 120 V.)

SEVEN-CONTACT
REMOTE
ACCESSORY
RECEPTACLE

The seven-prong plugs on the projector cords of the *KODAK EKTAGRAPHIC* Programmable Dissolve Control, Model 2, fit into the seven-contact remote-accessory receptacle of the projector. (Dissolve controls from other manufacturers have similar seven-prong plugs, also compatible with *EKTAGRAPHIC* Slide Projectors.)

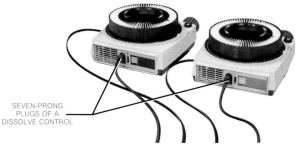

SEVEN-PRONG
PLUGS OF A
DISSOLVE CONTROL

NOTE: The lamp operates at 300 W only when a dissolve control is being used with the projector. During conventional single-projector operation, the lamp runs at 255 W; therefore, average lamp life is increased to 105 hours.

Lens Focus and Release Knob

To install or remove a projection lens, push the lens focus and release knob down toward the side of the projector as you insert or withdraw the projection lens.

Also, when inserting the lens, position the threaded rack of the lens barrel toward the right (as viewed from behind the projector) to engage the pinion of the focus-knob shaft.

Elevation Wheel

Turn the elevation wheel clockwise to raise and counterclockwise to lower the screen image. The elevation range is from zero to six degrees.

NOTE: The *EKTAGRAPHIC* III Projector provides an elevation range of from 0 to 16 degrees.

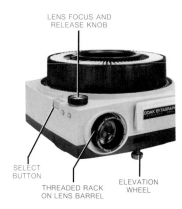

LENS FOCUS AND
RELEASE KNOB

SELECT
BUTTON

THREADED RACK
ON LENS BARREL

ELEVATION
WHEEL

Focus the image by turning the lens focus and release knob in the appropriate direction. If you are using a zoom lens, adjust image size first by rotating the lens barrel and then refocus the image.

Forward and Reverse Buttons

Briefly press the projector forward button or reverse button to change your slides one slide slot at a time. Holding either button down will change slides rapidly.

Select Button

When the select button is pressed and held down (with power on), the slide tray can be rotated to any slide position. The select button can also be used when projecting individual slides without a slide tray, or for ejecting a slide from the gate.

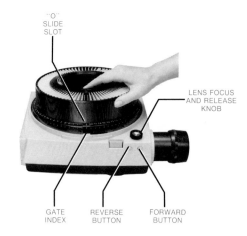

"O"
SLIDE
SLOT

LENS FOCUS
AND RELEASE
KNOB

GATE
INDEX

REVERSE
BUTTON

FORWARD
BUTTON

Setting Up

Loading the Slide Tray

Refer to the instructions on page 17 under "Loading the Slide Tray for Front-Screen Projection."

Installing the Slide Tray on the Projector

Refer to the instructions on page 18 under the same heading.

Operating the Projector

Quick Start-Up

- Plug the projector into a 110 to 125 V, 60 Hz power outlet. (The models B-2AR, AF-2K, S-AV2030, and S-AV2050, described later in this section, have different power requirements.)
- Place a loaded slide tray on the projector with the "0" slide slot aligned with the gate index of the projector.
- Move the projector power-selector switch to the LAMP position for single-projector use. (If light from the projection lamp spills onto the screen when the projector is turned on, the automatic dark-screen shutter in the projector is not engaged. Simply press the select bar on the projector once to engage the automatic dark-screen shutter so the projection lamp light is blocked.)
- When using a dissolve control, move the power-selector switches of your projectors to the FAN position.
- Lower the room lights, and push the forward button on the projector to project the first slide.
- Focus and align the image, and proceed with your program.

If the Slide Tray Jams

If the slide-changing mechanism will not operate because a defective slide is caught in the gate, use a coin to remove the tray to correct the problem. For detailed instructions on how to release the tray, refer to page 18, column 2.

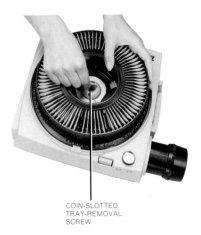

COIN-SLOTTED
TRAY-REMOVAL
SCREW

Alternative Projection Methods

Three alternative methods of showing your slides are possible. They are described on page 19 for the *EKTAGRAPHIC* III E Projector.

Long-Run Applications

For information on long-run applications, see page 19, under the *EKTAGRAPHIC* III E Projector.

Shutdown

You should adopt a standard shutdown procedure after each presentation, similar to the one that follows. This approach will not only help you to be ready for the next show but will also help provide proper care for the projector.

- With projector power on, rotate the tray to the "0" position while pressing the select bar.
- Turn off all power to the projector by moving the power-selector switch to the OFF position.

NOTE: Rapid cooling of the projector after each use is not necessary nor recommended. However, if the projector must be handled immediately after the show, the fan can be run to speed up cooling.

- Remove the slide tray.

If the projector will be moved before the next show

- Retract the elevation wheel and leveling wheel to help prevent damage in transit.
- If desired, remove the projection lens.
- Unplug the remote control (or the dissolve control cords, if used).
- Disconnect the power cord from the power source, and place the projector in a suitable container or travel case for maximum protection.

KODAK AV-III
Compartment Case

- Before you attempt any maintenance or cleaning of the projector, be sure it is cool and the power cord is disconnected from the power outlet. Also remove the slide tray and remote control or dissolve control.

Projector Maintenance

Replacing the Projection Lamp

CAUTION: The lamp may be hot. Don't handle the lamp with unprotected fingers. If you are in a hurry, you may wish to run the fan briefly to cool the lamp; or you can protect your fingers with a cloth or glove.

To replace the lamp, first turn the projector upside down. Then open the lamp door by turning the coin-slotted screw counterclockwise.

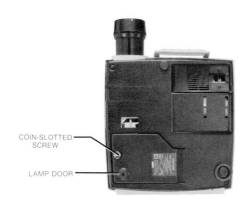

COIN-SLOTTED SCREW

LAMP DOOR

Release the lamp-ejector lever and lift the lever to eject the lamp from its socket. Remove the burned-out lamp, noting how the two pins on the lamp base fit into the socket.

Do not touch the bulb portion of the new lamp. If you accidentally get fingerprints on the bulb, remove them with a soft cloth moistened with rubbing alcohol.

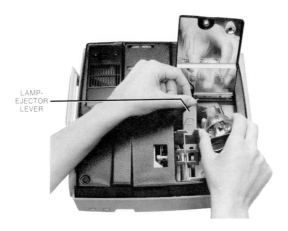

LAMP-EJECTOR LEVER

To install the new lamp, place it into the socket so that the two pins on its base fit into the two slots in the socket and the longer sides of the lamp base are parallel to the bottom of the projector. Then seat the lamp by lowering and latching the lamp-ejector lever. Press down on the lamp base to be sure it is properly seated and firmly push the socket toward the lamp. Then close and fasten the lamp door.

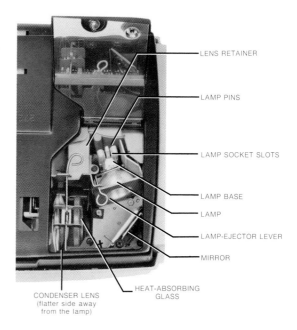

LENS RETAINER

LAMP PINS

LAMP SOCKET SLOTS

LAMP BASE

LAMP

LAMP-EJECTOR LEVER

MIRROR

CONDENSER LENS (flatter side away from the lamp)

HEAT-ABSORBING GLASS

Cleaning the Projection Lens

Remove the projection lens. Blow off any loose grit. Then wipe both glass surfaces with *KODAK* Lens Cleaning Paper or with a clean cloth moistened with a single drop of *KODAK* Lens Cleaner. (Equivalent products are available and may be used, if desired.) Fingerprints reduce the brightness and clarity of screen images but a little dust does not.

Cleaning Condenser Optics

CAUTION: The heat-absorbing glass can shatter unexpectedly. Always wear safety glasses. Allow the glass to cool before handling it. Be careful! Anytime the glass is exposed, keep it covered with a cloth to confine potential shattering. Handle the glass gently.

To clean the condenser optics, first turn the projector upside down. Then open the lamp door as described under "Replacing the Projection Lamp" on this page. Release the lens retainer from its notch and raise it so that it clears the optics. Carefully lift out the condenser lens and heat-absorbing glass, noting their exact positions in the chamber, and then place them in a soft cloth.

NOTE: Refer to the illustration stamped inside the lamp door of the projector. It shows the proper orientation of the optics.

Do not remove the mirror, as it is permanently aligned and should not be moved. Clean the mirror, as well as both sides of the condenser lens and heat-absorbing glass, with either *KODAK* Lens Cleaning Paper or a soft lintless cloth.

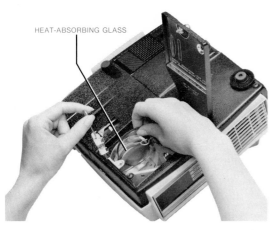

HEAT-ABSORBING GLASS

KODAK EKTAGRAPHIC
SLIDE PROJECTOR, MODEL B-2

The Model B-2 Projector has all of the features, functions, and maintenance requirements of the Model E-2 Projector, plus remote focusing, remote forward and reverse slide-change capability, and a four-position power-selector switch for OFF, FAN, and LOW and HIGH lamp settings.

The Controls and Their Functions

Power-Selector Switch

When the power-selector switch is set at FAN, the projector's cooling fan will operate but the projection lamp will not be lighted (unless the projector is connected to a dissolve control). Set the power-selector switch at FAN for connection of two or more projectors to a dissolve control.

The LOW and HIGH positions on the power-selector switch provide added versatility to the Model B-2 Projector. For single-projector use, move the switch to LOW to obtain maximum lamp life or HIGH for maximum brightness.

Replace the elements in the following sequence, holding each one with a soft cloth. (Do not leave fingerprints on the surfaces.) First, place the condenser lens in the guides nearer the front of the projector with the *flatter* side of the lens away from the lamp. Then, place the heat-absorbing glass in the guides nearer the mirror. Secure the lens retainer to its original position, being certain that it latches.

CAUTION: Damage to both the slides and projection lens will usually result if the projector is operated without the heat-absorbing glass in place.

Close and fasten the lamp door.

Allowing Proper Ventilation

Refer to the information on page 22.

Thermal Fuses

Refer to the information on pages 22 and 23.

Serial Number

The serial number of your projector is stamped on the bottom of the projector near the power cord compartment. Record this number—as well as the model number and the date and place of purchase—for future reference.

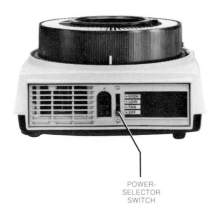

POWER-
SELECTOR
SWITCH

SERIAL
NUMBER

If You Modify the Projector

If you modify your projector, obliterate UL and CSA labels. Modified equipment must conform to electrical and other appropriate codes and safety requirements.

The Remote Control and Plug

The colored dot on the plug of the *KODAK* EC-2 Remote Control for the B-2 Projector is red. Plug the remote control into the remote-accessory receptacle of the projector so the red orientation dot on the plug is at the dot on the projector. Then briefly press either the forward or reverse button on the remote control to cycle the projector tray in the desired direction.

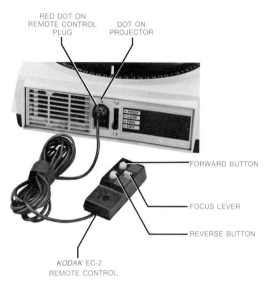

RED DOT ON REMOTE CONTROL PLUG

DOT ON PROJECTOR

FORWARD BUTTON

FOCUS LEVER

REVERSE BUTTON

KODAK EC-2 REMOTE CONTROL

The focus lever on the remote control performs the same function as the lens focus and release knob on the projector. Simply move the lever forward or back to adjust image focus on the screen. When using a zoom lens, adjust image size by rotating the lens barrel and then refocus.

Operating the Projector

Operation of the B-2 Projector is the same as the E-2 Projector, with the addition of the four-position power-selector switch as well as the remote focus and remote forward and reverse slide-change capabilities described earlier.

Projector Maintenance

Refer to the E-2 Projector instructions (page 33) for detailed maintenance procedures.

KODAK EKTAGRAPHIC SLIDE PROJECTOR, MODEL B-2AR

The Model B-2AR Projector has all of the features, functions, and maintenance requirements of the Model B-2 Projector, with the additional capability of operating on either 110 to 130 V or 220 to 240 V, 50 or 60 Hz. The projector adjusts automatically to the power supply and is designed for international use.

Voltage Sensing Characteristics of the *EKTAGRAPHIC* Slide Projector, Model B-2AR

When the projector is connected to a power source and turned on, the detection circuit in the projector will connect the motor and lamp directly to the power source if the power is in the 110-130 V range. If the circuit is 220-240 V, an autotransformer in the projector is brought into the circuit, so the voltage is cut approximately in half for both the motor and lamp.

In addition to this major automatic switching function, the projector detection circuit also brings into play a low-voltage boost-or-buck (increase or decrease) winding on the transformer of the projector.

Thus, if the voltage is 110 V, it is boosted about 8 V to supply approximately 118 V to both the lamp and the motor. If the voltage is 127 V (common in some countries that have 50 Hz power), the voltage is bucked (decreased), to supply about 119 V to the lamp and motor. The action is similar at the high and low end of the high-voltage (220-240 V) range, so that again, about 117-120 V is supplied to the lamp and motor.

The crossover point is about 117 V for the lamp and motor. Below that point, the voltage increases a few volts; above it, it decreases (bucks) a few volts. This provides more consistent light output and lamp life, and also proper motor performance.

If voltage fluctuated only slightly around the crossover point, light output would fluctuate as the boost-buck coil switched first one way and then the other. This would be undesirable, because of changes in the light output and relay "chatter." Therefore, a lag (or hysteresis) has been built into the circuit, so the light output will not fluctuate with small changes in voltage.

(CONTINUED)

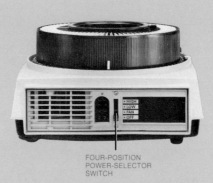

FOUR-POSITION
POWER-SELECTOR
SWITCH

However, there may be instances when voltage fluctuations will be large enough to cause the detection circuit to change the boost-buck coil and cause unwanted projection-light variations. For example, if a long lightweight power extension cord is being used, with one projector lamp lit in a two-projector dissolve pair, line voltage would be 125 V at the projector. This would cause the detection circuit to subtract the small voltage, supplying about 117 V to the projectors and the lamp which was lit.

At about the midpoint in a dissolve, lamps are lit in both projectors, drawing almost their full current. If this load were sufficient to cause the voltage to drop to perhaps 114 V (because of the lightweight extension cord), the sensing circuits in the projector would change the low-voltage coil from buck to boost—and the light levels of both projected images would immediately increase.

As the dissolve progressed, the off-going lamp would be reduced in brightness until it drew either no current or negligible current. This could permit the line voltage supplying the projectors to rise again, so the sensing circuit would again be activated, reducing the voltage and illumination.

Occasionally, there could be other reasons for the voltage change—and any which caused enough change would result in automatic compensation by the projector(s) and a change in light level.

To help prevent this, try to use controlled electrical circuits, so that voltage fluctuations are held to a minimum; or use circuits that provide voltages which are either sufficiently below or above the switch-over points. This will prevent the automatic sensing circuits in the projectors from making a change, even though there may be a fluctuation of several volts in the supply.

In the previous examples, some specific voltages are mentioned. The voltages on which projectors are operated should not fall outside the ranges for which the equipment is designed (110-130 V and 220-240 V). However, occasionally there may be some variation in the actual voltage at which projectors change from "boost" to "buck" configuration. And there may be very minor variations from one projector to another. In general, however, the changes will occur in approximately the center of the 110-130 V range (perhaps 115-120 V); or in the center of the 220-240 V range (perhaps 227-233 V). The point at which the actual change will occur, with either decreasing or increasing voltage, is not completely consistent (because of normal variations in electronic components); nor is it easily adjustable.

CAUTION: Bypassing the projector's boost-buck circuit is not advisable, since it may result in overheating or insufficient power in the motor and unacceptable variations in lamp life and light output.

The motor used in the Model B-2AR operates satisfactorily on either 50 or 60 Hz, and thus no special sensing or switching is required for frequency change. The motor runs slightly slower on 50 Hz. Slide change time is about 1.2 seconds on 50 Hz and about 1 second on 60 Hz. The fan-driving pulley on the motor is slightly larger than on the motors of most *EKTAGRAPHIC* Slide Projectors, so the fan will be driven at normal speed on 50 Hz to provide full cooling. It operates at a little greater than normal speed on 60 Hz.

Some Questions and Answers about the *KODAK EKTAGRAPHIC* Slide Projector, Model B-2AR

Q. What are some differences between the Model B-2 Projector and Model B-2AR Projector?

A. The B-2 Projector has a cord compartment while the B-2AR does not. The cord compartment space in the Model B-2AR is filled with electronic sensing and switching parts.

MODEL B-2AR

Also, the motor in the Model B-2AR runs a little faster on 60 Hz current than the motors in domestic projectors, so there will be plenty of cooling of the B-2AR when operated on 50 Hz also.

Q. What does the "AR" stand for?

A. "A" stands for "Automatic." "R" is a designation Kodak has used for equipment models made in the U.S. and Canada but which can be used on either 120 or 240 V, and on either 50 or 60 Hz.

Q. What projection lamps does the Model B-2AR use?

A. It normally uses the same lamp as domestic projectors—the ELH; however, the long-life (ENH) and high-output (ENG) lamps can also be used.

Q. Why don't the lamps burn out when the projector is used on high voltage?

A. An autotransformer built into the projector reduces the voltage to the proper level for the lamps.

Q. Wouldn't a solid state dimmer (with an SCR or Triac) do the job with less weight and problems?

A. Probably not. Unless a complicated circuit is used, the electrical "spikes" and "hash" from such devices can cause problems not found in electrical sine waves you get from a true transformer.

ANSI Code ELH Projection Lamp

Q. Why not use the *EKTAGRAPHIC* S-AV2050 Projector (described later in The *Source Book)* instead?

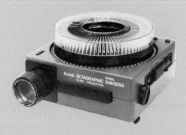

A. The Model B-2AR can be used with domestic parts and accessories, such as the *KODAK* EC Remote Controls, the *EKTAGRAPHIC* Programmable Dissolve Control, Model 2, multi-image computer programmers, and extension cords, etc, which will not interface with the *EKTAGRAPHIC* S-AV2050 Projector. But the automatic voltage switching capability is the biggest reason for using the Model B-2AR. It is a convenient projector to use in places that provide both low and high-voltage power sources. (These are common in a number of countries.) In addition, there is a faster lamp decay rate when using the Model B-2AR. (The light from the ANSI Code EHJ lamp in the S-AV2050 Projector decays more slowly when it is turned off than the light produced by the ANSI Code ELH lamps used in the Model B-2AR.)

Q. Will the Model B-2AR work with the *KODAK EKTAGRAPHIC* Programmable Dissolve Control, Model 2, and other dissolve controls, on either voltage range, and on either 50 or 60 Hz?

A. Yes.

Q. What happens if the Model B-2AR is connected to voltage outside the ranges specified for it?

A. Damage. Some of the projector components are likely to overheat and burn out with either too high or too low a voltage, just as with any domestic *EKTAGRAPHIC* Slide Projector that is operated on voltages outside its normal range. Signs of excessively low or high voltage include a chattering relay in the projector, failure of the motor to start, or unusually bright lamp. (Of course, as with any electrical appliance, you must know the voltage being supplied before using the projector.)

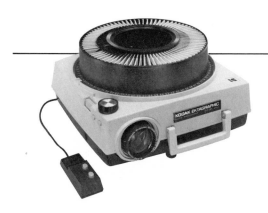

KODAK EKTAGRAPHIC
SLIDE PROJECTOR, MODEL AF-1

The Model AF-1 Projector has all of the features, functions, and maintenance requirements of the Model E-2 Projector. (The Model B-2 Projector has remote focusing capability; the Model AF-1 does not.) The Model AF-1 also has automatic focusing of similarly mounted slides, an autofocus on/off switch, the *KODAK* EC-1 Remote Control for remote forward and reverse slide change, and a four-position power-selector switch for OFF, FAN (for use with a dissolve control), LOW, and HIGH lamp settings.

The Controls and Their Functions

Power-Selector Switch

The four-position power-selector switch on the Model AF-1 Projector performs exactly the same functions as described earlier for the Model B-2 Projector.

FOUR-
POSITION
POWER-
SELECTOR
SWITCH

AUTOFOCUS
ON/OFF
SWITCH

Autofocus On/Off Switch

The function of the autofocus on/off switch for the Model AF-1 Projector is the same as that described for the *EKTAGRAPHIC* III A Projector. (Refer to page 26.)

The Remote Control and Plug

The colored dot on the plug of the *KODAK* EC-1 Remote Control (supplied with the Model AF-1 Projector) is yellow. Plug the remote control into the remote-accessory receptacle so the yellow orientation dot on the remote-control plug is at the dot on the projector. Then, briefly press either the forward or reverse button on the remote control to cycle the projector.

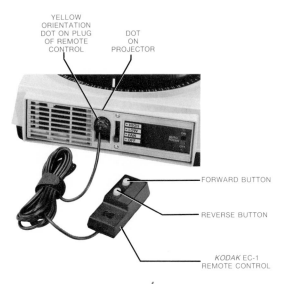

YELLOW
ORIENTATION
DOT ON PLUG
OF REMOTE
CONTROL

DOT
ON
PROJECTOR

FORWARD BUTTON

REVERSE BUTTON

KODAK EC-1
REMOTE CONTROL

Operating the Projector

Operation of the Model AF-1 Projector is the same as the Model E-2 Projector with the addition of a remote control packed with the projector, automatic focusing, an autofocus on/off switch, and the four-position power-selector switch. (Operation of the Model AF-1 Projector is the same as the Model B-2 Projector except that the Model AF-1 has automatic focusing capability and an autofocus on/off switch and the Model B-2 Projector does not.)

Projector Maintenance

Refer to the Model E-2 Projector instructions (pages 33 and 34) for detailed maintenance procedures.

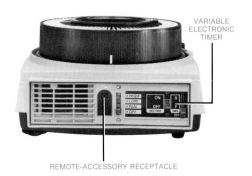

VARIABLE
ELECTRONIC
TIMER

REMOTE-ACCESSORY RECEPTACLE

KODAK EKTAGRAPHIC
SLIDE PROJECTOR, MODEL AF-2

The Model AF-2 Projector has all of the features, functions, and maintenance requirements of the Model AF-1 Projector plus remote-focus capability and a variable electronic timer. The variable electronic timer provides a choice of preset automatic slide-change intervals ranging from about 4 to 15 seconds.

The Controls and Their Functions

The Remote Control and Plug

The colored dot on the plug of the *KODAK* EC-3 Remote Control (supplied with the projector) for the AF-2 Projector is white. Plug the remote control into the remote-accessory receptacle of the projector so the white orientation dot on the plug is at the dot on the projector. Then, briefly press either the forward or reverse button on the remote control to cycle the projector in the desired direction.

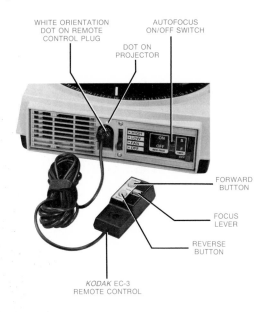

WHITE ORIENTATION DOT ON REMOTE CONTROL PLUG

DOT ON PROJECTOR

AUTOFOCUS ON/OFF SWITCH

FORWARD BUTTON

FOCUS LEVER

REVERSE BUTTON

KODAK EC-3 REMOTE CONTROL

The focus lever on the remote control performs the same focus function as the lens focus and release knob on the projector. Simply press it forward or backward to adjust image focus on the screen. When using a zoom lens, adjust image size by rotating the lens barrel and then refocus. Until released, the focus lever overrides the autofocus mechanism.

Variable Electronic Timer

The variable electronic timer on the Model AF-2 Projector provides continuously variable automatic timing of slide-change intervals, ranging from about 4 seconds at the fast end (F) to 15 seconds at the slow end (S). Place the slider control at the desired position and your slides will cycle automatically at any interval from 4 to 15 seconds when the projector is on. If you set the control in the middle of the vertical scale, it will produce intervals between automatic slide advances of about 9 seconds.

Operating the Projector

Operation of the Model AF-2 Projector is exactly the same as the Model AF-1 Projector with the addition of the remote-control focus capability and the variable electronic timer.

Projector Maintenance

Refer to the Model E-2 Projector instructions (page 33) for detailed maintenance procedures.

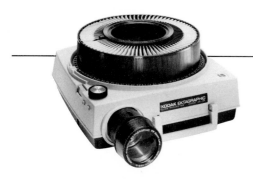

First, the Model AF-2K Projector is an international version of the Model AF-2, and can operate on 110 to 130 V, 50 or 60 Hz. However, before connecting the power cord to an electrical outlet, first adjust the frequency selector switch with a pointed tool to match the frequency of the local power source (50 or 60 Hz).

KODAK EKTAGRAPHIC
SLIDE PROJECTOR, MODEL AF-2K

The Model AF-2K Projector has all of the features, functions, and maintenance requirements of the Model AF-2, with the following differences:

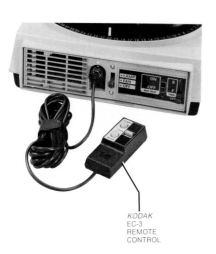

KODAK
EC-3
REMOTE
CONTROL

FREQUENCY-
SELECTOR
SWITCH

Secondly, the Model AF-2K Projector has only a single lamp setting equivalent to LOW on the Model AF-2 Projector. (This projector requires a step-down transformer to provide 110-130 V, if the supply voltage is higher.)

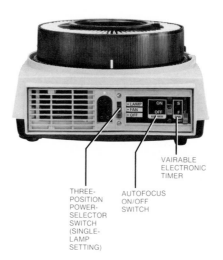

THREE-
POSITION
POWER-
SELECTOR
SWITCH
(SINGLE-
LAMP
SETTING)

AUTOFOCUS
ON/OFF
SWITCH

VAIRABLE
ELECTRONIC
TIMER

The Speed of Slide Change in *KODAK EKTAGRAPHIC* III and *EKTAGRAPHIC* Slide Projectors

Q. Why is slide-change "speed" of such particular interest today?

A. As the art and science of multiple projection of slide images (multi-image) continues growing, AV professionals want to achieve more impressive "animation" effects by more rapid image changes.

Q. Is the concern about the speed of slide change limited to multi-image presentations?

A. No. A fast slide change using a single projector means a shorter dark-screen interval between images, and therefore, a smoother presentation.

Q. Do cardboard, glass, plastic, or metal mounts affect the speed of slide change in a projector?

A. Hardly at all. A slide has to fall only 2 1/2 inches from the tray into the projector gate. The slide mount has little practical effect on the rate at which the slide falls.

Q. What effect does the projector's drive motor, slide registration system, and tray movement have on the speed of slide change?

A. Very little. The most important factor is the time required to get one slide out of the projector gate and the next slide in. Gravitational acceleration is one of the most important factors.

Q. Then gravity is the most important factor that determines the speed at which a slide can be changed in a Kodak slide projector?

A. In combination with other factors, yes. A slide can fall into the projector gate only as fast as gravity permits it to fall. In addition, there must be a control lever in the projector mechanism that supports the weight of the slide in the tray at the beginning of a slide change. The lever lowers the slide into the projector gate at less than the speed of gravitational acceleration. If the lever dropped faster, it would leave the bottom of the slide. In addition, it must slow down as it comes close to the bottom of the gate so the slide will come to a gradual stop and will not bounce or make noise. Once the slide is in the gate, the shutter opens and the image is projected on the screen.

Q. How is the slide moved out of the gate?

A. The procedure is reversed. The projector slide-lift lever must move up and touch the bottom of the slide and then raise it smoothly into the tray. This must be done with controlled speed because inertia would make the slide keep on going and pop out of the tray (if the tray ring is off) or hit the tray ring and produce an objectionable noise. As a result, the rate of lever slowdown must be consistent with gravitational pull which is operating in opposition to the inertia of the slide as it goes up into the tray.

Q. The up- and down-speed of the lever is important, isn't it?

A. Yes. You can't engineer the lever to go up or down at any speed you want. The maximum speed of the lever must take gravity into consideration.

Q. Are there other considerations?

A. Yes. Because of friction and air resistance between the slide and the air around it, an additional safety factor must be built in. The lever must be slowed down a little more. Once the slide is in the tray, the tray must move to the next slide position so the lever can lower the next slide and repeat the entire process. The time required to move the tray depends upon friction of the slides moving on the bottom of the tray. This movement can be reduced to a small fraction of a second, but it cannot—with present technology—be made instantaneous.

Q. What happens if you try to speed up the movement?

A. If you speed up the entire process, the slides hit the tray ring and produce objectionable noise, and slide-change reliability decreases.

In summary, adding the time required for the slide to descend into the projector gate and come back up to the time needed for the tray to move to the next slide equals about $4/5$ of a second.

Q. Well, how long does it take an *EKTAGRAPHIC* Slide Projector to change a slide?

A. About 1 second. The extra $1/5$ of a second provides a safety margin for reliability.

KODAK EKTAGRAPHIC S-AV
SLIDE PROJECTORS

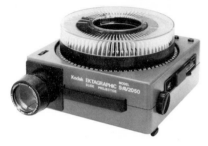

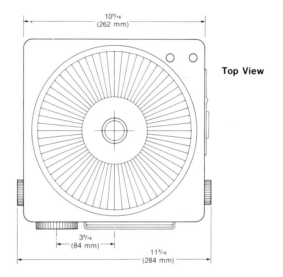

Top View

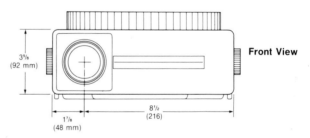

Front View

**Dimensional Line Drawings
for the *KODAK EKTAGRAPHIC* S-AV
Slide Projectors**

INTRODUCTION

The information in this section covers the controls and functions for the *KODAK EKTAGRAPHIC* Slide Projector, Models S-AV2030 and S-AV2050, manufactured in Stuttgart, West Germany—as well as the basic setup, preparation, use, shutdown, and maintenance procedures for both projectors.

General Features and Dimensions

S-AV Projectors are manufactured in West Germany by Kodak AG and imported into the United States by Eastman Kodak Company. These projectors are provided with international features. A built-in voltage-selector switch allows them to be used with power supplies from 110 to 250 V, 50 or 60 Hz, almost anywhere in the world.

These projectors have a heavy-duty motor, and excellent optics. They are often used for unattended, continuous-projection applications, such as in window displays and planetariums.

Shown at the right are dimensional line drawings for the S-AV Projector line to assist people who need this information in the design and construction of projection shelves, piggyback stands, carrying cases, etc.

Elevation: Approximately 1 inch ($6^1/_2$-degree upward angle)

Weight: 17 lb (7.7 kg)

NOTE: When designing enclosures for these projectors, do not obstruct air intake and exhaust areas located at the front, left, and rear sides of the projector. Also, allow about 2 inches (51 mm) behind and on the right side of the projector for plug connections, and about 3 inches (76 mm) clearance above the slide tray for tray removal. Allow for additional space at the right of the projector to permit opening the door for lamp change without moving the projector.

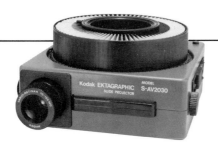

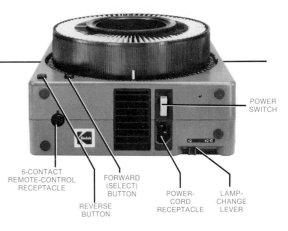

KODAK EKTAGRAPHIC SLIDE PROJECTOR, MODEL S-AV2030

This projector is generally similar to U.S.- and Canadian-made *EKTAGRAPHIC* Slide Projectors, but there are some important differences.

The Controls and Their Functions

Power Switch

This is an on/off rocker switch located on the back panel of the projector.

Power Cord

The grounded, 3-wire, 11.5 foot (3.5 m) removable power cord connects to the power receptacle at the back of the projector. The cord provided has a standard U.S.-Canada-type 3-connector plug. The connection to the projector is standard so that power cords with appropriate wall-plug connectors can be obtained in most countries. When plugged into a grounded outlet, the power cord provides an automatic safety ground for the projector chassis.

Forward (Select) and Reverse Buttons

The forward (select) and reverse slide control buttons are located on the top of the projector at the back. When the forward button is held down, it acts as a select bar, permitting manual tray rotation to any slide for projection or to the zero position for tray removal.

Lamp-Change Lever

A convenient lamp-change lever located at the lower right edge of the back panel of the projector allows the user to quickly move a replacement projection lamp into operating position during a show without moving the projector or opening the lamp door. This feature reduces the duration of the dark-screen time that usually follows projection lamp failure. New projection lamps can be installed later after the show at the convenience of the user. A tilt-out bar holds two 250 W, 24 V, low-voltage, tungsten-halogen ANSI Code EHJ lamps.

Remote-Control Receptacle

The 6-contact remote-control receptacle in the back of the projector accepts a German-made *KODAK EKTAGRAPHIC* S-AV Remote Control (shown below); it is similar to but **not** interchangeable with the *KODAK* EC-2 Remote Control. The 6-contact remote-control receptacle can also be used with other accessories made in Germany, such as an interval timer, or for connection to an audiovisual slide-control unit to synchronize the projector with a reel-to-reel or AV cassette recorder.

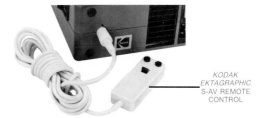

KODAK EKTAGRAPHIC S-AV REMOTE CONTROL

12-Contact Receptacle

The 12-contact receptacle on the left side of the projector (as seen from behind the machine) accepts a 12-contact plug for access to the internal circuits for a variety of purposes, including slide change forward and reverse, remote on/off control of the projection lamp, dissolve operation (with a dissolve control and second projector), automatic return of the tray to the zero position, and external shutter control.

Lamp Switches

Internal-External Switch ("Int-Ext")

The "Int-Ext" (internal-external) switch on the left side of the projector determines whether the lamp is switched internally for normal single-projector operation or externally for dissolve (or other special purposes) through the 12-contact receptacle.

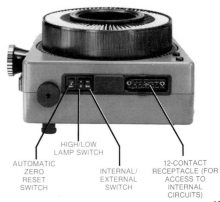

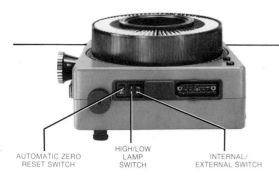

AUTOMATIC ZERO RESET SWITCH HIGH/LOW LAMP SWITCH INTERNAL/ EXTERNAL SWITCH

High (Full Power)/Low (Economy) Lamp Switch

The high/low lamp switch located next to the "Int-Ext" switch is operative only when the "Int-Ext" switch is set at the "Int" position. The high/low lamp switch sets the lamp for high (maximum brightness) or low (maximum lamp-life brightness), but can be used only during single-projector operation. When the "Int-Ext" switch is set at the "Ext" position (for external lamp control), the high/low lamp-control switch is inoperative and the lamp is automatically set for high brightness. During single-projector operation, selecting the low lamp setting reduces the projector light output by 30% but extends the life of the lamp by a factor of four.

Automatic Zero Reset Switch

This three-position switch is located next to the "Int-Ext" lamp switch and the high/low lamp switch. It controls the direction of automatic return of the slide tray to the zero position. In its center position, it is off. When the top of the switch is pressed, the circuit is actuated by the first empty tray slot and the projector will cycle continuously in reverse to zero, keeping the shutter closed so that lamp light does not reach the screen. Tray cycling will stop and the shutter will open automatically when the zero position is reached. When the bottom of the switch is pressed, the projector will do the same, but cycle in the forward direction to zero.

Focus

Turning the lens barrel focuses the lens by means of a spiral groove on the barrel.

NOTE: This projector cannot be used with *KODAK* Projection *EKTAGRAPHIC* FF Lenses nor *EKTANAR* Lenses familiar in the U.S.

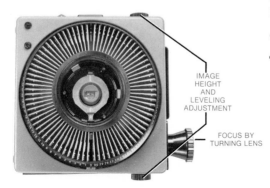

IMAGE HEIGHT AND LEVELING ADJUSTMENT

FOCUS BY TURNING LENS

Image Height and Leveling

The two black milled knobs located on both sides of the projector are used to adjust the height and leveling of the image.

Fuse

The fuse is next to the voltage selector switch. To change the fuse, unscrew the fuse cap with a coin, and pull out the fuse with the fuse holder. For 110-130 V operation, use the 3.15 A slow-blowing fuse. For 220-250 V operation, use the 1.6 A slow-blowing fuse.

Serial Number

The serial number appears on the identification plate on the bottom of the projector.

Setting Up

Loading the Slide Tray

Refer to the information in the *EKTAGRAPHIC* III E Projector section on page 17 for tray loading instructions.

Installing the Slide Tray

Refer to the information in the section on the EKTAGRAPHIC III E Projector on page 18 for instructions on tray installation.

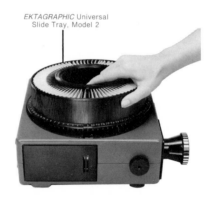

EKTAGRAPHIC Universal Slide Tray, Model 2

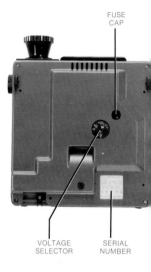

FUSE CAP

VOLTAGE SELECTOR SERIAL NUMBER

Operating the Projector

Quick Start-Up

Place the projector on a firm support. (The projector can be set at an angle of up to 30 degrees to the horizontal in any direction.)

CAUTION: Air vents must be kept free of obstructions.

• Set the voltage selector switch on the bottom of the projector to the appropriate position and insert the projector power cord plug into the power outlet.

NOTE: The voltage selector switch can be set to permit operation almost anywhere in the world, on 110, 130, 220-230, or 240-250 volts, 50 or 60 Hz.

IMPORTANT: Operating the projector with the voltage-selector switch at the wrong position can damage the projector.

- Place a loaded slide tray on the projector with the "0" slide slot aligned with the gate index of the projector. (The *KODAK EKTAGRAPHIC* Universal Slide Tray, Model 2, and the *KODAK EKTAGRAPHIC* Universal Deluxe Covered Slide Tray are recommended for use with this projector.)
- Move the projector power switch to the on position.
- Lower the room lights, and push the forward button on the projector to project the first slide.
- Focus and align the image, and proceed with your program.

Alternative Projection Methods

The *EKTAGRAPHIC* Slide Projector, Model S-AV2030 can be used in a wide range of special projection modes, including two-projector dissolve shows and multi-image presentations. Methods of projection using single projectors include:

- **Continuous Projection With 81 Slides:** Before installing the slide tray, insert an additional slide in the gate. This utilizes the zero compartment of the tray for continuous projection. For automatic slide changing, use a continuous-loop tape recorded for continuous projection.

- **Uninterrupted Multi-Tray Projection (Using One Projector and Two Trays):** This method of projection is useful for showing many slides without a break in the show when changing trays. Before starting the show, place slide number 81 in the gate and set slide tray No. 1 to slide number 1. Change the slide tray while slide No. 81 is being projected. This slide then returns to the zero compartment of tray No. 2.

- **Automatic Slide Tray Zero Reset:** The zero-reset switch selects the direction in which the tray runs to zero. If a slide set has less than 40 slides, let the tray run toward zero by pushing the switch up. During slide tray return, an automatic shutter cuts off the projection light but moves out of the light path again on reaching the zero position. (The zero-reset signal is triggered by an empty slide slot in the tray.)

- **Flashing of Images:** Images can be made more impressive or interesting by flashing them. The flash is controlled via the 12-pole receptacle on the side of the projector. (Details are provided in the instruction manual packed with the projector.)

Long-Run Applications

For information on long-run applications, refer to page 19 under the *EKTAGRAPHIC* III E Projector.

Operating the Projector

General

Operate the projector in basically the same manner as domestic *EKTAGRAPHIC* Slide Projectors, allowing for the differences in controls and their use. Significant differences (described in detail in the instruction manual packed with the S-AV Projector) include:

- Projection lamp alignment for optimum illumination.
- Checking that the proper condenser is in the best position for the slide type and lens (focal length) being used.

NOTE: The slide-cycle time (the time required for the *EKTAGRAPHIC* S-AV2030 Projector to change a slide) is slightly longer than for domestic *EKTAGRAPHIC* Slide Projectors, *EKTAGRAPHIC* III Projectors, and the *EKTAGRAPHIC* Slide Projector, Model S-AV2050, discussed later. The slide-cycle time for the S-AV2030 Projector is about 1.4 seconds when operating on 60 Hz power and 1.7 seconds when using 50 Hz power.

Emergency Tray Removal

In case of operational failure caused by a bent slide, the tray can be removed from the projector by pushing aside and holding the slide tray latch while lifting off the tray.

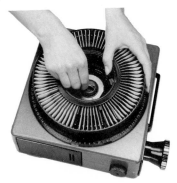

Shutdown

You should adopt a standard shutdown procedure after each presentation, similar to the one that follows. This approach will not only help you to be ready for the next show, but will help provide proper care for the projector.

- With projector power on, rotate the tray to the zero position by pressing and holding down the slide-forward button.
- Remove the slide tray.
- Turn off all power to the projector with the power switch.

If the projector will be moved before the next show:

- Retract the elevation legs.
- If desired, remove the projection lens.
- Unplug the remote control unit (or dissolve control if used).
- Disconnect the power cord from the power source and from the projector; place the projector in a suitable container or travel case for maximum protection.
- Before you attempt any maintenance or cleaning of the projector, be sure it is cool and the power cord disconnected from the power outlet. Also remove the slide tray and remote control or dissolve control.

Projector Maintenance

Switching the Projection Lamp

This projector has two low-voltage tungsten-halogen lamps of 24 V, 250 W available, ANSI Code EHJ. The lamps are mounted on a rapid lamp changer. If the lamp in use should fail, the spare lamp is immediately ready. If the lamp fails to light when the projector is turned on, but the fan operates, the lamp-control lever is in the wrong position or the lamp is burned out. To change the lamp over, move the rapid lamp changer at the rear of the projector to the appropriate position.

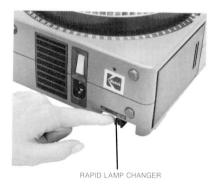

RAPID LAMP CHANGER

Replacing a Burned-Out Lamp

CAUTION: The lamp may be hot. Don't handle the lamp with unprotected fingers. Unplug the power cord. Push the rapid lamp changer over fully to the right to the lamp-removal position. Open the lamphouse door. Swing out the lamp holder through 90 degrees by the lever. With a protective glove, pull out the faulty lamp and replace it with a new 24 V, 250 W tungsten-halogen lamp, ANSI Code EHJ.

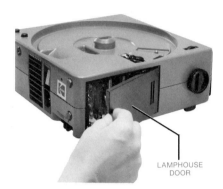

LAMPHOUSE DOOR

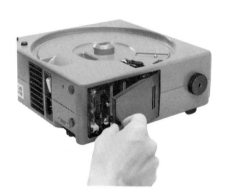

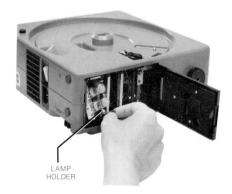

LAMP HOLDER

IMPORTANT: To avoid fingerprints on the glass envelope of the lamp, always handle the lamp by the sleeve supplied with it.

Before swinging back the lamp holder, push up the latch. After inserting the new projection lamps, push the lamp lever fully to the left-hand operating position.

Centering the Lamp

After installing the new projection lamp, the lamp must be centered correctly for maximum projection light output.

The adjustment screw centers the lamp horizontally. The stud centers it vertically.

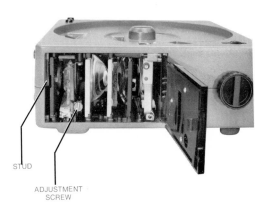

STUD

ADJUSTMENT
SCREW

Detailed lamp centering instructions for the various lenses appear in the "User's Instruction Manual" packed with the projector.

Cleaning the Projection Lens

Remove the projection lens. Blow off any loose grit. Then wipe both glass surfaces with *KODAK* Lens Cleaning Paper, or with a clean cloth moistened with a single drop of *KODAK* Lens Cleaner. (Equivalent products are available and may be used, if desired.) Fingerprints reduce the brightness and clarity of screen images, but a little dust does not.

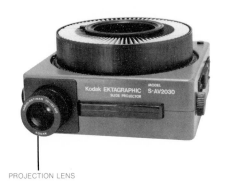

PROJECTION LENS

The Condenser Optics

The condenser system in the projector is designed to match the projection lens in use. If the condenser lens is in the wrong position, or if the wrong condenser lens is being used, the projected image may not be as bright as it could be. Details about the condenser system are provided in the "User's Instruction Manual" supplied with the projector.

Allowing Proper Ventilation

Refer to the information on the *EKTAGRAPHIC* III E Projector for instructions on proper projector ventilation (page 22).

Automatic Thermal Safety Switch

The *EKTAGRAPHIC* Slide Projector, Model S-AV2030, is fitted with an automatic thermal safety switch, which turns off the projector if it overheats because of a lack of cooling air or jamming of the slide-change mechanism. Once the projector has cooled, it switches on again automatically.

Running the fan to cool the projector after the lamp is turned off is not necessary nor recommended. If the tray is to be removed, it should be returned to zero before shutting off the projector.

Dirt and dust cause deterioration of the projector lubricant and can eventually cause machine malfunction. We recommend that the projector be serviced after 500 hours of operation. For projectors used in very dusty locations (such as in fairs or exhibitions), more frequent servicing may be advisable. More detailed instructions for cleaning the optics, changing and aligning projection lamps, and other user-performed services are included in the "User's Instruction Manual" packed with the projector. Service requiring disassembly should be performed by a qualified service technician, such as those at Kodak's Equipment Service Center in Rochester, NY. Kodak installations which can provide information or service in most countries of the world are listed in *International Photographic Headquarters, KODAK* Publication No. AC-16. Single copies of this publication can be obtained without charge from Dept. 412L, Eastman Kodak Company, 343 State Street, Rochester, New York 14650.

KODAK EKTAGRAPHIC SLIDE PROJECTOR, MODEL S-AV2050

The Model S-AV2050 Slide Projector is also made by Kodak AG in Stuttgart, West Germany, and has most of the features, functions, and maintenance requirements of the Model S-AV2030. The Model S-AV2050 has the advantage of a shorter slide-cycling time of about 1 second on 60 Hz current and 1.2 seconds on 50 Hz current. It also has a projection-lens mount that accepts *KODAK* Projektion *RETINAR* Lenses (distributed by Kodak AG) as well as the less expensive *KODAK* Projection *EKTAGRAPHIC* FF and *EKTANAR* Lenses familiar in the U.S.

NOTE: The remote focus lever on the *KODAK EKTAGRAPHIC* S-AV Remote Control shown in the next column can be used to remotely focus the S-AV2050 Projector with either type of lens installed in the projector—a *KODAK* Projektion *RETINAR* Lens or an American-made *KODAK* Projection *EKTAGRAPHIC* FF or *EKTANAR* Lens.

The Model S-AV2050 Projector also has a constant lamp-brightness setting that is equivalent to high brightness on the Model S-AV2030. The Model S-AV2050 does not have the built-in automatic return to zero feature but it does have a built-in zero-position switch that can be used by an external control to provide automatic tray return to the zero position.

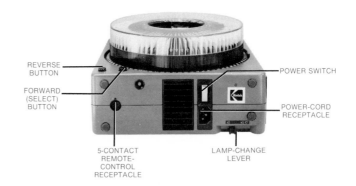

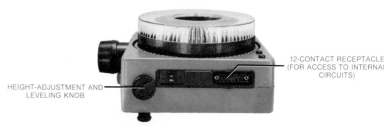

The *EKTAGRAPHIC* Slide Projector, Model S-AV2050, can be used with a *KODAK EKTAGRAPHIC* S-AV Remote Control.

The Controls and Their Functions

The controls and functions of the Model S-AV2050 are generally the same as described for the Model S-AV2030, with the following exceptions:

• **Lamp Setting:** The Model S-AV2050 has only a single lamp setting equivalent to the "full power" brightness setting on the Model S-AV2030. (Instructions for centering the lamp appear in the "User's Instruction Manual" packed with the projector. A spare lamp holder for a third lamp is provided on the inside of the lamp door.)

• **Focus:** Focusing of slides is accomplished in one of two ways depending on the type of *KODAK* Projection Lens used. If you have a *RETINAR* Lens distributed by Kodak AG, focus the lens itself by turning the barrel along the spiral grooves (in the same manner as the S-AV2030 Projector). If you have an *EKTAGRAPHIC* FF or *EKTANAR* C Lens (familiar in the U.S.), set the image focus with the focus knob on the projector. If

you are using a *KODAK EKTAGRAPHIC* FF Zoom Lens, 100 to 150 mm *f*/3.5, made in the U.S., first adjust image size by turning the lens barrel, and then refocus the image. If you are using a German-made *VARIO-RETINAR* zoom lens, adjust image size by pulling the front of the lens out or push it in, and then focus by turning the lens.

• **Shorter Slide-Cycling Time:** The slide-cycling time of the S-AV2050 Projector has been reduced from 1.5 seconds to about 1 second on 60 Hz current and 1.2 seconds on 50 Hz current. The result is a reduced dark-screen interval for single-projector programs. For multi-image programs, faster slide advancing is possible. The 0.5 second faster slide-cycling time with the S-AV2050 Projector means that intervals between slide changes can be programmed to be even shorter. For this reason, slide presentations programmed using the S-AV2050 Projector (using slide change times faster than 1.5 seconds) should not be projected with S-AV2030 Projectors without a thorough rehearsal. (Reprogramming of some image transitions may be necessary). After two slide changes in quick succession with S-AV2030 Projectors, the slide change may not be completed during the dark time of the lamp and there may be a white "flash" on the screen. In addition, if one S-AV2030 Projector continues to receive slide-advance commands at intervals of less than 1.5 seconds, some of the advance signals will be ignored and the projectors will fall out of synchronization. Of course, programs made using the S-AV2030 Projector can be run on the S-AV2050 Projector without difficulty.

KODAK EKTAGRAPHIC Slide Projector, Model S-AV2030

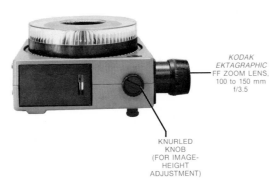

KODAK EKTAGRAPHIC FF ZOOM LENS, 100 to 150 mm f/3.5

KNURLED KNOB (FOR IMAGE-HEIGHT ADJUSTMENT)

The KODAK EKTAGRAPHIC S-AV2050 Slide Projector can be used with the EKTAGRAPHIC Universal Deluxe Covered Slide Tray.

• **Projector Leveling:** The height of the projector is adjusted by rotating the two knurled knobs on the sides of the projector (the same as the Model S-AV2030). The projector can then be locked in position—to a maximum of 7 degrees—by turning the inner wheel of the knurled knobs.

NOTE: The projector will function correctly on a slope of up to 30 degrees in any direction.

Emergency Tray Removal

In case of operational failure caused by a bent slide, the tray can be removed from the projector by pushing aside and holding the slide tray latch while lifting off the tray.

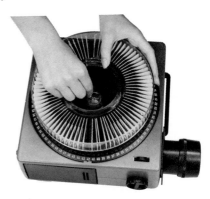

Lamp Nigrescence and Incandescence Times for the 24-Volt EHJ Lamp Used in the *EKTAGRAPHIC* S-AV2050 Slide Projector

The time required for the 24 V EHJ lamp to go up from 10 percent light output to 90 percent light output (incandescence) is 310 ms, and the time required from 100-percent light output to 10-percent light output (nigrescence) is 225 ms.

Some points of the lamp light decay curves are show below:

INCANDESCENCE

Light Output (percent)	Time Up (in milliseconds)
10	Starting Point (0)
30	70
50	115
70	180
90	310
100	500

NIGRESCENCE

Light Output (percent)	Time Down (in milliseconds)
100	Starting Point (0)
60	25
40	70
30	100
20	150
10	225

Changes in power supply voltage do not affect the lamp incandescence and nigrescence rates shown above. (Voltage supplied to the lamp is always transformed down to 24 volts.) Changes in power frequency do not affect the rates either.

Some Questions and Answers About the *KODAK EKTAGRAPHIC* Slide Projector, Model S-AV2050

Q. What does "S-AV2050" mean?

A. "S" stands for Stuttgart (Germany), where Kodak makes the projectors. "AV" stands for audiovisual, and "2050" is the model designation.

Q. Why the name "EKTAGRAPHIC S-AV2050" rather than CAROUSEL S-AV2050 Projector?

A. Mostly because the projector is closer to the U.S.-Canadian concept of *EKTAGRAPHIC* Slide Projectors than to domestic *CAROUSEL*® Projectors. The projector has

- Slide registration for improved superimposition of images.
- EMI (electromagnetic interference) supression.
- Heavy-duty clutch with arc supression.
- Three-wire grounding power cord.
- Gray casing for easy identification as a professional AV projector. Its primary purpose, outside the U.S. and Canada, is for audiovisual and professional use, not for home or amateur use, and is sold in the U.S. and Canada by dealers in Kodak AV products.

Q. Why do people want to buy the EKTAGRAPHIC S-AV2050 Projector?

A. A number of very good reasons: it can operate on four different voltage ranges for use in almost any country; the lamp is easily switched during a show and there is space for a spare; it provides positive, repeatable, horizontal and vertical slide registration; built-in arc suppression controls EMI (electromagnetic interference) of the focus motor; the carrying handle is retractable; there are different condenser positions for more efficient coverage of super slides and 24 x 36 mm slides; there are a variety of focal-length lenses available; the projector uses conventional lenses (non-retrofocus) as short as 28 mm in focal length without vignetting 24 x 36 mm transparencies; there is a large receptacle on the side for access to many internal circuits; the slide-cycle time is improved over earlier S-AV projectors, etc.

Q. Those sound like real advantages; why would I buy another EKTAGRAPHIC Slide Projector model?

A. Because some other model might fit your needs better. Here are some of the features of the *EKTAGRAPHIC* Slide Projector models or *EKTAGRAPHIC* III Projector models that are not available in the S-AV2050: built-in automatic timer; autofocus; autofocus defeat switch; high and low lamp settings; special-applications receptacle; convenient select bar tray removal with power off; use of 140 slide trays; prefocused lamps; faster lamp flashing; automatic adjustment to proper voltage setting (Model B-2AR); built-in miniprojection screen

for editing and previewing; two tie-down points for projector security; convenient power-cord wrap; standby light; reading light; illuminated control panel; less weight than the Model S-AV2050; many U.S. and Canadian accessories available, and so on.

Q. What about all the other accessories available in Europe and elsewhere for the S-AV2050?

A. Kodak can provide information on sources of supply for these accessories in the U.S., but we have no plans to import accessories ourselves at present. (You can send your inquiry to Eastman Kodak Company, Department 625, 343 State Street, Rochester, NY 14650.) A number of accessories are already available from other sources in the U.S. These include dissolve controls, timers, lenses, etc.

Q. Do these lenses have shorter or longer focal lengths than those on imports?

A. Both. In addition, D.O. Industries, 317 East Chestnut Street, East Rochester, NY 14445, offers some curved-field lenses for the S-AV models (the lenses imported by Kodak are all flat-field type).

Q. Why does the S-AV2050 Slide Projector weigh so much (17 pounds without tray, power cord, or lens)?

A. Because it contains a husky, multicap transformer—the reason that it can operate on such a variety of voltages. As a point of reference, the *EKTAGRAPHIC* Slide Projector, Model AF-2, weighs 10 pounds (4.6 kg), and the *EKTAGRAPHIC* III E Projector weighs 12 pounds (5.4 kg).

Q. Can the S-AV2050 Projector be controlled by AV cassette tape recorders or KODAK EKTAGRAPHIC AudioViewers with built-in synchronizers?

A. Yes. All that's needed is an adapter or new plug on the control cord. In fact, any AV tape player (with a suitable adapter) that produces a circuit closure of approximately 500 milliseconds can be used to provide automatic slide-advance signals.

Q. Is the remote-control circuit the same as in domestic projectors?

A. It is similar, but not the same. The voltage is about the same, but it uses direct current rather than alternating current.

Q. Do all KODAK Slide Trays work well with the S-AV2050 Projector?

A. Trays that were manufactured with a plastic latch (instead of metal) used to cause minor problems. These have been resolved, however, and all U.S.-made Kodak trays (except the 140 type, which is not recommended for use with this projector) now work fine.

Q. Are warranty and repair services available from Kodak?

A. Yes; from Kodak's Equipment Service Center in Rochester, New York.

METAL
LATCH

PART III—
KODAK Slide Projector Accessories

KODAK Slide Projector accessories will help you present your AV program more easily and with greater convenience and effectiveness. For example, presenting your message with two or more projectors coupled to an *EKTAGRAPHIC* Programmable Dissolve Control, Model 2, can greatly improve the visual appeal, psychological impact, and teaching effectiveness of your shows.

KODAK EKTAGRAPHIC PROGRAMMABLE DISSOLVE CONTROL, MODEL 2

This Dissolve Control puts sophisticated two-projector dissolve presentations at your fingertips with a variety of visual effects. (A third projector can be connected and advanced to project a "border" slide, a superimposed "word" slide, etc.) You can program presentations using standard AV reel-to-reel or cassette tape recorders that allow separate recording of a digital synchronizing track.*

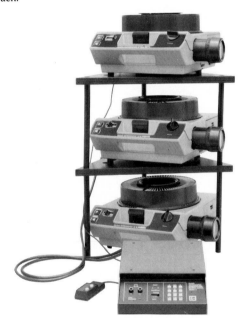

Solid-state microprocessor technology and a digital sync-track system keep projectors and sound track synchronized—even after tape "fast forward" or "rewind." You can restore synchronization with a few simple corrective steps, even after power interruptions.

In addition:

• The cue track can be edited without rerecording the entire tape (with most AV recorders).

• The "Reset" control can be used to return the trays to the starting point of the program automatically.

• The "Remote" outlet on the back panel of the Dissolve Control can be connected to the 1000 Hz synchronizing output of an AV tape recorder so that two-projector shows can be presented (at a single dissolve rate) using recorded ANSI Standard 1000 Hz slide-advance signals.

• The "AUX" outlet can be used to program tape stop, or switch a motion picture projector, third slide projector, or special-effect device on or off. The outlet has two contacts: one normally open and one normally closed; the maximum rating is 30 V at 3 A.

• The Dissolve Control can control two slide projectors equipped with up to 500 W incandescent lamps and is compatible with most *KODAK EKTAGRAPHIC*, *EKTAGRAPHIC* III, and *CAROUSEL* Slide Projectors that have a seven-contact remote-accessory receptacle (exceptions: Arc Slide Projector Module RF and Pocket *CAROUSEL* Projectors).

KODAK CAROUSEL PROJECTOR CASE, MODEL E

The *KODAK CAROUSEL* Projector Case, Model E, can accommodate an *EKTAGRAPHIC* Slide Projector, any single *EKTAGRAPHIC* or *CAROUSEL* Slide Tray, a *KODAK* EC Stack Loader, a *KODAK* Projection Lens, a spare projection lamp, and a *KODAK* EC Remote Extension Cord. It is made of brown simulated leather. The dimensions are $15^5/_8$ x $13^5/_8$ x $8^3/_4$ (397 x 346 x 222 mm).

*For helpful information on tape recorders that can be used with the *EKTAGRAPHIC* Programmable Dissolve Control, Model 2, write to Eastman Kodak Company, Dept. 412L, 343 State St., Rochester, NY 14650 and ask for a single free copy of *KODAK* Publication No. S-15-114-AP—*Some Helpful Guidelines for Choosing Tape Recorders for Use With the KODAK EKTAGRAPHIC Programmable Dissolve Control.*

KODAK CAROUSEL SLIDE TRAY CASE

The *KODAK CAROUSEL* Slide Tray Case will accommodate three slide trays in their protective boxes or two slide trays (in boxes) plus a *KODAK EKTAGRAPHIC* Programmable Dissolve Control. It is made of brown simulated leather. The dimensions are 12 x 9⅝ x 12½ inches (305 x 245 x 318 mm).

KODAK AV-III COMPARTMENT CASE

The *KODAK* AV-III Compartment Case will accommodate a *KODAK EKTAGRAPHIC* Slide Projector or *EKTAGRAPHIC* III Projector, one slide tray, two extra projection lenses, remote controls and cords, and a spare projection lamp. (A keylock and key are also provided.)

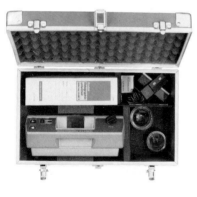

KODAK SLIDE TRAYS

KODAK EKTAGRAPHIC UNIVERSAL DELUXE COVERED SLIDE TRAY

The *EKTAGRAPHIC* Universal Deluxe Covered Slide Tray holds up to 80 2 x 2-inch slides in glass, plastic, or cardboard mounts up to ⅛ inch (3.2 mm) thick. It is compatible with all *EKTAGRAPHIC* S-AV Projectors, *EKTAGRAPHIC* Slide Projectors, and *EKTAGRAPHIC* III Projectors. (It is also compatible with all *KODAK EKTAGRAPHIC* AudioViewers and *EKTAGRAPHIC* AudioViewer/Projectors.) The clear acrylic, locking dust cover protects the slides and keeps them securely in place. When the acrylic cover is removed, the cutaway side of the tray makes loading and changing slides easier and faster. The bottom metal plate and latch on this tray can be replaced, if damaged, without the use of tools. (The lock ring for the *EKTAGRAPHIC* Universal Slide Tray, Model 2, or the *CAROUSEL TRANSVUE* 80 Slide Tray may be used on the Deluxe Covered Slide Tray if the cover is lost or broken, but this leaves the slide corners exposed.) The clear cover for the Deluxe Covered Slide Tray cannot be used on other trays.

KODAK EKTAGRAPHIC UNIVERSAL SLIDE TRAY, MODEL 2

The *EKTAGRAPHIC* Universal Slide Tray, Model 2, holds up to 80 2 x 2-inch slides in glass, plastic, or cardboard mounts up to ⅛-inch (3.2 mm) thick. It comes in its own storage box with space organized as described for the *EKTAGRAPHIC* Universal Deluxe Covered Slide Tray.

KODAK CAROUSEL TRANSVUE 80 SLIDE TRAY

The *CAROUSEL TRANSVUE* 80 Slide Tray holds up to 80 2 x 2-inch slides in plastic, glass, or cardboard mounts up to $1/10$ inch (2.5 mm) thick and is supplied in a protective box.

KODAK CAROUSEL TRANSVUE 140 SLIDE TRAY

The *CAROUSEL TRANSVUE* 140 Slide Tray holds up to 140 2 x 2-inch slides in plastic or cardboard mounts up to $1/16$ inch (1.6 mm) thick. It can not be used on S-AV models. It is useful for maximum storage capacity, but is not recommended where slides are not in top condition. It is supplied in a protective box.

KODAK PROJECTION LENSES

Nine different *KODAK EKTANAR* C Lenses and *KODAK EKTAGRAPHIC* FF Lenses are available for *EKTAGRAPHIC* and *EKTAGRAPHIC* III Projectors made in the U.S. and Canada as well as for the Model S-AV2050 Projector made in West Germany.

FLAT-FIELD LENSES

Flat-field lenses are recommended for glass-mounted or the general mix of 2 x 2-inch (50 x 50 mm) slides:
- *EKTAGRAPHIC* FF Lens, 65 mm $f/3.5$
- *EKTAGRAPHIC* FF Lens, 76 mm $f/3.5$
- *EKTAGRAPHIC* FF Lens, 102 mm $f/2.8$
- *EKTAGRAPHIC* FF Lens, 124 mm $f/2.8$
- *EKTAGRAPHIC* FF Lens, 178 mm $f/3.5$
- *EKTAGRAPHIC* FF Zoom Lens, 100 to 150 mm $f/3.5$

CURVED-FIELD LENSES

Curved-field lenses are designed to improve overall image sharpness of open-mounted (cardboard) 2 x 2-inch 35 mm original transparencies.
- *EKTANAR* C, 102 mm $f/2.8$
- *EKTANAR* C, 127 mm $f/2.8$
- *EKTANAR* C Zoom, 102 to 152 mm $f/3.5$

KODAK PROJECTION RETINAR LENSES

Two *KODAK RETINAR* Projection Lenses are available for the *EKTAGRAPHIC* S-AV2030 and S-AV2050 Slide Projector.
- 60 mm $f/2.8$ (for slide apertures up to 40 mm square)
- 150 mm $f/3.5$ (useful in large halls or on small screens in normal-size rooms)

KODAK EKTAGRAPHIC FILMSTRIP ADAPTER

The *EKTAGRAPHIC* Film Strip Adapter projects standard 35 mm single-frame filmstrips either in rolls or in short lengths, adding further versatility to most *KODAK EKTAGRAPHIC* III and *EKTAGRAPHIC* Slide Projectors. The adapter can project first and last frames with no leader required, and includes a *KODAK* Projection *EKTANAR* Lens, 3-inch *f*/2.8. (This lens can be used only with the Filmstrip Adapter.)

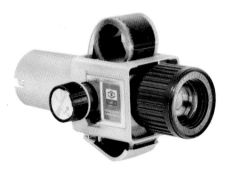

KODAK EC SOUND-SLIDE SYNCHRONIZER

The *KODAK* EC Sound-Slide Synchronizer is intended for the preparation and presentation of synchronized sound-slide programs and features a 1000 Hz signal frequency. It is compatible with most stereo tape recorders that have independently adjustable record levels for both channels and most *EKTAGRAPHIC* III and *EKTAGRAPHIC* Slide Projectors that accept a five-pin accessory plug. It is not intended for use with audiotapes made to the ANSI Standard for 1000 Hz projector advance, nor is it suitable for making such tapes.

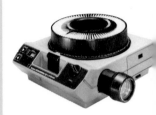

Mixing and Matching *EKTAGRAPHIC* III and *EKTAGRAPHIC* Slide Projectors

Q: Can an *EKTAGRAPHIC* III Projector be substituted for an earlier *EKTAGRAPHIC* Slide Projector in a dissolve pair, or other multiple projector applications?

A. We do not recommend it, but it is possible.

Q. Is that because the new projectors are brighter?

A. Partly. However, achieving an approximate brightness match is often possible by switching to LO for the regular (EXR) lamp on the new *EKTAGRAPHIC* III Projector and using the earlier *EKTAGRAPHIC* Slide Projector on HIGH.

Q. What about dissolve, when both lamps are operated on HIGH?

A. In this situation, the user can choose lamps to give about the same light output. Use the next higher output lamp for the *EKTAGRAPHIC* Slide Projector, or the next lower output lamp for the *EKTAGRAPHIC* III Projector. Here is a helpful lamp-code table.

Brightness Desired	EKTAGRAPHIC III Projectors	EKTAGRAPHIC Slide Projectors
Maximum	EXW	None
High	EXR	ENG
Medium	FHS	ELH
Low	EXY	ENH

The match probably will not be perfect in either light output or color temperature, but it will be acceptably close. (The high and medium pairs match the best. Also refer to page 91, "Reducing Image Brightness.")

Q. The new projectors provide a better center-to-corner ratio. What does that mean?

A. The brightness of the image center, in relation to the image corner, is the center-to-corner ratio. It is a measure of even illumination. The new models are improved, and the improvement is usually easiest to see when two or more slides are projected side by side for a panorama.

Q. Can we adjust the brightness ratio to achieve a better match between new *EKTAGRAPHIC* III PROJECTORS and earlier *EKTAGRAPHIC* Slide Projectors?

A. The ratio is a basic design element, and it is not practical to change it in a given projector. But the guidelines listed above will usually yield satisfactory results if mixing the new and earlier models is necessary.

(CONTINUED)

Q. Are there other projection considerations, such as response to a dissolve control?

A. There are usually few obvious differences between the two types of projectors. The new lamps used in the *EKTAGRAPHIC* III Projectors operate on a lower voltage and take a small fraction of a second longer to reach full brightness when flashed compared with the line-voltage lamps used with *EKTAGRAPHIC* Slide Projectors. For a fast cut, or any other dissolve rate, most people in the audience will not notice a difference between the two types of projectors. However, projectionists familiar with their audiovisual programs may notice subtle differences.

Must Projection Lenses of the Same Focal Length Be Matched Closely?

If you are projecting an image 100 inches wide with one lens, and a second lens 2 percent shorter in focal length is used at the same distance, the image from the second lens will be 102 inches wide (all other conditions being equal).

If a third lens 2 percent longer in focal length is used at the same projection distance, the image will be 98 inches wide (again, all other conditions being equal).

Some projection lens manufacturers charge a premium for matched lenses (about 20 percent usually); and in general their matched lenses are guaranteed to be plus or minus 0.5 percent of stated focal length; their unmatched lenses are usually plus or minus 2 percent of their stated focal length.

A ± 0.5 percent difference between lenses of the same focal length can usually be ignored for most multiple-projector shows. If the lenses are racked back and forth so that the images match in size, you usually can't tell that one or the other image is a little out of focus, if the lenses are as close together as plus or minus 0.5 percent. However, if image size *and* image focus *must* be closely matched (such as in some programs using side-by-side comparison projection or some multi-image presentations that contain full-screen panoramas), individual projectors can be moved 0.5 percent closer to or further from the screen (i.e., 3 inches in 50 feet) until focus and image size are matched. However, for most conventional audiovisual presentations, such "fine tuning" is not necessary.

KODAK EC AUTOMATIC TIMER, MODEL III

The *KODAK* EC Automatic Timer, Model III, provides automatic slide advance with *EKTAGRAPHIC* III and *EKTAGRAPHIC* Slide Projectors that accept a five-pin accessory plug. The timer is continuously variable from about 3 to 22 seconds.

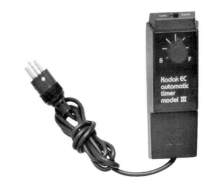

KODAK EC REMOTE CONTROLS

Three models of the *KODAK* EC Remote Control are available to match specific models of *EKTAGRAPHIC* III and *EKTAGRAPHIC* Slide Projectors that accept a five-pin accessory plug.

- *KODAK* **EC-1 Remote Control:** This remote control provides forward and reverse slide change with Projector Models III E, III ES, III A, III AS, E-2, and AF-1, plus earlier models that have forward and reverse capability (except the 500 Series).

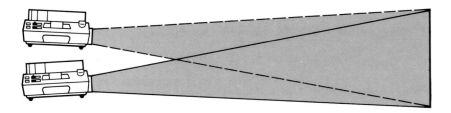

- **KODAK EC-2 Remote Control:** The EC-2 Remote Control provides forward and reverse slide change as well as remote focus with Projector Models III B, B-2, and B-2AR, plus all earlier models with FWD, REV, and remote focus (except those which also have auto-focus, and the 500 Series).

- **KODAK EC-3 Remote Control:** Forward and reverse slide change as well as remote-focus capability (that can also override the autofocus function) is provided by this remote control when used with Projector Models III AT, AF-2, and AF-2K.

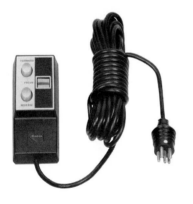

KODAK EKTAGRAPHIC S-AV REMOTE CONTROL

This remote control provides forward and reverse slide change as well as remote focus with all S-AV Projector Models.

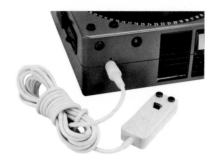

KODAK EC REMOTE EXTENSION CORD, 25-FOOT

The *KODAK* EC Remote Extension Cord, 25-Foot, extends the range of the 12 ft (3.7 m) *KODAK* EC Remote Control Cord so that you can operate your projector from up to 112 ft (34.1 m) away from the projector. (As many as four extension cords may be added to one remote-control cord without loss of function). This Extension Cord can not be used with the *EKTAGRAPHIC* S-AV Remote Control, which has a six-pin accessory plug.

KODAK EC STACK LOADER

The *KODAK* EC Stack Loader is used for quick reveiw of up to 40 slides in 2 x 2-inch cardboard or plastic mounts (1/16 inch or 1.6 mm maximum thickness for forward projection only).

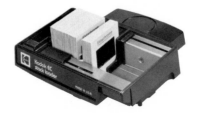

KODAK EC LAMP MODULE

The *KODAK* EC Lamp Module is equipped with a coated condenser lens and a heat-absorbing glass (but not a projection lamp). The module allows you to change the projection lamp quickly and easily in any *EKTAGRAPHIC* III Projector without disturbing the alignment of the projector. The module also includes a dimming shutter that allows you to adjust light intensity for the illuminated control panel.

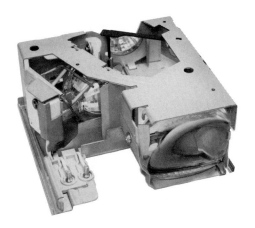

KODAK EC PROJECTOR DUST COVER

This attractive dust cover is made from black textured polystyrene and can be used to protect any *EKTAGRAPHIC* III Projector from dust and dirt when the projector is not in use. It snaps firmly into place and is easily removed by means of a sliding latch.

KODAK EKTAGRAPHIC TRAY BANDS

When attached to 80-capacity *KODAK EKTAGRAPHIC* Slide Trays, *KODAK EKTAGRAPHIC* Tray Bands help you to identify the specific slide in the projector gate quickly and easily. Large white-on-black numbers are easy to read, and additional space is provided for program identification purposes. They are available in two formats—for single- and multi-image presentations (No. S-85 —box of 24); and for dissolve presentations (No. S-86—box of 12 pairs).

KODAK EKTAGRAPHIC SEAMLESS SLIDE MASKS (For Three-Projector Panoramas)

EKTAGRAPHIC Seamless Slide Masks (For Three-Projector Panoramas), are available in two versions: *KODAK* Publication No. S-90, an envelope with plastic-sleeved center and side masks for 3 complete panoramas or montages; and *KODAK* Publication No. S-91, a continuous strip of center and side masks that yields 50 complete panoramas or montages.

KODAK EKTAGRAPHIC WRITE-ON SLIDES

EKTAGRAPHIC Write-On Slides are used for quick and easy production of hand-drawn titles, charts, or other graphics, and are made on an *ESTAR* Base film with a matte surface on one side. Three writing area sizes are available: 38 x 38 mm, 31 x 31 mm, and 24 x 36 mm.

KODAK EKTAGRAPHIC HC SLIDE FILM (HCS 6552)

This film allows you to easily load your camera for production of white images on a black background and for reverse-text, black-and-white title slides. It is cut directly from *KODALITH* Ortho Film 6556, Type 3, and is packaged in 135-size, 36-exposure magazines. *KODAK* Developer *D-11* is recommended.

Projector Accessories Made by Other Manufacturers for Use with *KODAK EKTAGRAPHIC* III and *EKTAGRAPHIC* Slide Projectors

Q. Why are there so many projector accessories supplied by other manufacturers for use with *KODAK EKTAGRAPHIC* III Projectors and *EKTAGRAPHIC* Slide Projectors?

A. For two reasons: First, our projectors are widely used; and second, they are easily connected to and used with other equipment.

Q. Were *EKTAGRAPHIC* III and *EKTAGRAPHIC* Slide Projectors designed primarily to be used with products made by other manufacturers?

A. Not primarily; but it turns out that they can be. The *EKTAGRAPHIC* III Projectors, for example, have several features that make them easier to use with other equipment. Some examples are the remote-control receptacle for slide forward and reverse; the special-application receptacle for access to internal projector circuits; and the two tie-down points located on the bottom of the projector for projector security.

Q. Well, doesn't Kodak offer all the accessories that users need for these projectors?

A. Yes, in most cases. But for special applications, projector users need extra-long focal-length projection lenses, sophisticated stacking stands, special shipping cases, state-of-the-art multi-image computer programmers with dissolve controls, and so on.

Q. Does Kodak certify or approve other manufacturers' equipment for use with *EKTAGRAPHIC* Slide Projectors?

A. No, we have no control over how other manufacturer's equipment is made.

Q. What about modifications to Kodak projectors? Does Kodak license or approve those?

A. No. If either users or other manufacturers buy Kodak projectors, the projectors become their property, and they can modify the projectors as they wish—just as someone who buys an audio system or an automobile can make modifications and resell them.

Q. Does Kodak help design other manufacturer's products used with Kodak projectors?

A. No. We try to provide answers to questions they may have about our projectors—questions concerning projector operating characteristics, electrical requirements, and so on. But of course Kodak cannot make recommendations about how they design and build their products.

Four Considerations Manufacturers of Projector Accessory Equipment Must Be Aware of When Designing Equipment for Use with *KODAK EKTAGRAPHIC* III Projectors

Consideration No. 1—Electrical "Spikes"

Manufacturers of equipment made for use with *KODAK EKTAGRAPHIC* III and *EKTAGRAPHIC* Slide Projectors should be aware that several electrical components in our projectors generate electrical pulses or "spikes," which can cause equipment malfunctions if they are transmitted through electrical connections to a projector accessory that has a digital logic circuit to control any function of the slide projector. (All electrical switches emit some level of electrical spikes when actuated.)

Digital logic circuits are commonly used in multi-image programmers, dissolve controls, random-access equipment, and computer-interface equipment. The manufacturers of such equipment should provide the necessary filtering circuit to protect against these spikes.

Consideration No. 2—Switch-Closure Times that Help Avoid Multiple Cycling

To avoid multiple cycling in either forward or reverse with *KODAK* slide projectors, the maximum switch closure time should be 750 milliseconds. Minimum recommended switch closure time for a forward cycle is 70 milliseconds; for reverse with *EKTAGRAPHIC* Slide Projectors (Models E-2, B-2, AF-2, etc), it is 200 milliseconds.

The cycle-release clutch of the *EKTAGRAPHIC* III Projector has been redesigned for more reliable reverse cycling with a short activation of the projector-reverse button: One hundred milliseconds minimum and 750 milliseconds maximum will provide reliable reverse cycling. Switch closures of 70 milliseconds minimum and 750 milliseconds maximum will provide reliable forward cycling.

NOTE: Cycling the projectors using switch closure times outside the values provided here (with less contact time) is possible; however, these values provide greatest reliability in long-life operation.

(CONTINUED)

Consideration No. 3—Attempting to Use the Projector-Reverse Circuit for Forward Cycle of *EKTAGRAPHIC* III and *EKTAGRAPHIC* Slide Projectors

An extremely short reverse-circuit closure can result in forward cycling—*but this is not a reliable method of cycling the projector forward and Kodak does not recommend it unless a sensing circuit is used.* In addition, the required length of the closure (for forward cycling by the reverse circuit) will vary from one projector to another and may change as the projector ages.

To use the reverse circuit to cycle the projector forward, the cycle-pulse duration must be controlled and completed within 10 milliseconds after the clutch switch opens. This can be accomplished by means of a circuit that senses the clutch switch opening. To be reliable and compatible with all variations of *EKTAGRAPHIC* Slide Projectors, the sensing circuit should be designed to operate reliably with a minimum projector impedance of 15 K ohms when the clutch switch is open, and a maximum of 5 K ohms after the switch is closed.

When there is a need to cycle a Kodak slide projector continuously at the fastest possible rate in either the forward or reverse direction using external programming equipment, a circuit that senses the closing of the projector clutch switch should be used. Such a circuit is especially recommended when automatically cycling the slide tray back to the zero position as quickly as possible.

The forward and reverse circuits of an *EKTAGRAPHIC* Slide Projector energize a solenoid to cycle the mechanism. During a forward cycle, the cycle lever and clutch spring interrupt power to the solenoid when they separate, generating an electrical arc. After many thousands of forward cycles, the clutch contact surfaces may erode to the point that clutch repair or replacement is necessary. Less arcing (and wear) occurs on *EKTAGRAPHIC* III Projectors due to suppression circuitry. However, the reverse circuit of Kodak slide projectors is designed so that the clutch switch is bypassed whenever the projector is cycled in reverse. The solenoid remains energized, and the cycle lever keeps the direction lever actuated, which results in a reverse movement of the slide tray.

Although the clutch in Kodak slide projectors will usually last longer if the reverse circuit (rather than the forward circuit) is used to cycle a projector forward, our experience indicates that unreliable cycling can occur after a period of use if *KODAK* slide projectors are continually cycled forward by a control device that utilizes the reverse circuit. Therefore, we advise against this practice unless a sensing circuit is used.

The Special-Applications Receptacle and the Remote-Accessory Receptacle of the *EKTAGRAPHIC* III Projector provide access to the forward and reverse cycle circuits. To avoid interaction and possible malfunction, however, the electrical sensing circuit should operate using only one of the receptacle circuits.

If a sensing circuit is *not* used, however, and equal, continuous slide-advance commands are used to cycle the projector as rapidly as possible, the commands must be no less than 1.25 seconds apart to maintain synchronization of the slide tray and the memory of the external programmer.

When using accessory equipment to cycle and focus the *EKTAGRAPHIC* III Projector, the total electrical resistance external to the projector should be no greater than 4 ohms, including wire connections.

Consideration No. 4—High Current Surges from Lamp-Filament Failure

When using electrical devices to control the projection lamp, caution should be taken to protect against a possible high-current surge that may take place in the circuit when the lamp filament fails. This surge could be as high as 600 amperes for 2 to 8 milliseconds. The switch used to control the lamp should be suitable for use with a tungsten-filament lamp and have a current rating greater than or equal to six times the steady state tungsten load for alternating current.

Introduction

In this part of *The Source Book*, you will find a variety of tips and techniques that should help you produce more effective slide programs: we discuss the real differences between open-frame slide mounts and glass slide mounts, the planning, production, and presentation of continuous (repeating) sound-slide programs, the "whys" and the "hows" of color matching slide projector lamps, the best ways to avoid or reduce keystoned images, the importance of registration slides, the last word in protecting your equipment from the cold, the most important things to consider when using Kodak slide projectors overseas, and much more.

Open-Frame Slide Mounts versus Glass Slide Mounts

In the past, glass mounts were generally thought necessary in achieving and maintaining optimum slide image quality. But this is no longer necessarily the case. Discussed below are the major advantages and disadvantages of both kinds of mounts, so that when the need arises, you can make an informed choice.

Physical Protection of Transparencies

Although glass does provide protection against fingerprints, dust, dirt, and scratches, slides stored in boxed trays or other containers (regardless of the kind of mounts used) are not likely to be badly damaged or become dirty or scratched. In fact, people usually exercise more caution when handling open-frame slides than those mounted in glass because the vulnerability of the transparency in an open-frame mount is more obvious. (If it can be touched, it can be scratched.) In addition, glass-mounted slides used in libraries usually must be cleaned more often than open-frame mounted slides because people handle the ones in glass less carefully.

Transparency Life

In general, transparencies kept in open-frame mounts can be expected to last longer than those kept in glass mounts. A transparency mounted in glass has a thin insulating layer of air between it and the glass, and the heat from the projection lamp must be transmitted through the layer of air on each side of the transparency, and then through the glass. The transparency will get hotter before the temperature stabilizes than will a similar transparency in an open-frame mount. With an open-frame mount, the heat is carried away by air moving over the transparency surface.

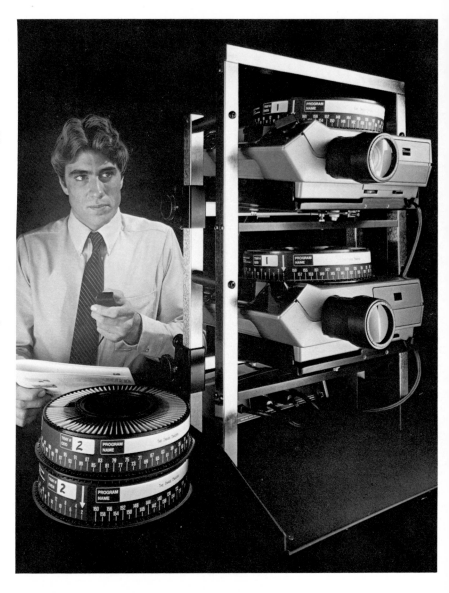

Humidity and Moisture

Photographic emulsion is hygroscopic—it absorbs moisture from humid air until it reaches a balance. If the humidity decreases, the moisture leaves the emulsion (as water vapor) until balance is again restored. In an open-frame mount, the transparency emulsion can quickly pick up moisture from the air or release it. In a glass mount, the transparency moisture increases more slowly—but it also disappears more slowly.

If the transparency is in an open-frame mount, ventilating air carries the moisture (as vapor or gas) away from the transparency. In a glass-mounted slide, the vapor tends to condense on the inner surfaces of the glass, forming a layer of liquid water. The result is usually an objectionable, moving amoeba-like pattern on the screen lasting until the glass warms up enough to convert the water back to vapor. This problem is worse

with slides that have been stored in high humidity and then projected in a high-intensity projector (arc projector) without prewarming them.

The cures for this problem include

- Storing the slides in a low-humidity atmosphere.
- Prewarming the slides in a low-temperature oven or box with a light bulb in it.
- Projecting the slides with a low-wattage projector (to warm up the glass and get rid of the water as vapor) before using the slides.

Open-frame mounts do not solve all humidity problems. If the humidity is high enough, fungus may grow on the emulsion—regardless of the mount type.

Image Brightness

A glass-mounted slide has four glass-to-air surfaces, plus two film-to-air surfaces. This is a total of six surfaces, each of which reflects about three percent of the light back toward its source. Thus, about 22 percent of the light that the projector lamp provides will be reflected. The image will be about 78 percent as bright as if there were no reflections.

With an open-frame mount, there are only two film-to-air surfaces, and only 8 percent of the light will be reflected. This is a gain of about 18 percent in brightness, compared with a glass-mounted slide. In addition, the glass may not be easy to clean because it has four surfaces which can accumulate dust or dirt.

Of course, glass can be cleaned or new glass substituted—but a dirty or scratched transparency seldom can be restored to good condition. On the other hand, a transparency in a glass mount is less likely to have something accidentally spilled on it or to be scratched than a transparency in an open-frame mount.

Transparency Flatness and Newton's Rings

Although a glass mount will usually provide a flatter transparency than an open-frame mount, Newton's rings may develop in a glass-mounted slide if the distance between the glass and the film surface is especially small. (Newton's rings are interference patterns caused by light reflections and are usually multicolored.) They can be prevented by using special anti-Newton-Ring glass, or fine powder to prevent extra-close contact of film and glass. (Glass mounts with good anti-Newton Ring chacteristics are now available.)

Usually, the emulsion surface of a transparency should be held flat within ten thousandths of an inch or less so that the image will appear sharp at average viewing distances, using an f/3.5 or f/2.8 projection lens.

Most projection lenses are designed to produce a flat two-dimensional image on the screen from a flat two-dimensional transparency. But ordinary photographic film tends to curve. Most projection lenses will form a curved image of a curved object. With an open-frame

mount and normal projection lens, it would be necessary to use a slightly curved screen to keep all of the image in focus. A glass-mounted slide flattens the film, however, so the image on the screen would also be flat.

In recent years, the importance of the ability of glass mounts to flatten the transparency has been somewhat diminished by the development of curved-field lenses and improved transparencies. (See "Choosing Between Curved-Field and Flat-Field Projection Lenses, on page 92.) Years ago, transparencies in open-frame mounts often "popped," as they were projected—somewhat like the bottom of an oil can. The direction of film curvature would suddenly change from positive to negative as the heat generated in the film emulsion by the projection light dried it out, causing the emulsion to shrink and apply tension to the film base.

Now, however, the bases of popular slide films are made with a slight curve in the direction that the shrinking emulsion tends to make the transparency curve. When the emulsion shrinks, it may make the curve slightly steeper, but it doesn't "pop" in the opposite direction.

The average curvature of the film is similar for most slides in most projectors. The curve is toward the light source for ordinary slides, with the emulsion toward the projection lens. Almost all reversal duplicate slides and slides printed from negatives are also made this way, so the curvature will be similar to the original reversal transparencies.

By using curved-field lenses, it is possible to have the advantages of open-frame mounts without the disadvantage of popping transparencies causing poor center-to-corner sharpness.

Open-frame super slides may cause problems, however. They have a large, unsupported transparency area that will not assume a predictable curvature. And if you turn the slide around in the tray to project on a rear-projection screen, the curved-field lens curves the image in the wrong direction—making center-to-corner sharpness worse than with a flat-field lens.

Film curvature is not always uniform from slide to slide. One transparency may curve a little more than another because it may be on a different film, it may be older, or it may have a different density (and thus gets warmer or cooler than the other slides in the tray).

The autofocus mechanisms in many modern slide projectors will usually take care of these differences, but once in a while the amount of correction is not as perfect as we would like—particularly if there is important detail throughout the image area.

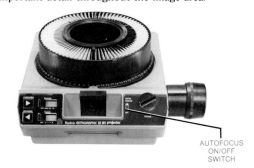

AUTOFOCUS
ON/OFF
SWITCH

Some Advantages of Glass Mounts

So what are glass-mounted slides good for? Well, they do hold the film flatter. That is an advantage where overall sharpness is critical.

And when two or more pieces of film are "sandwiched" in one slide, glass mounts can be very important. For example, if a black-letter clear-background title slide is mounted over a background scene on a second transparency, the only way to keep both sharp is to use a glass mount that will hold them together, emulsion to emulsion. Otherwise, they may curve slightly differently, making sharp simultaneous focusing of both images impossible.

The same idea is true for side-by-side film transparencies. If two half-size transparencies are mounted side-by-side, keeping them flat and together at the "join" area is easier by placing both in a glass mount. Although multiple-aperture, open-frame mounts may be used in some situations, they will usually not provide as uniform flatness as normal mounts. In addition, the "dividing bars" across the open frames may make the projector autofocus mechanism misbehave.

Of course, open-frame mounts are lighter than glass mounts. That is an advantage when shipping the show, and also results in somewhat longer life for slide trays and projector mechanisms in long-running programs. Conversely, heavier slides may operate more reliably in gravity-feed projectors, particularly if dust and dirt, extreme projector elevation angles, and perhaps static electricity create problems. Glass mounts are normally stiffer and less subject to warping than open-frame mounts.

Expense

Open-frame mounts are usually less expensive than glass mounts, and the mechanics of mounting transparencies in open-frame mounts is less labor intensive and hence also less expensive. (Hand mounting is usually necessary with glass mounts.)

When only a few sets of duplicate slides are needed, the cost of mounts and mounting is likely to be relatively small, compared with the cost of preparing and showing the program. But when hundreds of sets of slides are going to be made and distributed, the cost of mounts, mounting, and shipping become important.

Some Compromises

There are obviously some compromises between glass mounts and open-frame mounts. One compromise is to laminate the film transparency to a single sheet of glass that will hold the transparency flat and will provide one film surface open to the air for cooling, with better cooling on the other side because of direct conduction of heat to the glass. It also provides only two reflecting surfaces. However, lamination requires skill—especially if the slide is to be used in a multi-image program requiring precise registration of all images.

Using glass on one side of a transparency without lamination is also possible. For example, a sheet of 2 x 2-inch cover glass can be inserted with a transparency in a frame with a mask or open-frame mount. The glass will limit how far the transparency can curve and the emulsion side of the transparency will be open to air for cooling.

Neither "laminated" slides nor "glass-on-one-side mounting" is completely satisfactory for all situations. Their advantages are not great enough to justify always using them.

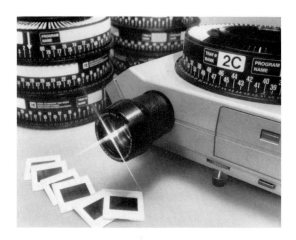

What Is the Best Choice?

It is dependent on program requirements. For example, the better cooling of open-frame mounts may be important in a program that runs continuously. But that may not be as important as optimum sharpness in programs that will be presented only occasionally.

What Does the Future Hold?

Sometime in the future, someone may invent the "perfect" slide mount. Such a mount will provide perfect transparency flatness, excellent protection against dirt or damage, rigidity, good cooling, and low cost. Until then, we must choose according to the requirements of the program.

How to Produce Continuous (Repeating) Sound-Slide Programs

The following information describes many ways that you can produce continuous AV programs. We also show you how to avoid or solve some of the common problems users encounter when producing audiovisual programs designed to repeat continuously.

The round trays used on *KODAK* Slide Projectors make it possible to repeat the slide portion of a program continuously or to have it ready to repeat without the necessity of manually reversing or advancing the slides to the starting point. Continuous-loop cassettes, cartridges, and reel-to-reel audiotapes can provide the same advantage for the sound portion of a program. Therefore, it is logical to combine the two for continuous or "repeating" (ready-to-run) sound-slide programs.

Continuous sound-slide programs are often used in

- Hospitals (for in-patient instruction).
- Industry (for employee information and motivation).
- Education (where repetition helps students learn more easily).
- Point-of-purchase displays.
- Trade show exhibits.
- Museums and art galleries.

The Mathematics of Circular Reasoning—*KODAK* Slide Trays

Slides to be used in a continuous or repeating AV program are quite often projected on slide projectors that use trays having a nominal capacity of either 80 or 140 slides. Of the two, the 80-slide tray (examples are the *KODAK EKTAGRAPHIC* Universal Slide Tray, Model 2, the *KODAK EKTAGRAPHIC* Universal Deluxe Covered Slide Tray, and the *CAROUSEL TRANSVUE* 80 Slide Tray) is almost always better for continuous programs for the following reasons:

- When using the *EKTAGRAPHIC* Universal Slide Tray, Model 2, or *EKTAGRAPHIC* Universal Deluxe Covered Slide Tray, almost any type of slide mount (cardboard or plastic or glass) can be used.

- Warped or worn slide mounts operate more reliably in 80-slide trays than in the thinner slots of the 140-slide trays, so there is much less tendency for slides to "hang up" and fail to project.

- For most continuous sound-slide programs, 140 slides are usually too many—even if they are changed rapidly. There are exceptions, of course, but people will tend to lose interest and may not remain for the entire message.

Multiple Slide Sets

The following suggestions are based upon the assumption that your program will use a single projector. (The slides can be arranged later into two trays for dissolve projection.)

Often, 80 slides are too many for one program. However, you can produce shorter slide shows and place a number of duplicate sets in a single tray (for a show that will use a single projector). (Remember, the 80-slide tray actually has 81 slots, including the one marked "0".) For example, if 81 slides are too many, then three identical sets of 27 slides can be used. Or you can use nine sets of nine slides each; or 27 sets of three slides each.

What if each slide set consists of 25 slides? That's relatively simple; use three sets with two blank slides between each one. Or how about three sets of 21 slides with six blanks between each one? In the latter case, the pause betweens sets (caused by the time needed to run through the blank slides) will be about 6 seconds if the projector is programmed to advance through them as rapidly as possible.

Some Advantages of a Dissolve Control

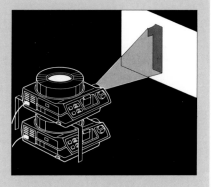

A program using a single projector usually can be greatly improved by rearranging the slides into two trays (odd and even) for projection using two projectors and a dissolve control. The most striking improvement (and the one most appreciated by the audience) is the replacement of the repetitive "dark-screen interval" that occurs between each image *when using a single projector* by the more pleasing "dissolve effect," which occurs when the dissolve control fades the light beam down in one projector while changing the image and fading the light beam up in the other.

The object of a good dissolve show used to be the smooth blending of one image into the next. However, many modern dissolve controls produce a number of useful screen effects, ranging from an abrupt "quick cut" (an almost instantaneous image change) to an extended 8-second dissolve (often used for slowly fading off the last image of the show)—plus flashes, freeze dissolves, superimpositions (one image held on top of the other), and reverse dissolves (backing up). Some units allow connection and advance of a third projector for projection of a "border" slide (used to "frame" the program slides), superimposed "title" slides, and "background" slides. Most modern dissolve controls also allow manual (fingertip) keyboard control or automatic playback from magnetic tape using an audiovisual cassette or reel-to-reel tape machine.

Often, some introductory music, a few sound effects, and imaginitive programming of the image changes, will transform a single-projector show into an effective audiovisual presentation that the audience will remember and act upon.

Four Sets of 20 Slides?

Suppose that you have four sets of 20 slides in one tray, which comes out nicely to 80 slides. However, the "0" position on the tray is still open, so only one blank can be used for all the sets—an unsatisfactory solution. One alternative is to use only three sets of 20 slides with seven blanks between each set; this keeps the sets (slides plus blanks) consistent.

On the other hand, inserting an uneven or staggered number of blank slides between sets is often better. For example, you can use four sets of 20 slides each, with only one blank in the tray; or use four sets of 19 slides, with one blank between three sets and two blanks between the first and fourth set. (Unfortunately, this uneven distribution of blank slides can cause synchronization problems if you plan to use recorded slide-advance signals to advance a slide projector. Some solutions are provided later on.)

A related problem occurs when the number of slides in a program is more than 40. Switching to a 140-slide tray will not solve the problem unless you are using only cardboard-mounted (or other thin-mount) slides. If you do use a 140-slide tray (i.e., *KODAK CAROUSEL TRANSVUE* 140 Slide Tray), a possible solution is to use three sets of 40 cardboard slides with seven blanks between each set. Another solution is to add more slides to each set so that you have fewer blanks, and, hence, shorter pauses between each program. Perhaps the best solution is to reduce the number of slides per set to fewer than 41. (In most point-of-purchase or similar types of programs, 41 slides are normally more than a potential customer will stay to watch, anyway.)

Most producers of continuously repeating programs insert at least one blank slide (or leave an empty slide slot) between the end of one show and the beginning of the next one for a definite break between shows. Of course, other types of slides may be used for the same purpose—for example, interesting patterns of color or lines or perhaps a company logo.

Tape Without End—A Review of Continuous-Loop Audiotapes

Basically, magnetic-sound audiotape loops are simple. The inside end of a roll of tape (the tail) is spliced to the outside end (the head). Enough slack is then provided for the tape to come off the center of the roll, to pass by the sound pick up head of the tape recorder, pinch roller, and capstain, and then back onto the outside of the roll.

A bit more analysis, however, shows that it's not quite that easy.

The tape can't stay in a flat roll; it must at some time slide up at an angle, travel in a different plane, and then get back onto the roll. As the roll of tape revolves, the tape slips continuously on itself. (The inner convolutions must turn faster than the outer ones.) Special lubrication is usually necessary, even though the driving and guiding mechanisms for the tape are designed to reduce both friction and static electricity.

Continuous-loop cassette tapes work very dependably—usually for hundreds of plays. However, a few general precautions should be observed:

- Be sure to insert the cassette into the tape player with the label side away from the mechanism (usually up).

- Whenever possible, position the AV tape player so that the cassette is in the horizontal position.

- Do not run the tape in the fast-forward or rewind mode.

- Do not try to pull the tape out of its plastic housing, and of course, avoid breaking or creasing the tape.

- The tape machine playing mechanism will usually need more frequent cleaning because of heavier use and the extra lubricant found on loop tape.

- Try to use tapes that are 6 minutes or shorter in length.

- Provide backup tape copies.

- Break out both of the plastic tabs from the closed edge of the cassette show tapes so they cannot be accidentally erased and recorded. (With the tabs removed, the tape record button on the tape machine cannot be pressed in. To erase and record the tape again, cover the tab holes with cellophane tape.)

Continuous-Loop Tapes

Continuous-loop tapes fall into two main categories:

The most popular types were the $^1/_4$-inch tape cartridges used mostly in automobile tape players. These tapes usually have eight separate tracks (four sets of stereo tracks) and a stepping arrangement that plays the length of the tape four times before repeating. Similar cartridges were used in tape players designed to control slide projectors by means of slide-advance signals recorded on one or more tracks. Conductive metalized tape can also be added to the magnetic tape for additional functions—for example, an automatic "tape stop" (program pause) contact.

A second type of continuous-loop tape is housed in what appears to be a conventional compact cassette. However, the roll of tape is entirely at one end and never winds to the other end. The maximum playing time for a continuous-loop tape in the compact-cassette format is about 20 minutes. Shorter lengths are also available and are usually more reliable.

Generally speaking, compact-cassette format continuous-loop tapes are most reliable when operated in the horizontal plane, label up. Those of you who own tape playing equipment that holds the cassette in the vertical plane may be interested in continuous-loop cassettes, available at a premium price, that are designed to be played in the vertical plane. (Refer to the text box on the next page.)

The ANSI Standard

Most often, continuous-loop cassette tapes used with projection equipment adhere to ANSI Standard PH7.4—1981 for controlling the slide projector. Tracks 1 and 2 on the tape are used for audio. Tracks 3 and 4 are usually used for slide-advance signals. A 1000 Hz signal is recorded on the control track (tracks 3 and 4, or 4) to advance the projector. Sometimes a 150 Hz signal is also recorded for automatic tape stop.

CASSETTE TAPE

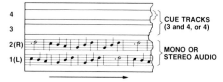

Some tape recorders also provide a switch to permit using the 150 Hz signal for another purpose (such as for controlling a second projector). A copy of ANSI Standard PH7.4—1981 may be purchased from the American National Standards Institute, 1430 Broadway, New York, NY 10018.

Recording Continuous-Loop Tapes

With the exception of very simple audiotape loops, it is not easy to load, repair, shorten, or lengthen continuous-loop tapes. The best procedure is to make the recording first on a conventional reel-to-reel tape recorder, edit it, and then transfer the recording to a continuous-loop cassette. The length of the recording can be adjusted to fit one of the continuous-loop playing times regularly available — or you can buy special-order tapes of almost any playing time up to the maximum length.

Many commercial audiotape laboratories and sound studios offer services for transfering conventional recordings to continuous-loop tapes, including the addition of slide-advance signals, program-pause signals, or other control signals. Most labs can also produce original recordings, if necessary. When large quantities of continuous-loop tapes are required, these services are more practical than trying to make them "in-house." Of course, you should communicate clearly to the lab exactly what kind of projector-control signals are needed and then "test" sample tapes.

Automatic Program-Pause Sensors

Most tape players with automatic program-pause sensors do not shut off the entire tape machine in response to a program-pause signal. Normally, the program-pause signal will simply shut off current to the tape-drive motor so that the tape stops moving with the pinch roller still in contact with the capstan.

Restarting the tape is accomplished by turning the power back on (usually by push button). This is often done with the audio amplifier still on. If sound is recorded at the pause point of the tape, the tape slowdown, stop, and start-up noise will be amplified through the loudspeaker. To eliminate this interference, some tape players automatically disconnect the loudspeaker or turn off the amplifier whenever the tape pauses. In either case, you should avoid recording any sound at the pause points of the tape because the sound will be distorted or not heard at all. (Be sure to allow at least 2 seconds of silence both before and after a program-pause signal whenever you are recording a new program.)

Getting Tape and Slides to Come Out Even

For continuous sound-slide programs to work consistently, remember that the number of slide-advance signals on the tape, in most cases, should equal the number of slides in the tray.

For example, if there are 81 slides in the program, then 81 slide-advance signals will normally keep the program in sync. Each time the tape plays a complete revolution, the tray will revolve once and both will automatically play again (or be ready to play again).

On the other hand, if there are fewer than 80 slides in the tray, 81 signals will still be needed to keep the slides and tape in sync. (If you have 70 slides in your program, 11 additional slide-advance signals will be needed to advance the tray through the 11 blank slides so that the program will be ready to start again.)

Be sure that you record a separate slide-advance signal for each slot in the tray. *Allow for a minimum pause of 1½ seconds between the beginning of one slide-advance signal and the next one.* If the signals are placed too close together, some may arrive before the projector has finished advancing the tray.

The slide-advance mechanism in the projector has no memory, so if a signal appears before a slide-advance cycle has completed, it will be ignored. Thus, it is not satisfactory to record a prolonged slide-advance signal— that is, one long enough to recycle the projector back to the start of the program, unless the zero position switch on projectors so equipped is used to stop the return signals until the next program is to start.

Using a Tape with Less (or More) Signals

Sometimes, it is not necessary to use a long continuous-loop tape with several signals on it. For example, if you have three sets of 27 slides in a tray, a continuous-loop tape with only 27 slide-advance signals will suffice. The first time the tape plays, it will be synchronized with the first 27 slides. The second time the tape loop goes around, it will synchronize with the second set of slides (slides 28 through 54). The third time, it will synchronize with the third set (slides 55 through zero); then your set of three programs will be ready to start again with the tape revolving three times for each revolution of the tray.

If your program has 25 slides per show, two more slide-advance signals can be recorded on the tape (for a total of 27 slide-advance signals). The two extra signals will advance through the blank divider slides: numbers 26 and 27, 53 and 54, and 80 and 0.

The same method may be used for 3, 9, or 27 slide-advance signals on a particular tape. The tape will then play, respectively, 27, 9, or 3 times for each complete revolution of the tray.

What if Your Slide Sets Don't Come Out Even?

Suppose that you have four sets of 18 slides in a tray so that 72 slots of an 80-slide tray are filled. Instead of adding nine blank slides at the end of the tray (for a total of 81 slides), two dark slides may be added after each set so that 80 slots are filled. However, one slot (the zero position) will still be empty. If the tape loop has 20 slide-advance signals on it, the show will stay in sync until the tray reaches the zero position. Then, it will be one slide behind the tape. The next revolution of the tray will put it two slides behind, and so on.

There are three readily apparent solutions. The first involves a compromise in the number of slides you use,

the second a minor modification to conventional slide projectors and trays, and the third requires a projector with an automatic return-to-zero position capability.

Solution Number 1: Use only three sets of 18 slides; add nine blanks between each set and nine slide-advance signals (for a total of 27 signals). Your show will then be back in sync; the tape will revolve three times for each complete revolution of the tray.

Solution Number 2: Add a control switch to the slide projector; the switch will be tripped by a cam (a piece of plastic, wood, or similar material glued to the side of the tray). The cam will close the switch only when the tray is at the zero position.

The switch should be wired in parallel with the slide-forward button of a *KODAK* EC Remote Control (discussed earlier). Each time the tray comes to the zero position, the switch will close and the tray will advance one more slot (without a signal from the tape). Once the cam has passed by the switch, the switch will open and the program will be back in sync.

The above techniques require enough blank tape (at least one and one-half seconds) after the 27th slide-advance signal to allow the projector to advance once more before the program starts again.

This technique may also be used to solve other synchronization problems. For example, if your slide show has 70 slides, a longer cam can be attached to the tray; this keeps the switch closed until the tray advances through slide positions 70 to 0 and is then ready to start again.)

What if something goes wrong and your tape is ahead of the slides at the end of the program? To correct this, record two or three more slide-advance signals on the tape than there are actual slides in the set. The tape will make certain that the tray advances far enough so the cam will cause a return to the starting point.

If after the last recorded slide-advance signal a program-pause signal is recorded on the tape, the tape deck will stop automatically; both will be ready to start in sync. If the opposite occurs (the tray is ahead of the tape), the program will still be corrected automatically. The extra signals recorded on the tape will be ignored because they will reach the projector's slide-advance mechanism while it is automatically advancing the slides, since the cam has closed the switch. The tray will not be advanced past the zero position unless you record too many slide-advance signals.

Solution Number 3: Use a projector or a controller that has an automatic return-to-zero feature. (The *KODAK EKTAGRAPHIC* Programmable Dissolve Control, Model 2, has such a feature, and can be used with a single projector, as well as with a pair of projectors.)

The *KODAK EKTAGRAPHIC* III E, ES, B, A, AS, and AT Projectors have a special-application receptacle that allows a qualified technician to wire these projectors for automatic zero positioning of the slide tray. (Some of the necessary information appears in the operating instruction manual delivered with each projector.)

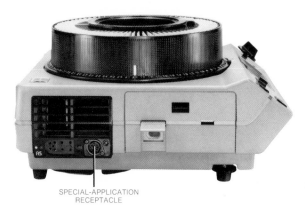

SPECIAL-APPLICATION
RECEPTACLE

The *KODAK EKTAGRAPHIC* Slide Projector, Models S-AV2030 and S-AV2050, have a zero-position circuit that can be used for unattended continuous sound-slide programs. In the Model S-AV2030, the built-in self-starting, self-operating, zero-positioning function automatically returns the slide tray to zero over the shortest route—either forward or reverse—with the shutter closed so the screen remains dark. Zero positioning is actuated either by an empty slide compartment or a special blank slide located at the end of a slide set. Thus, if only 10 slides are being used, for example, the projector can be set to reverse to zero; if 70 slides are used, the projector can be set to go forward from slot 71 to 0.

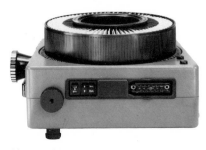

In addition, if you connect a *KODAK* EC Automatic Timer to the *EKTAGRAPHIC* III or Model S-AV2030 Projector, the projector will ignore any recorded advance commands while it is returning to zero. When the slide tray is set at zero, the interval before it advances to the first slide will depend on the timer. So if the timer is set for a 5-second advance, the projector will either advance immediately, or it will wait for as long as 5 seconds before advancing again.

If an audiotape loop is used with these projectors, it should be made long enough to allow for the automatic return-to-zero feature. The timing is longer for the Model S-AV2030 Projector than for all other *KODAK EKTAGRAPHIC* Projector models—allow about $1\frac{3}{4}$ seconds per tray slot for the Model S-AV2030 Projector and approximately $1\frac{1}{2}$ seconds for all other projector models. If you have a Model S-AV2030 Projector and a 10-slide show it would take about $1\frac{3}{4}$ seconds for the projector to cycle from slot 10 to slot 11 where it would find no slide in the slot and begin to reverse to zero, plus $11 \times 1\frac{3}{4} = 19.25$ seconds, for a total of approximately 21 seconds. Thus, the audiotape for this situation should allow for 12 slide changes before signaling the projector to cycle again through the presentation.

Using the *EKTAGRAPHIC* Programmable Dissolve Control, Model 2, for Continuously Repeating Sound-Slide Programs

If you attempt to record and play back the digital synchronizing signal (the "sync track" signal) generated by the *EKTAGRAPHIC* Programmable Dissolve Control, Model 2, for most endless-loop programs, the start of the second revolution of the audiotape will command the trays to return to the first slide of the program rapidly, disrupting sound-image synchronization.

Using the Programmable Dissolve Control's digital sync-track signal for endless-loop (repeating) sound-slide programs is acceptable only when the number of recorded tray advances equals the number of slides in the trays.

In most cases, therefore, it is necessary to use the 1000 Hz slide-advance method of projector control when using the Progammable Dissolve Control for endless loop slide programs.

One method of 1000 Hz advance involves using the built-in tape deck of an *EKTAGRAPHIC* AudioViewer to

The built-in tape deck of a *KODAK EKTAGRAPHIC* AudioViewer can be used to advance an *EKTAGRAPHIC* Programmable Dissolve Control (using the 1000 Hz method of projector advance).

play an endless-loop tape. The AudioViewer is connected to the Dissolve Control with a *KODAK* AudioViewer EC Interconnect Cord. Each time a recorded 1000 Hz signal is detected by the AudioViewer, a closure is routed to the Dissolve Control which advances the projectors.

Of course, an AV cassette recorder having built-in 1000 Hz synchronization capability can also be used (see below).

Some Operational Tips

If both the continuous-loop tape and player as well as the slide-advance mechanism of the slide projector are working properly, then all the equipment may be left with the power on all day if necessary—as long as it is properly ventilated. Usually, the projector equipment will warm up for the first 20 or 30 minutes and then the temperature will stabilize.

There should be no adverse effect on the useful life of the audiotape machine, audiotape, slides, or slide projector when operating them continuously in a well-ventilated area. As a general guideline, 100 hours of continuous operation will have about the same effect as 3,000 showings of a 5-minute presentation spaced 30 minutes apart. However, you should also be aware of the following considerations:

- Long-life projection lamps
- Maintenance schedules
- Duplicate slides
- Adequate ventilation
- Voltage

Long-life projection lamps: The projected image in a continuous sound-slide program will often be smaller than for normal projection. Using a long-life projection lamp (with the power selector switch of the slide projector at the low position) results in much lower lamp cost and still provides a satisfactorily bright image for most projection situations. For example, with *EKTAGRAPHIC* Slide Projectors, an ENH projection lamp (or for *EKTAGRAPHIC* III Projectors, an EXY lamp) used at the low position will last for several hundred hours. Conversely, the high-brightness ENG lamp (for *EKTAGRAPHIC* Slide Projectors) or the high-brightness EXW lamp (for *EKTAGRAPHIC* III Projectors) provides the greatest light output but burns out much sooner.

Maintenance schedules: If your equipment runs continuously for several hours, seting up a good maintenance schedule—particularly if the location is dusty and warm is important. With continuous use, equipment may operate as much in one week as it normally would in a year for lecture or casual presentations.

You should clean the tape path of the tape machine frequently since continuous-loop cassette tapes and cartridges are usually lubricated more than normal tapes. It is especially important to clean the tape heads, capstan, and pinch rollers regularly. (Neglect may cause distorted sound and tapes to jam.)

Slide trays may also require occasional maintenance. Damaged trays should be repaired (if possible) or replaced.

Duplicate slides: Slide sets projected several hours each day should be considered expandable. Projecting duplicate slides rather than originals in projection equipment that is operating continuously is a good idea.

You may notice slight fading or color changes in the slides after many hours of program use. This may present a greater problem in some projection situations than in others. For example, if good color match with a product is important, minor shifts in color will be more critical than if color is used only as a key in a chart.

Continuous slide changes will also tend to wear out the slide mounts. Mounts with aluminum frames may show more wear than those made of steel, cardboard, or plastic.

Adequate ventilation: Ventilation is important. If it is inadequate, slide and equipment life will be shortened. Thermal fuses or other thermal shut-off devices provided in the projectors will not prevent overheating; these safety devices are intended to prevent fire and other heat hazards—not to provide maximum life of the equipment. If your equipment is housed in a cabinet, ports must be carefully located so that hot exhaust air from the projection equipment will not be recirculated.

Voltage: Be certain that the voltage supplied to the equipment is adequate. Operating the equipment at a higher or lower voltage is likely to cause overheating and damage.

The most common problem in the U.S. and Canada is voltage that is too low, sometimes caused by overly long or lightweight extension cords or defective plugs and sockets. Make certain that both the extension cords and power supply are sufficient.

Restarting the Program on Demand

A popular application for continuous sound-slide programs is to cue the presentation equipment to shut off automatically after each showing. The program can then be restarted by various means: built-in tape pause/restart, a switch and cam, push button or relay, or other types of switches and timers.

Built-in automatic tape pause/restart: The easiest method is to use an AV tape deck equipped with an automatic pause/restart feature. Whenever the playback head of the tape recorder reads the recorded 150 Hz program-pause signal, it turns off the tape deck motor. Closing the circuit momentarily (by pushing a button on the tapedeck or by some other means) will restart the motor. The tape deck will continue to run until it comes to the next recorded 150 Hz program-pause signal.

Most tape recorders with built-in slide-advance and program-pause features operate basically the same way. After the tape stops, a momentary push of a button will start the tape again.

A switch and a cam: If your tape recorder does not have a tape pause/restart feature, it can easily be added to an *EKTAGRAPHIC* Slide Projector to stop both the projector and tape recorder. Simply mount a roller-activated switch on the slide projector so that a cam on the slide tray activates the switch. (The method is the same as the one described earlier for returning the tray to the zero position, except the results are different.) The normally closed contacts on the switch are used; the contacts are opened by the cam on the tray that operates the switch. The switch is wired to a power outlet that feeds the tape recorder and slide projector. When the switch is activated by the cam on the tray, the power will be cut off to the equipment.

A push button or relay: A push button or relay can also be used to restart the program. One contact (rated for several amperes at 125 volts) supplies power to the slide projector and tape recorder by shorting across the roller switch contacts. The second contact—in parallel with the slide-forward button on the projector—cycles the projector once. The roller-actuated switch will close again and the projector and tape recorder will continue to run. The next slide-advance signal from the continuous-loop tape will then take over for automatic advancing of the projector. (You can obtain suitable push buttons from most electrical supply houses.)

Other switches: In addition to push buttons, almost any mechanical or electronic switch can be used to restart your programs. Among the devices which can be used are some switches, intrusion detectors, photo cells with relays, pressure-sensitive switches in floor mats, push buttons, and so on.

Small clock-motor switches can be used to start the program at specific intervals—such as once or twice an hour. Standard 24-hour electric timers can also be used to turn the program on and off at specific intervals.

Similar timers are available that will permit you to schedule the hours of operation for an entire week.

If timers are used to turn off the program, it's a good idea to use a self-synchronizing program with the projection equipment for this reason. If power is completely cut off to the equipment, the tape could possibly stop just before the arrival of the next slide-advance signal, or before the projector finishes a slide-advance cycle. When power is restored for another show, the projector may either miss the first slide-advance signal or advance one extra time on the same signal. Such malfunctions will cause the program to go out of synchronization.

Using a Continuous-Loop Tape as a Timer

Since a continuous-loop tape can be used to control the slide-advance function, it's possible to also use it as an automatic timing device. For example, an unrecorded 5-second tape loop with only one slide-advance signal recorded on the control track of the tape can be used to advance a tray of slides every 5 seconds. In general, however, using a continuous-loop tape in this way is not as desirable as using the built-in timer on those *EKTAGRAPHIC* III or *EKTAGRAPHIC* Slide Projectors that have it, or an external timer connected to the projector.

There may be occasions when a timer is not available, however. For example, if your slide program does not require sound, then it may be easier to use a tape recorder as a timer rather than obtain and use an external timer.

Using a tape recorder as a timer may also be convenient when *variable timing* is necessary. If, for example, you want to project one slide for 7 seconds and the rest of the slides for only 3 seconds each, the slide-advance signals can be recorded the same way they would be recorded for a program using sound.

Sometimes, you may want to use slide-advance cycling times outside the range normally available on external or built-in timers. For example, you may want to cycle slides only once a minute. The automatic timers built into some projectors provide maximum cycling times of either 15 or 22 seconds, depending on the model.

Occasionally, you may need to advance a series of slides rapidly—every 2 seconds or so. Most timers will not operate this rapidly; however, you can record a continuous-loop tape with slide-advance signals to solve the problem. (Be sure to allow at least 1/2 seconds between each slide-advance signal.) And again, if you use a continuous-loop tape to rapidly advance a slide projector (without audio recorded on tape tracks 1 and 2), it's just as necessary to clean the tape heads, capstan, and pinch roller as when sound is also being used.

CONTINOUS-LOOP CASSETTE TAPE

KODAK EC AUTOMATIC TIMER, MODEL III

What About Audio?

Q. How important is the audio portion of a sound-slide program?

A. Very important. Try listening to a TV program, or a sound motion picture, without watching the image. Then try watching without sound. You'll soon be convinced the audio part of any program carries a lot of vital information.

Q. Is there a simple test for room acoustics?

A. Yes. A sharp handclap in the room you're going to use for your program. If you hear echoes and reverberation, you're likely to have acoustical problems which can hamper the intelligibility of the recorded message.

Q. What are some of the things we can do to improve the quality of sound in a room that has marginal acoustics?

A. Set the volume of your amplifier as low as possible, so the sound can still be heard. If you have it too loud, you merely heap echo on echo, and that doesn't help intelligibility. Also, set the tone control toward the treble range. It is the higher frequencies that make live or recorded speech intelligible. The low bass tones are more likely to reverberate and mask speech frequencies.

Q. Is loudspeaker placement important?

A. Yes. Place the loudspeaker where it can be *seen*, and then test the result for naturalness of sound reproduction. If the loudspeaker is placed behind the wall in which the projection screen is mounted or is blocked by some other obstruction, the sound will be muffled. If the loudspeaker is placed in a corner, the bass frequencies may be unrealistically emphasized and the sound will be boomy. Also, speech frequencies travel in straight lines. If people can *see* the loudspeaker, they can hear the higher frequency sounds—the sibilants which make speech intelligible. Also avoid using loudspeakers scattered over a low ceiling. Multiple loudspeakers tend to reinforce some frequencies and cancel others because of phase differences and this will cause frequency distortion of the sound. A good solution is to use high-quality loudspeakers mounted above the heads of the audience to project an audio pattern somewhat like brightness from a lenticular screen. By aiming them toward the back of the room, you can achieve almost equal volumn levels in the front and back row of seats.

Projectors Don't React to Signals

Q. What kind of signal is needed on an audiotape to make an *EKTAGRAPHIC* III or *EKTAGRAPHIC* Slide Projector advance?

A. Actually, projectors don't respond to a signal, even though a recorded signal may be needed to make them advance.

Q. Then to what do the projectors respond?

A. A simple switch closure. It may be a push button—such as the forward button on a *KODAK* EC Remote Control—or it can be a contact in a relay, or a solid-state electronic switch, such as a silicon-controlled rectifier or triac. The contacts also should be capable of switching a maximum surge current of about 2 amperes, though normally it's less than that.

Q. Does that much current mean there's a shock hazard?

A. No, because it's low voltage—about 24 volts— and isolated from the power line. So there's not a shock hazard or requirement for special insulation.

Q. Back to the signal, or cue; don't cues, in fact, exist as signals on the tape that control a sound-slide program?

A. Yes, they do. Most often, a 1000 Hz signal is used for projector advance. And it usually lasts about a ¹/₂ second, or a little less. *But that cue or signal isn't detected by or fed directly to the projector.* Instead, it goes to some kind of synchronizing device that, in turn, makes the contact closure needed to advance the projector. (This point is often misunderstood.)

Q. How does the synchronizing device do this?

A. Usually, the signal is picked up by a playback head on a tape recorder, in much the same way as any other audio signal would be. It's amplified to make it stronger, and then it goes to the switching device. That is the relay or solid-state switch, which actually completes the electrical circuit in the projector, and makes the slides change.

Q. What's an example?

A. Well, the *KODAK* EC Sound-Slide Synchronizer is one such device. It's used to feed a signal to one stereo channel of a tape recorder for recording. Then, on playback, the same signal is detected and amplified in the tape recorder and fed back to the sound synchronizer that turns on a silicon-controlled rectifier (an electronic switch), and advances the slide projector.

Q. But many tape recorders used for sound-slide programs connect directly to the projector. Don't they need a synchronizing device?

A. In such cases, the synchronizer is built into the tape recorder. The detection and amplification both take place in the recorder. While most of the recorders having a built-in synchronizer use an electromechanical relay to close the contacts connected by a cable to the projector and cause a slide change, some use an electronic switch.

Q. What's an example of that kind of arrangement?

A. The *KODAK EKTAGRAPHIC* AudioViewers and *EKTAGRAPHIC* AudioViewer/ Projectors. They have a built-in synchronizer that picks up the cue signals on the tape and activates the slide-change mechanism of the unit. (The AudioViewer has an outlet to route the advance signal to an external projector, if desired.) There are many models of cassette tape recorders made by a number of different manufacturers that operate in the same way and also provide an external connection for a cable going to a projector or dissolve control.

(CONTINUED)

Q. If the synchronizing tones or cues used to advance slides are recorded and played back on tape recorders, why don't we hear the tones?

A. Usually, it's because they aren't fed to a loudspeaker. You could hear them if they were amplified and sent to a loudspeaker.

Q. Why not use a supersonic frequency, so the cues and audio can be on the same tape channel?

A. Theoretically, that's possible. But practically, tape recorders won't record and play back nonaudible frequencies reliably. Besides, recording sounds and cues on separate tape tracks permits changing one, without affecting the other.

Some other synchronizing methods have been used or are used—such as the very low cue frequencies (usually 50 Hz) often found on discs for sound filmstrips, and sometimes on tape recordings.

Other methods have included conducting or reflecting tape or paint applied to the tape, or holes cut in it for mechanical feelers. But now the most popular method for cassette users is the separate track signal, as used with AudioViewer/Projectors and AV cassette players.

Q. Does the *KODAK* EC Sound-Slide Synchronizer work that way?

A. Yes and no. It uses one stereo channel for cue signals, and one channel for audio. (You sacrifice one channel of sound.) It does generate a signal for recording of about 1000 Hz and responds to that signal on playback. The signal placement on the tape is different, however. As with most synchronizing equipment, the sound signal is recorded and played back from one half of the cassette tape, and the cues are recorded and played back on the other half of the tape.

Q. Can a tape made with a stereo recorder, using the *KODAK* EC Sound-Slide Synchronizer, be played back successfully on an AudioViewer/Projector?

A. No, it can't. The two methods of recording and detecting the cues aren't compatible because of the track placement on the tape. (Recordings made with the EC Sound-Slide Synchronizer do not conform to ANSI Standard PH7.4—1975.)

Q. Doesn't the idea of having the audio on half the tape and the cues on the other half waste tape, since you can't turn it over and play it in the other direction; and also time, since it must be rewound?

A. You might look at it that way. But it's a much more reliable method. The cue signals are stronger, since they are wider; there is less signal leakage from the control channel of the tape to the audio channel so you are less likely to hear faint "beeps" from the audio track, and this track arrangement does make the changing of either audio or cues possible (if the tape recorder permits it).

Q. Who determined what all the signals are to be?

A. The most widely recognized authority on cues for cassette tapes is ANSI Standard PH7.4—1975. Its title is *American National Standard for Audio-Visual and Educational Use of Coplanar Magnetic Cartridge, Type CP II (Compact Cassette)*. A copy of this *Standard* can be purchased from the American National Standards Institute, 1430 Broadway, New York, NY 10018.

EFFECTIVELY COLOR-MATCHING SLIDE PROJECTOR LAMPS FOR DISSOLVE AND MULTI-IMAGE PRESENTATIONS

In two-projector dissolve programs, and in most multi-image presentations, the images on the screen are dissolved one into the next or appear side-by-side on one screen or on dual screens. When this occurs, the *color characteristics* of the projected images from two or more *EKTAGRAPHIC* III or *EKTAGRAPHIC* Slide Projectors must be matched. Sometimes color matching is necessary for aesthetic reasons—for example, to avoid the visual discontinuity that will occur if the part of the scene or panorama projected by one projector has a warm tone and another portion of the same scene next to it (projected by another projector) is cold.

Other times, image color matching is important for reasons of audience comprehension. For example, if a doctor is giving a lecture that depends on small but important differences in skin or tissue colors or if a botanist is comparing leaf colors, matched image color quality will obviously be important to full student understanding.

Some Causes of Image Color Differences

Color differences in projected images originate in many ways. Most producers of multi-image presentations realize, for example, that two different film types (for example, *KODACHROME* and *KODAK EKTACHROME* Film) may yield slightly different color renditions of the same scene. Similarly, the same film (even the same emulsion batch) may render colors differently when exposed and processed immediately, versus after the film has been stored for a few months—particularly if the storage conditions are less than satisfactory.

Projection Lenses

Projection lenses also affect color rendition on the screen. Different lenses can yield slightly different colors. For example, if a *KODAK* Projection *EKTAGRAPHIC* FF Lens, 124 mm *f*/2.8, is used in one projector, and a *KODAK* Projection *EKTANAR* C Zoom Lens, 102 to 152 mm *f*/3.5, is used in a similar projector, there may be a slight difference in both image color and brightness.

Heat-Absorbing Glass

The color quality of the heat-absorbing glass in *EKTAGRAPHIC* Slide Projectors may also vary slightly over long periods of production. A projector with a new heat absorber may yield slightly different color on the screen than its 10-year-old "twin" with the original heat absorber. However, the condenser lenses and mirrors in *EKTAGRAPHIC* III and *EKTAGRAPHIC* Slide Projectors have little effect on color.

Voltage Variations

Voltage variations can also affect color rendition. A drop in voltage of 5 percent will usually reduce the color temperature of a lamp about 50 degrees Kelvin. (In other words, the voltage drop makes the color temperature slightly warmer or more yellow.) On the other hand, raising the voltage 5 percent will produce a colder or bluer color balance. Therefore, it is advisable to connect paired projectors to the same electrical circuit when possible—especially if image color matching is critical. With such an arrangement, when one projector lamp changes color slightly, so will the other.

Projection Screens

Projection screens can also affect color balance. While most screens are nominally white (i.e., they reflect all color equally), an old screen may look yellow compared to a new one. In addition, some types of screen surfaces are "colder" or "warmer" than others.

Therefore, it is a good idea to project paired images on the same type of screen (or at least comparable screens) if image color balance is critical.

Projection Lamps

Projection lamps are probably responsible for more color balance variation than any other component in the projection path (with the exception of the colors in the transparencies being projected). Most projection lamps have a filament that produces light of approximately 3200 K color temperature. Some shorter life, high-output lamps tend to produce a higher (bluer or cooler) color temperature; while some long-life, reduced-output lamps yield a lower (warmer or more yellow) color temperature. Conventional tungsten lamps also change color temperature as they age—toward a warmer tone (lower in degrees Kelvin). Tungsten-halogen (halogen-cycle) lamps, however, stay virtually the same in color temperature from the beginning of their useful life to burnout, so long as their voltage is constant. (These lamps are often called "quartz" because they normally have a quartz envelope.) Tungsten-halogen lamps are tungsten lamps and, with the exception of their desirable aging characteristics, they behave like other tungsten lamps—their color temperature varies with voltage and design life.

INTEGRAL REFLECTOR

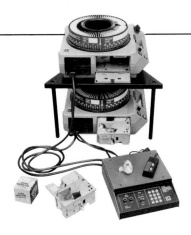

With lamps currently used in many *EKTAGRAPHIC* III and *EKTAGRAPHIC* Slide Projectors, the biggest source of color variation from lamp to lamp is the integral reflector of the lamp. Good examples are the EXR and ELH slide projector lamps. The reflector surfaces in these lamps are formed of exceptionally thin layers of reflecting material that serve as a selective reflector for radiated energy. Ideally, they are manufactured so that all of the visible light generated by the lamp filaments is reflected forward through the projector gate and projection lens, and all of the infrared energy (radiated heat) generated by the lamp filament is transmitted. That is, the infrared radiation would go through the reflector and never reach the film or projector parts in front of the lamp.

In the real world, however, if you look at a lighted EXR, ELH, ENH, or EXW projection lamp, you will see the filament and lamp shining very brightly through the reflector—indicating that not all of the visible light is reflected. Similarly, it is possible to feel—as heat—the energy (visible and infrared) that is reflected toward the gate of the projector. However, the integral reflectors on these lamps do work well enough (by surrounding most of the filament, and capturing and reflecting a great deal of the visible light) so that a 300-watt ELH projection lamp will provide the same projector light output as a 500-watt old-style lamp (even when both are tungsten-halogen lamps).

The obvious advantages offered by the ANSI Code ELH, ENH, and ENG lamps (for *EKTAGRAPHIC* Slide Projectors) and the FHS, EXY, EXR, and EXW lamps (for *EKTAGRAPHIC* III Projectors) include lower power consumption, less total heat generation, reduced fan noise because of lower cooling requirements, and increased film transparency life.

However, with these advantages is the minor disadvantage of somewhat poorer color match from one lamp to another—the result of slight differences in the reflective coatings on the lamps.

Many multi-image producers and projectionists, discovering this fact of life, have resorted to a variety of means for matching the color quality of the projected images. Some have mounted filters over the projection lenses or have inserted a filter into the slide mount with the transparency. Most commonly, they have simply compared the colors that the raw projector light beams (i.e., projector screen illumination with no slide in the gates of the slide projectors, or with just an open-frame mount in each gate) on the screen. Then they have gone through a long, tedious process of randomly changing the lamps until the light beams match in color quality, or have moved projectors around until those projectors showing the most extreme differences in color cover different parts of the screen. (Color differences in projected images are less noticeable when the color extremes are not on the same or adjacent screen areas.)

This process of lamp selection can consume a great deal of time (and can cause burned fingers)—especially if a presentation deadline makes people hurry the process by changing lamps before they have cooled enough to handle. (Of course, the *EKTAGRAPHIC* III Projector lamp module simplifies lamp selection considerably.)

Using an Overhead Projector

Place a group of new projection lamps of the same type (and preferably from the same manufacturer), on the stage of an overhead projector. Turn on the overhead projector and observe the projected images of the lamp reflectors on the screen.

Very often, they will show strong colors—exaggerating the differences in the coating on the reflectors. (Usually there are greater differences in the visible light transmitted than in the light reflected by the lamp reflectors.)

Sort together the lamps that show relatively little difference in color. That is, group the deep greenish lamps together, the blues in another group, the yellowish lamps together, and so on. (Remember that the light they produce in a projector will match much more closely than the light which comes through their reflectors.)

You will find that there will be variation even in lamps with the same manufacturing lot numbers. However, by sorting the lamps into different color groups, you will have supplies of replacement lamps that will provide close color matches when they are used in projectors.

Using a Large Slide Illuminator

It is also possible to use a large slide illuminator to sort the projection lamps. (However, the bright, semicollimated light of the overhead projector stage makes sorting easier.) If an illuminator is used, be sure to pick one with a tungsten light source. (The lamp reflectors may appear to be a different color with a fluorescent light source.)

Keeping Your Lamps Sorted for Multi-Image Presentations

If possible, sort a set of matching projection lamps and replacements for the entire "run" of a multi-image presentation. If it is to be used indefinitely, be sure to have enough matched spares on hand so that, as necessary, additional lamps with the same general color can be added to the spare groups. *Those that do not match are not defective.* They can be set aside for use in other programs or can be used in single-projector shows, or for other noncritical programs. For ordinary single-projector use, or matched with other lamps producing a somewhat similar color, they are satisfactory. The human eye forgives color differences that are not seen simultaneously. In other words, two projection lamps with fairly different color characteristics will produce images that will be remembered as being the same color if the images are seen with a time or location gap between them.

Unfortunately, present technology does not allow lamp manufacturers to produce lamps that have perfectly matching integral dichroic reflectors. Asking them to sort lamps on the basis of color would result in considerable price increases. The best solution, for the present is to sort them.

AVOIDING OR REDUCING KEYSTONED IMAGES

We have all experienced keystoned images at one time or another—screen images that should be rectangular or square but instead are geometrically distorted at the top, bottom, or sides. Keystoning is caused by angling your slide projectors away (up, down, right, or left) from a line perpendicular to the center of your projection screen. Fortunately, this problem can be reduced, if not eliminated. The problem is most serious with multi-image programs, and especially with panoramas when two or more projectors are used to produce a single image.

A variety of projection lenses especially designed to minimize the image distortion caused by keystoning are currently available. Contact the following companies—not Kodak—for additional information. (Specify whether you will be using front projection or rear-screen projection.)

Undistorted image

Keystoned image

• Buhl Optical Company
1009 Beach Ave.
Pittsburgh, PA 15233
Phone (412) 321-0076

• D. O. Industries, Inc.
(*NAVITAR* Lenses)
317 East Chestnut St.
Rochester, New York 14445
Phone (716) 385-4920

• Optical Radiation Corp.
1300 Optical Dr.
Azusa, CA 91702
Phone (213) 969-3344

Single Image vs. Multi-Image

To align images for a single-image program, aim your slide projector so that the center of the projected light beam is at right angles to the center of the image area on the screen. Do the same thing when you are aligning projectors for accurate edge matching and registration for multi-image programs.

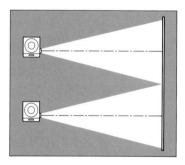

Whenever you project superimposed and dissolve images, position the projectors as closely together as possible.

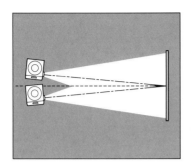

Curved Screens

The projection of multiple images onto a curved screen presents some additional problems. Be certain that each projector is positioned so that the center of its beam is on a radius of the curve. Arrange multiple projectors so that their light beams cross at the center of the screen curvature. Depending on image size and lens focal lengths, the projectors may be either closer to the screen than the crossing point or farther away.

Centering the Beams

To position a projector so that its beam is perpendicular to the screen, hold a small mirror flat against the screen surface in the center of the projected image. Then move the projector until the beam reflected from the mirror is centered on the projector lens.

With most lenticular screens a change in screen angle that causes only slight keystoning can often improve the image overall by rejecting stray light and increasing the image brightness seen by the audience.

Some Views on Registration

Alignment slides are a must-have tool for setting up a multi-image presentation. They are also handy for aligning two-projector dissolve shows. Most audiovisual professionals keep them permanently in the 80th slot of each tray.

Here are a few tricks to remember when using alignment slides.

First, don't put the alignment slides directly into the projector gate manually. Why? It's the outside edge of the gate that determines precise horizontal alignment. If you push the slide down into the gate with your fingers rather than allowing the projector mechanism to do it, the slide probably won't come to rest in the proper position. Put the alignment slide into a tray and let the projector cycle the slide into the gate.

Second, align your images by using two guide lines—one vertical and one horizontal, each going through the center of each slide. You'll split any slight keystoning of the images that exists between the top and bottom and between the left and right edges of the images. (The center portions of the guidelines of two or more superimposed alignment slides will match exactly, but the extreme ends of the guidelines may not, depending upon the degree of keystoning. (If you align along the bottom edge of the image, you'll accumulate keystoning errors at the top.)

Here are some sources for alignment slides.

- Association for
 Multi-Image
 8019 North Himes
 Ave., Suite 401
 Tampa, FL 33614
 Phone (813) 932-1692

- Visual Horizons
 180 Metro Pk.
 Rochester, NY 14623
 Phone (716) 424-5300

- Heindl Mask 'N'
 Mounts
 PO Box 150
 Hancock, VT 05748
 Phone (802) 767-3536

- Wess Plastic
 50 Schmitt Blvd.
 Farmingdale, NY 11735
 Phone (516) 293-8994

- R.M.F. Products, Inc.
 PO Box 413
 1275 Paramount
 Pkwy.
 Batavia, IL 60510
 Phone (312) 879-0020

- Will Szabo Associates,
 Limited
 121 Wellington Ave.
 New Rochelle, NY 10804
 Phone (914) 235-6332

Protecting Your Projectors (and Other Equipment) from the Cold

As you may know, bringing audiovisual equipment hardware or software directly indoors from the cold can create problems. Here are a few ideas for avoiding or solving these problems.

Fighting the AV Cold War

One obvious problem caused by cold is condensation. Just as your cold eyeglasses fog up when you enter a warm building on a cold winter day, so will a cold projector or slide.

Droplets of water on slide film are visually annoying and often can cause permanent spots on the transparency. Water droplets can also cause difficulties with the innards of slide projectors (and other audiovisual equipment). For example, moisture in delicate amplifier circuits can degrade and even destroy performance.

Cold equipment may also run slowly, or not at all. Most audiovisual equipment is designed and lubricated to be used in rooms of average temperature—not for environments as cold as a refrigerator.

Cold film and audiotape may snap instead of flex. So may the belts in your slide projectors. Extreme cold (below −40°F) may cause damage that cannot be cured by warm-up and dry-out. Some capacitors may freeze and split, requiring equipment service.

If you cannot avoid transporting your equipment and materials in the cold, reduce transit time. Put the equipment in your car just before you leave (and place it where the heater can keep it warm).

Use cases or plastic sacks for the equipment. When a cold piece of equipment or film is brought into a warm room (especially with high humidity), leave it in the case or bag. The air inside will have little moisture in it, and the temparature will slowly increase, without condensation, in an hour or so, to a safe unpacking point.

IMPORTANT: Don't ever turn a cold projector on to warm it up. The first few seconds of forced ventilation will coat all of the inside parts with moisture. Irreparable damage may result.

Protecting Your Projectors from Theft

Unfortunately, the magic of AV sometimes includes "disappearing" equipment. Audiovisual hardware must be available to be effective; but too often availability invites wanderlust. The best idea is to keep equipment easy to use but not easy to steal.

Two tie-down points are provided on the bottom of the *EKTAGRAPHIC* III Projector. They can be used to bolt the projector down for security, transportation, or to maintain position on a stand or in a cabinet. Both points accept $^1/_4$ in. x 20 bolts. One is a blind hole toward the front of the cord wrap; it will accept up to $^1/_2$ in. of bolt. The second hole is found by unscrewing the leveling leg from the back corner of the projector. A $^5/_8$- to $1^1/_8$-inch long bolt (measured from the bottom of the projector) can be screwed into it. (A longer one will interfere with removal of the lamp module.)

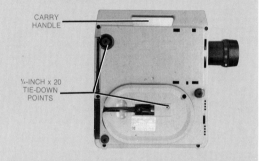

The carry handle can also be used to enhance equipment security. Plastic-covered boat-rigging steel cable, looped through the handle and attached to a stand, eyebolt, or passed through a hole in the table, permits normal adjustment and use of the projector.

Cables or chains with key or combination locks are also available from bicycle dealers.

A metal or plywood cover may be locked over a projector, with holes in the cover providing access for controls and ventilation.

Another antitheft and recovery device is good record keeping—including inventory and loan records, with serial numbers or other means of equipment identification.

When presenting an out-of-town program, investigate local security services for overnight surveillance of your setup. Often the hotel where you are presenting the program can provide security service names and telephone numbers.

USING DOMESTIC MULTI-IMAGE PROGRAMS OVERSEAS—SOME IMPORTANT CONSIDERATIONS

One question that should appear on every multi-image producer's checklist is: "Will this program be used abroad?" If your program is to be used overseas, begin your planning early. If your boss or client says, "Let's ship this program overseas for use next month," allow yourself just a moment of panic. Then check out the following information and proceed.

Many domestic multi-image programs have been used abroad successfully. This section outlines some of the problems you may need to solve when planning to show your presentation abroad. It also offers some suggested solutions to help make your program a success *wherever* it is shown. The information is based upon our experience as a multinational company in putting on audiovisual programs overseas. It also incorporates information provided by many of our customers regarding the problems they have encountered, and how they solved them.

Among the questions we cannot answer, however, are those involving customs clearances required for hardware and software, whether shipment by sea or air is best, whether you must post bonds, hire local people to put on your program, and so on. These questions are best answered by specialists who are familiar with the places where your show will be screened and who regularly ship materials to and from those locations.

General Considerations—Climate, Electrical Power, and Multi-Image Equipment

In many ways, using a multi-image program abroad is not too different from using it in the next town or next state. Of course, you'll have to allow for more time, but other than that, you'll generally run into similar types of situations.

One potential problem is climate. If your program is to be presented where the climate is extremely hot,

cold, dusty, humid, or dry, these adverse conditions can affect your hardware and software. So, if the climatic conditions at your presentation site or along the shipping route are unusual, you may have to make special arrangements for refrigeration or air conditioning just to keep your equipment and materials in good condition or plan on more cleaning and maintenance than is normal. For the most part, audiovisual equipment and materials are "comfortable" where people are comfortable and require special considerations only if *you* need some type of protection against climatic extremes.

Electrical power is one of the first issues raised because many other decisions hinge on it. For example, if 120 V, 60 Hz current is readily available, it may be practical to ship the same equipment you've been using in the U.S. or Canada, plug it in, and turn it on.

But, unfortunately, most of the world differs with the U.S. on the matter of electrical power. For single-phase, ac power (the kind most domestic AV equipment requires), there are more countries that have 220 to 250 Vs than those having the more familiar 110 to 125 Vs, and more that have 50 Hz current, rather than our domestic 60 Hz current.

So, cross your fingers and plug it in anyway? Unfortunately, with few exceptions, that won't work.

(The exceptions include the *EKTAGRAPHIC* Slide Projector, Model B-2AR, discussed earlier on pages 35 and 36. Plug it in, turn it on, and it will work well on either 50 or 60 Hz, and any voltage between 110-130 or 220 to 240. In addition. The *EKTAGRAPHIC* Slide Projector, Models S-AV2030 and S-AV2050, discussed earlier can adapt to almost any electrical power available.)

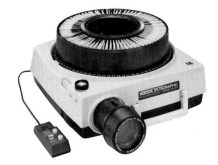

Once you've determined the electrical power that's available, check the equipment you'd like to use and see whether it will work on that current. There are three good places to look—the labels or nameplates on the equipment, the instruction manuals, or the people who know (the dealer from whom you purchased the equipment, or the manufacturer). When you check with people, or the instruction manuals, make certain you have the *exact* name and model of the equipment. Keep in mind that just because one piece of equipment works well on a variety of currents doesn't mean that all of your associated equipment will. So, check them all.

Suppose you find that there's some disagreement—that not *all* of your multi-image equipment will work on the current available where your show is scheduled? There are many options available, and you'll probably have to consider most of them in order to select the best one. The first is to rent or buy equipment that will work, either domestically or in the country where it's to be used. How do you go about that?

A good practice is to check with your contact in the particular foreign country you're visiting. Be certain your contact understands the problems. Just because a person is an electrical engineer doesn't mean that he or she knows about audiovisual equipment and the challenges you're faced with. So look for assurance from someone who *does* understand your questions—perhaps an audiovisual specialist at an overseas office of your company, an audiovisual dealer in that country, or perhaps someone from the educational field who's had audiovisual training in the U.S.

If you plan to rent or borrow multi-image equipment, be sure you know your overall needs as well as the details. It's not enough, for example, to specify that your program uses 1/4-inch audiotape for sound and programmer signals. You must be sure your program is compatible with the programming equipment that's available to rent, and that the control signals can be transferred or reprogrammed using available equipment.

Be certain that the equipment does not impose limitations that your program cannot accept. An important limitation on slide projectors with some multi-image programs overseas is projector-cycling time (briefly discussed in the section on the S-AV2050 Projector on pages 48 and 49). Domestic U.S. and Canadian *EKTAGRAPHIC* Slide Projectors cycle (change slides) about once per second. But 50/60 Hz versions of these same projectors run slower on 50 Hz; they require about 1.2 seconds to change a slide. The *EKTAGRAPHIC* Slide Projector, Model S-AV2030, is even a little slower—it changes slides in about 1.25 seconds on 60 Hz current and about 1.50 seconds on 50 Hz current. (The Model S-AV2050 Projector changes slides about once per second, like U.S.-made projectors.)

Slower slide advancing usually makes little or no difference at all. However, in some fast-paced multi-image shows, failure to allow for slower cycling time can cause synchronization problems. A few sophisticated programmers on the market keep track of when a

projector actually cycles and feed it advance commands until it catches up with the program. But most programmers depend on the projector's reliability and continue on with the program. If the projectors miss a cue they will remain out of sync, which will require reprogramming (editing) the tape track containing the programmer's projector-control signals so that there is more time between fast projector-advance commands. (Normally, the entire show will not have to be reprogrammed—usually only a few short sequences will need it.)

Another "speed" consideration involves slide projector lamps. (Refer to the text boxes on lamp nigrescence on pages 49, 86, 87, and 88.) Kodak slide projectors made in Germany use low-voltage lamps. The filament wire in

these lamps is shorter and heavier than the filament in a 120 V lamp of the same wattage. More time is required for the 24 V lamp to come up to full brightness when turned on; plus the lamp takes longer to fade out when it's turned off. For basic projection setups, this difference is of little or no concern. But if your multi-image program includes animation and flashing effects, then the difference can be considerable. If you're using 120 V lamps, a slide projector can be flashed four to six times per second; but with 24 V lamps, a practical limit is two or three times. (Rapidly flashed low-voltage lamps will neither reach full brilliance nor dim completely.)

Slide Trays

Slide trays may also be an important consideration in using AV programs overseas. Kodak projectors made in Germany will not accept U.S.- and Canadian-made 140 slide trays.

This is not usually a problem, however, since most producers use 80-slide trays for maximum reliability. But even the 80-slide trays can cause problems with a program to be used abroad. If U.S. and Canadian 80-slide trays are used on Kodak projectors made in Germany, it's important that they have the metal latch in the center of the slide tray—not the small, plastic latch. (Both the older as well as the current trays sold in the U.S. and Canada have the proper metal latch.)

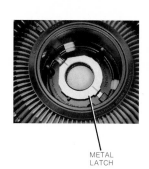

METAL LATCH

Associated AV Equipment

When you're considering if available multi-image equipment can be used abroad, it's also necessary to determine whether your programmer, tape recorder, projector, and other AV equipment will match the power available.

Much the same may be true for tape recorders. Some tape recorders will work satisfactorily on either 50 or 60 Hz, 120 or 140 V; other recorders will not. So they may require special adapters for use with 50 Hz current, and perhaps transformers to permit use at high voltage.

It's often possible to use domestic equipment abroad on 220- to 250-V current if it is connected to a step-down transformer. However, a transformer will change only the voltage, not the frequency of the electrical power. And if you use a transformer, be sure it has enough capacity to supply the current required by your equipment. The transformer must normally operate on 50 Hz current, which usually means it will also operate without overheating on 60 Hz current.

If more than one projector is to be operated simultaneously, *multiple* transformers should be used, or a single transformer with enough output can be used to handle the total wattage load of the projectors. *EKTAGRAPHIC* Slide Projectors require power equal to the lamp wattage (i.e., 300 W for EXR or ELH-type lamps) plus 50 W for the mechanism motor.

An *EKTAGRAPHIC* Slide Projector with a 300 W lamp requires about 400 W at 110 to 125 volts. Two projectors will require twice as much power if both are operated at the same time. A tape recorder will normally require only 50 to 100 W, and programming equipment may require very little wattage. The safest procedure is to read the labels on the equipment or check the instructions. (Labels for dissolve controls may include power requirements for the projectors as well.)

Sometimes power is stated in watts, sometimes in volt-amperes (VA), and sometimes in amperes at a stated voltage. Watts or volt-amperes are determined by multiplying volts times amperes (V x A). Thus, a projector requiring 3.33 A at 120 V will consume 3.33 x 120 (or 400 W). The same projector at 240 V will still consume 400 W (or 400 VA) but will require only 1.67 A.

An electrician can easily translate power requirements for you, from one voltage to another. Knowing about these requirements is important in specifying what will be needed for your program.

What if a transformer is not sufficient; that is, if your equipment will not work on 50 Hz current, and only 50 Hz current power is available? There are some possibilities for making your equipment work, although, from a practical point of view, it's often easier to rent or borrow suitable equipment rather than try to convert power from 50 Hz to 60 Hz.

A rotary converter may be used to provide 60 Hz (at 110 to 125 V, if required) from 50 Hz current. Such a converter is essentially an electric motor that drives a generator to produce the power required. It's heavy, large, and rather expensive in the sizes normally needed for a multi-image program. However, if it's available for rent or loan, you'll find it will usually suit your needs.

Another possibility is a gasoline (or other type) generator. Some of the portable generators readily available in the U.S. will provide enough 110- to 125-V, 60 Hz power to operate several projectors, usually being driven by a single-cylinder gasoline engine. Other units are larger and can power even more equipment. Sometimes generators can be mounted in a truck or similar vehicle (powered by the truck engine) and provide enough 110- to 125-V, 60 Hz power to supply four to six slide projectors with 300 W lamps, plus the programming equipment and tape recorder.

Often, inverters are used to provide 110- to 125-V, 60 Hz current from 12-volt batteries; but usually they cannot be used for AV equipment and are limited to 100- or 200-watt output. Those with greater output cause a heavy battery drain; and most inverters are not recommended for use with the induction motors and transformers present in audiovisual equipment because they do not provide the required power waveform.

Once you've determined the types of audiovisual equipment that can be used overseas, you may still have some matching-up problems to resolve.

One fairly frequent problem is simply the mechanical connection of equipment to other equipment, and to the power source. Synchronizing equipment available outside the U.S. and Canada, for example, will often have a plug that connects to a slide projector or dissolve control, but it won't be the familiar five- or seven-pin connector used with domestic *EKTAGRAPHIC* and *CAROUSEL* Slide Projectors. Instead, it's likely to be a six-pin connector with one pin in the middle and five more arranged around it over a 240-degree radius, or perhaps a large, flat 12-pin connector. In any case, either using adapters or removing connectors and substituting others may be required.

In some countries, regulations are very strict regarding who can and cannot make changes to AV equipment wiring or electrical outlets. So, it's a good idea to make arrangements in advance with your local contact to be certain that you'll be able to have your equipment set up and ready to use, without infringing upon local electrical or fire regulations.

Another consideration in taking your multi-image program abroad is spare parts, tools, backup equipment, and software. Most users of multi-image programs in the U.S. know that they should have on hand spare lamps, one or more spare projectors, extra program tapes, and so on. The requirements for overseas use are the same, only more so.

For example, if you are using slide projectors with ELH lamps in the U.S., you may realize it will be difficult to find a store open at midnight where you can

purchase a lamp. But abroad, it's possible you may not be able to find one within 100 miles—even in the middle of a business day. This is true even in countries with a Kodak installation, and perhaps with many dealers in Kodak audiovisual products. U.S. and Canadian *EKTAGRAPHIC* Slide Projectors are not used very extensively abroad, and ELH lamps (or, for that matter, other AV accessories) are not readily accessible. We believe you'll find that the local dealer in Kodak products will be very sympathetic and as helpful as possible; but it still may take a week or more to obtain an ELH lamp. (And that's probably also true if you order from the local representative of the lamp manufacturer.) And it's true for most programming equipment and other hardware that's made in the U.S. and Canada but not commonly used overseas.

So how do you decide what *will* be needed? It's primarily a matter of common sense. If your program is a one-time show, it's unlikely that you will need a large supply of spare lamps, cords, tapes, or other hard- and software items. On the other hand, if your show is going to run in a trade fair 12 hours a day for a week, then you'd better take along all the spare lamps and other paraphernalia you believe you might possibly need. That will include a spare projector or so, extra slides and other program materials, instruction and service manuals for your equipment, and tools. And remember, most U.S. equipment is not metric; removing a ¼-inch hex nut with anything other than a ¼-inch hex-nut driver can be a problem.

Getting Around the Language "Barrier"

In addition to having the typical AV equipment, accessories, and tools on hand, it's a good idea to carry along a dictionary with technical terms, printed in the local language (or a language that's widely spoken and read). Communication in technical areas dealing with multi-image projection and sound equipment can be difficult. It's particularly true if your local contact is not well versed in audiovisual equipment and techniques. A translator may be able to help with your day-to-day living needs; but he or she may be at a loss if you start talking about requirements such as fuses, resistors, etc.

Fortunately for people living in the U.S. and most of Canada, English is the most widely understood language in the world today. Often, communication with simple English and a bit of sign language is quite successful in most countries, and visuals, of course, are also universal. But if you're taking your show abroad, you may still want to consider whether the narration for your sound track should be translated into the local language. This requirement may introduce further problems— particularly these two:

First, most languages have endings and compulsory modifiers that are not normally used in English. It's not always easy to do a 1:1 translation in the same length of time. So your narration, if lengthy, may require some trimming in order to fit the timing of your programming, music, sound effects, and so on.

Second, it may not be enough to have a good, scholarly translation and rerecording made into a different language. The classical language may be no more understandable than English for people who speak a local dialect.

That's where you can, again, rely on your local contact to make sure that any translation will be properly understood and convey the right message. You may even find it's better to leave the English (or French, or German, or whatever) as is—and project white-letter subtitles, superimposed on or near the multi-image screen.

A Final Note

The main requirements for successful use of your multi-image program in another country are common sense, time, and help. Your own organization or contacts at the place where the program will be presented can give you invaluable advice. And with proper planning, the universality of your multi-image program as an effective means of communication with clients and business associates abroad will continue to provide a successful and rewarding experience unattainable with other media.

PROJECTION LAMPS AND LENSES

Lamps

The projection lamp supplied with most current *EKTAGRAPHIC* III, *EKTAGRAPHIC*, and S-AV Slide Projectors provides light output that is satisfactory for most projection situations. However, an unusually large screen image or the presence of poorly controlled ambient light may suggest that you change to a projection lamp with greater light output.

On the other hand, there are situations in which a lamp with lower-than-normal light output may be needed. A very short projection distance (such as you would find in a study carrel), or use of the projector in a telecine chain, are two conditions where a lower projection lamp output will be needed. Following a discussion of general guidelines for projection lamps, we will explore in this section some ways to modify the light output of your projector. (Most of the information below pertains to 82 V and 120 V lamps used in U.S. and Canadian-made projectors. Somewhat different values are encountered with the 24 V lamp used in German-made *KODAK* S-AV Projectors.)

Lamp Life and Light Output

The life rating of a tungsten lamp is an average figure—some lamps will last much longer than others when used at the recommended voltage. For extremely important presentations, we suggest that you replace lamps at the end of their rated life or even before to minimize inconvenient (midprogram) burnouts. Lamps not yet "used up" can be saved for informal situations such as editing and previewing.

NOTE: If *EKTAGRAPHIC* III Projectors are being used, we recommend keeping spare lamp modules close to the projectors so that a burned-out lamp can be changed quickly.

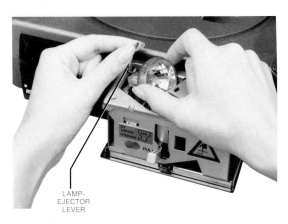

LAMP-
EJECTOR
LEVER

If you can accept a reduction in light output, lamp life can be extended considerably by operating your projector in the lower portion of its rated voltage range, and also by using the LOW lamp setting on the projector.

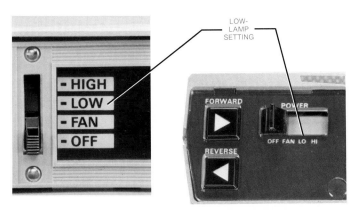

With a properly adjusted projector and adequate ventilation, the life of lamps rated at either 120 or 82 V will be increased about two times when operated on 115 V current and about three times at 110 V. And if your projector has a LOW-HIGH lamp-selector switch, life expectancy of these lamps will be approximately *tripled* if you keep the switch at the LOW setting.

If voltage is in question, it should be checked with a voltmeter at the ac outlet to which the slide projector will be connected. Be sure that you turn on both the projector and its lamp-selector switch during the voltage check.

CAUTION: Voltages greater or less than those recommended can cause overheating and erratic operation, and may also result in costly damage to your projector.

Evaluating Lumen Output

The following tables on page 84 show the lumen output of current *EKTAGRAPHIC* III, *EKTAGRAPHIC,* and *EKTAGRAPHIC* S-AV Slide Projectors based on a number of conditions, including type of projection lamp, brightness setting, lens focal length, and slide aperture. As you can see, a variety of different combinations may be chosen to fit your individual needs.

The figures in the two tables are averages for projectors and lamps selected at random; an individual measurement can, of course, vary from the average. All lamps were operated at their rated voltages, and all lenses were *KODAK* Projection Lenses. Procedures were based on recommendations of the American National Standards Institute. (The American National Standards Institute (ANSI, 1430 Broadway, New York, NY 10036, publishes—and sells copies of—accepted national standards for a wide range of industries and products.)

Brightness figures for German-made *KODAK* S-AV Slide Projectors appear in the bottom table. They were measured at a line voltage of 220 V, with the projector's voltage selector switches set at 220/230. At a line voltage of 230 V, these figures should be multiplied by a factor of 1.13. If line voltage is 110 V to 115 V, then the voltage-selector switch should be set at 110; if line voltage is 115 V through 135 V, the switch setting should be 130 V because these settings at these line voltages will provide the required voltages for the projector remote-control circuits and motor. However, within these line voltage ranges these settings may not produce optimum lamp voltage in the projector, and lumen output may vary approximately 10 percent. These lumen figures also assume that the recommended condenser lens is used with each projection lens, and the lamp and mirror are adjusted according to instructions in the projector manual.

U.S. and Canadian *EKTAGRAPHIC* Ⅲ and *EKTAGRAPHIC* Slide Projectors

Lamp and *KODAK* Projectors	Mask Size (in mm)	65 mm (2½″) f/3.5	78 mm (3″) f/3.5	102 mm (4″) f/2.8	124 mm (5″) f/2.8	178 mm (7″) f/3.5	Zoom 100-150 mm (4-6″) f/3.5 100 mm	Zoom 100-150 mm (4-6″) f/3.5 150 mm
		Lumen Output						
EXW lamp (15 hrs)		635	780	1,160	1,170	895	830	740
EXR lamp (35 hrs)	22.9x34.2	545	670	1,000	1,070	770	715	635
FHS lamp (70 hrs)	(135)	430	535	800	800	620	565	505
EXY lamp (200 hrs)		340	420	630	630	490	445	400
in *EKTAGRAPHIC* Ⅲ Projectors using 82-volt lamps.								
ELH lamp in *EKTAGRAPHIC* Projectors using 120-volt,300-watt lamps.*	15.9x22.9 (135-half frame)	263	312	457	489	371	275	263
	15.8x12.0 (110)	161	180	237	239	202	165	162
	26.5x26.5 (126)	353	459	710	774	653	551	527

Figures represent HIGH position on projectors equipped with HIGH and LOW brightness settings. The LOW setting reduces light output approximately 30%.

*ENH long-life output is approximately 65% of ELH lamp output. ENG high-brightness lamp output is approximately 130% of ELH lamp output.

KODAK EKTAGRAPHIC S-AV Slide Projectors*

Lens	Full Power Lamp-Switch Setting† 24 x 36 mm Mask	Full Power Lamp-Switch Setting† 40 x 40 mm Mask	Economy Lamp-Switch Setting 24 x 36 mm Mask	Economy Lamp-Switch Setting 40 x 40 mm Mask
	Lumen Output			
RETINAR				
35 mm f/2.8	755	940	555	690
60 mm f/2.8	730	910	540	670
90 mm f/2.5	815	1,015	600	745
150 mm f/3.5	640	905	475	665
180 mm f/3.5	620	910	455	670
VARIO-RETINAR				
Zoom f/3.5				
70 mm	715	960	525	705
120 mm	575	795	420	580

*EHJ lamp in *KODAK EKTAGRAPHIC* Slide Projector, Models S-AV2030 and S-AV2050.
†Model S-AV2050 Projector has only a single lamp setting that is equivalent to ''full power'' setting on Model S-AV2030.

Variations in Light Output

The following tables illustrate how a slight fluctuation in lamp-socket voltage will change both the average rated lamp life as well as the relative-brightness value of a projection lamp. Average lamp life is shown in hours, and brightness in percentage.

Most tungsten lamps tend to diminish in brightness and their color temperature changes throughout their useful lives. However, the tungsten-halogen ANSI Code ELH lamp (for *EKTAGRAPHIC* Slide Projectors) and the EXR lamp (for *EKTAGRAPHIC* III Projectors) retain almost full brightness and color temperature throughout their lives.

The Model E-2 and AF-2K Projectors do not have a LOW-HIGH selector switch. To extend lamp life, the lamp used in these projectors operates at the equivalent of a LOW setting on Models B-2, B-2AR, AF-1, and AF-2.

EXCEPTION: When you connect the Model E-2 Projector to a dissolve control (such as *the KODAK EKTAGRAPHIC* Programmable Dissolve Control, Model 2), the lamp always operates at high brightness.

For the E-2 and AF-2K Projectors, use the values indicated for LOW. Lamp-life figures are *averages* and assume proper ventilation with normal ambient temperatures. Restricted ventilation and/or higher-than-normal ambient temperatures can reduce lamp life considerably.

Lamp Data for *EKTAGRAPHIC* Slide Projector, Models E-2, B-2, B-2AR, AF-1, AF-2, and AF-2K

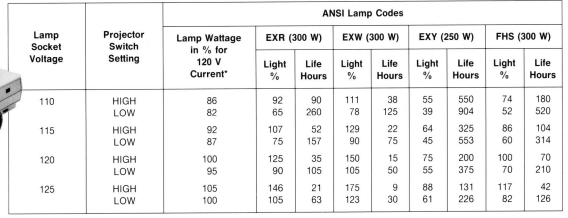

Lamp Socket Voltage	Projector Switch Setting	Lamp Wattage in % for 120 V Current*	ANSI Lamp Codes					
			ELH (300 W)		ENG (300 W)		ENH (250 W)	
			Light %	Life Hours	Light %	Life Hours	Light %	Life Hours
110	HIGH	86	74	90	91	38	42	440
	LOW	82*	52	260	67	125	37	800
115	HIGH	92	86	52	112	22	56	260
	LOW	87*	60	157	77	75	43	490
120	HIGH	100	100	35	130	15	65	175
	LOW	95*	70	105	90	50	50	330
125	HIGH	105	117	21	152	9	76	105
	LOW	100	82	63	105	30	58	200

*Wattage for lamp plus dropping resistor.

Lamp Data for *EKTAGRAPHIC* III Projector, Models E, ES, B, A, AS, and AT

Lamp Socket Voltage	Projector Switch Setting	Lamp Wattage in % for 120 V Current*	ANSI Lamp Codes							
			EXR (300 W)		EXW (300 W)		EXY (250 W)		FHS (300 W)	
			Light %	Life Hours	Light %	Life Hours	Light %	Life Hours	Light %	Life Hours
110	HIGH	86	92	90	111	38	55	550	74	180
	LOW	82	65	260	78	125	39	904	52	520
115	HIGH	92	107	52	129	22	64	325	86	104
	LOW	87	75	157	90	75	45	553	60	314
120	HIGH	100	125	35	150	15	75	200	100	70
	LOW	95	90	105	105	50	55	375	70	210
125	HIGH	105	146	21	175	9	88	131	117	42
	LOW	100	105	63	123	30	61	226	82	126

*Wattage for lamp plus dropping resistor.

Some Questions and Answers About Lamp Decay (Nigrescence) and Shutter Closure Times in *KODAK EKTAGRAPHIC* III Projectors

Q. What's so special about the EXR, EXW, and other 82 V tungsten-halogen incandescent projection lamps used with *EKTAGRAPHIC* III Projectors?

A. The new tungsten-halogen lamp is similar in general concept to the older ELH and other integral-reflector tungsten-halogen lamps used in *EKTAGRAPHIC* Slide Projectors. However, it is smaller in diameter and has round mounting pins. It provides more illumination and greater efficiency (lumens per watt). The 82 V filament is made of heavier wire, which means the filament is more rugged than a line voltage filament of the same wattage.

Q. Why did you decide to use the 82 V lamps?

A. Here's a brief review of lamp operation: If a lamp is operated on 120 V AC (RMS), it will burn at the same brightness as if operated on 120 V direct current. The actual voltage will vary from zero to about 120 V twice during each alternating current cycle. If a diode (rectifier) is inserted in series with the lamp across 120 V, the lamp will burn with the same brightness as if it were operated on 82 V AC (RMS) or 82 V direct current.

Thus, the 82 V lamp can be powered by a transformer or by connecting it in series with a diode across 120 V AC. Kodak has chosen to use the transformer (motorformer) method of powering the lamps for technical reasons. An important reason is that if the lamp is transformer-powered, it can be controlled by solid-state dimmer circuits such as those used in dissolve controls, thus making the new projectors compatible with the circuitry of existing dissolve controls.

Q. Any other reasons for using these lamps?

A. Yes. The 82 V lamps combine the advantages of 120 V lamps and low-voltage lamps. These advantages include compactness, more rugged filaments, and a dichroic reflector that allows most of the infrared radiation to escape through the back and reflects most of the visible light out the front.

Q. Does the light produced by 82 V lamps (such as the EXR lamp) decay (die down) at a slower rate (when the lamp is quickly turned off, such as by a dissolve control) than the light from the lamps used in *EKTAGRAPHIC* Slide Projectors (such as the ELH lamp), and thus affect the "movement" of screen images in multi-image presentations?

A. First, the new lamps do decay more slowly. (We will discuss why in a moment.) Second, unexpected visual results can occasionally occur in some multi-image programs. These unexpected results are related to the timing between projector shutter release and lamp "turnoff." The result is "shutter chop"—an abrupt cut-off of the projector light beam. It sometimes happens when older "canned" shows (that were programmed using *EKTAGRAPHIC* Slide Projectors with ELH or ENG lamps) are used on the newer *EKTAGRAPHIC* III Projectors (using EXR or EXW lamps).

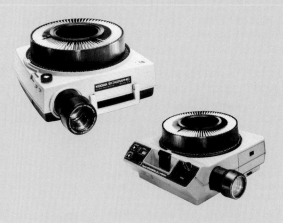

Audiovisual professionals who use *EKTAGRAPHIC* III Projectors for their multi-image presentations may want to reprogram certain portions of these older presentations. One important programming consideration is the length of time that exists between lamp "turn-off" on one projector and the advance of the next projector. (Refer to the lamp-decay forward-circuit recommendations that appear in the middle of column 1 on page 88.) However, we do not believe that most presenters of multi-image programs are going to encounter disappointing results with the 82 V tungsten-halogen incandescent lamps in *EKTAGRAPHIC* III Projectors. The new lamps are a significant advance over older types, and provide users important benefits.

Q. What are those benefits?

A. Because of the 82 V lamps, the *EKTAGRAPHIC* III Projectors provide the same light output with about twice the lamp life of the older lamps, or more light with the same lamp life. The new lamps are smaller, yet screen illumination is much more even—a major advantage in multi-image panoramas. At the same time, the new lamps are more rugged. (The filament in the 82 V lamp is larger in diameter and thus less likely to fail when hot.)

(CONTINUED)

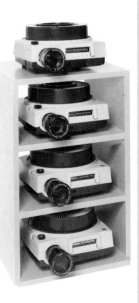

Q. But why are the new lamps slower?

A. A low voltage (82 V) incandescent lamp takes a little longer to reach full brightness when switched on, and requires more time to cool below incandescence than a high voltage (120-V) lamp of the same wattage. (Because the filament in the 82 V lamp is larger in diameter, more time is required to heat it up and cool it down.) This is very evident in comparing projectors having 120 and 24 V lamps. However, there is relatively little difference between 120 and 82 V lamps.

Q. How long does it take for the lamps to become incandescent?

A. When ELH (120 V lamps used in *EKTAGRAPHIC* Slide Projectors) and EXR, EXW, or FHS lamps (the 82 V lamps used in *EKTAGRAPHIC* III Projectors) are turned on, they reach half brightness in about $^1/_{30}$ second, and $^3/_4$ brightness in about $^1/_{15}$ second. But these times are decreased if a "trickle voltage" across the lamp is provided by the dissolve control equipment. Not all programming equipment provides this lamp trickle voltage.

Q. How long does it take for the lamps to cool?

A. Incandescent lamps require more time to "die down" than to turn on. It may take a projection lamp filament $^1/_2$ second or more to cool to the point where you see no image on the screen. It depends on filament thickness and temperature, how tightly the filament is coiled, how large the image is, and so on.

Q. How different are the decay (nigrescence) rates for the old and new lamps?

A. Older ELH (120 V) lamps die down a bit faster than the new FHS, EXR, and EXW (82 V) lamps. The difference is between 15 and 20 percent.

Q. Isn't that a large amount?

A. Not really. When an ELH lamp is turned off in a projector, it takes about 150 milliseconds to cool to the point where the light it makes falls to 75 percent. The new 82 V lamps take about 175 milliseconds. The difference is 25 milliseconds—only $^1/_{40}$ second. The time to cool to half-light output is about 325 milliseconds for the ELH, and about 375 milliseconds for the FHS and EXR—a difference of about $^1/_{20}$ second. The light output drops to the quarter point in about 525 and 625 milliseconds, respectively, or a difference of $^1/_{10}$ second.

Q. What will be the effect on the multi-image projector user?

A. In practical terms, it makes no difference for dissolve rates of a second or more, or a single fast cut. It will mean a slight difference for a series of fast cuts in animation or flashing. The 15 to 20 percent longer decay rate with the 82 V lamp means less "picket fence" or strobe effect.

Q. What is that?

A. The transition from one image to the next is a little smoother. Those who prefer a harder animation or flashing effect may want to flash the new lamps at a 20-percent slower rate— perhaps four times each second instead of five.

Q. Is there a way to test to see if the new lamps will affect a presentation in an undesirable manner?

A. Yes. The most direct way is to run through a program on *EKTAGRAPHIC* Slide Projectors (such as the Model E-2), and then run the same program on *EKTAGRAPHIC* III Projectors (such as the Model III E). Few, if any, people will detect any significant difference. In fact, most programs will look better when run on the new *EKTAGRAPHIC* III Projectors because of increased illumination and uniformity of brightness from corner to corner of the projected image.

Q. What chops off the light so quickly when a slide is advanced?

A. The normal closure of the shutter in the projector, rather than a slower lamp fade-out caused by a dissolve control or turning the lamp off.

Q. How fast does the shutter close?

A. From the start of closure, the *EKTAGRAPHIC* III Projector takes 40 to 45 milliseconds; the *EKTAGRAPHIC* Slide Projector takes about 30 to 35 milliseconds.

Q. Isn't the chopping effect different in the *EKTAGRAPHIC* III Projectors?

A. The timing is slightly different. The shutter in the *EKTAGRAPHIC* III Projector starts to close at 40 to 60 milliseconds after the change cycle is started by a contact closure, such as pushing a forward button. In earlier *EKTAGRAPHIC* Slide Projectors, the shutter usually doesn't start to close until about 70 to 160 milliseconds after contact closure. (These are actual measurements of a variety of *EKTAGRAPHIC* Slide Projectors.)

Q. What does that mean to the user?

A. Usually, nothing. But it may affect a multi-image program that has fast cuts and rapid slide changes, precise synchronization of sound and

(CONTINUED)

image, or panoramas produced by two or more projectors.

It can also make a difference if you want to be sure the image fades out completely, rather than having it cut quickly by the shutter. If you want a fade-out, you should wait until the lamp has died before triggering a slide change. That is true of older models, as well as the *EKTAGRAPHIC* III Projector.

The earlier shutter closure on the *EKTAGRAPHIC* III Projector makes a difference when the lamp is turned off at the same time the forward contact is closed. If you cycle and turn the lamp off at the same time on either the *EKTAGRAPHIC* Slide Projector or *EKTAGRAPHIC* III Projector, you will see the shutter cut into the light beam ("shutter chop").

Q. Is that because of the slower decay or "nigrescence" time for the new 82 V lamp?

A. It is partially due to lamp turn-off time and partially due to when the shutter closes. (It is not only because the shutter closes sooner.) If you want a lamp decay fade-out when using *EKTAGRAPHIC* Slide Projectors with the long dimension of the slide in the horizontal position, it's best to allow at least 630 milliseconds between the time you turn the lamp off and the time the forward circuit is closed.

When using *EKTAGRAPHIC* III Projectors, allow 760 milliseconds between lamp turn-off time and forward-circuit closure. Allow 20 milliseconds *more* time for each type of projector when using the long dimension of the slide in the vertical position (650 milliseconds for *EKTAGRAPHIC* Slide Projectors and 780 milliseconds for *EKTAGRAPHIC* III Projectors).

Q. Why was the shutter closure made earlier in the *EKTAGRAPHIC* III Projectors?

A. To give consistent performance. There is usually no need to worry about a "fast" or "slow" *EKTAGRAPHIC* III Projector, even with multi-image panoramas. (This consistency is also part of the more reliable reverse.) A quick pulse to reverse cycle will be more reliable with an *EKTAGRAPHIC* III Projector. To get this added reliability, the shutter must start earlier.

Q. Any other advantages?

A. Yes. The consistent time interval from the initiation of the cycle to shutter closing, and the improved image appearance provided by the *EKTAGRAPHIC* III Projectors make it easier to reliably synchronize image "fade-on" or "fade-off" with sound effects and narration.

Also, in multiple-projector shows, you will be able to show more slides per second for more lifelike effects using the *EKTAGRAPHIC* III Projector than with the *EKTAGRAPHIC* Slide Projector.

There is also no longer the need to alter the timing of the shutter to get early "commit" time or to correct for wear that takes place in long-life projector operation. The timing will not change in an *EKTAGRAPHIC* III Projector. The shutter is closed for approximately 80 percent of total cycle time on *EKTAGRAPHIC* III Projectors versus 70 percent on *EKTAGRAPHIC* Slide Projectors.

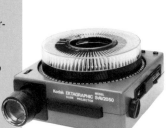

Q. What about other *EKTAGRAPHIC* Slide Projectors? For example, what are the differences, if any, in the speed and brightness of projection lamps used in the Models AF-2K and B-2AR compared to Models S-AV2050 and S-AV2030?

A. Although there are a few minor differences, depending on projection lenses and slide apertures, Models S-AV2050 and S-AV2030 have about the same light output as Models AF-2K and B-2AR. The Model S-AV2030 will provide either high (24 V) light output with a 50-hour-rated lamp life, or a low (22 V) light output with a 200-hour-rated lamp life.

The Model S-AV2050 has only a single lamp setting—equivalent to *high* output on the Model S-AV2030. The 250 W, 24 V EHJ-type lamp does not have a reflector, base, or prepositioned filament, so when a lamp is replaced, the filament position should be checked and horizontal and vertical adjustments made at the first opportunity.

In addition, the filament wire in the EHJ lamp is shorter and heavier than the filament in the 120 V lamp (i.e., ELH type) used in Models AF-2K and B-2AR.

Therefore, it takes more time for the 24 V lamp to reach full brightness when turned on and more time to dim when turned off. For basic projection setups, this difference is of no concern; but if you are projecting a multi-image program with animation and flashing effects, then the difference can be an important consideration.

Increasing Image Brightness

The efficient optical systems of *EKTAGRAPHIC* III and *EKTAGRAPHIC* Slide Projectors provide bright images; however, poorly controlled ambient light and/or very large projected images can require even greater image brightness. And to be noticeable to the eye (brightness changes are seen logarithmically), image brightness must be increased by about 30 percent. Such an increase in apparent brightness can be achieved if you apply one, or a combination, of the following suggestions.

Projection Screens

You can choose from a variety of screen characteristics to obtain a brighter image. For example, if a high-gain screen permits a large enough image and is properly aligned, the image will be two to three times as bright over the normal viewing area as an image of the same size on a regular matte, beaded, or lenticular screen.

When stray light levels are high, locating the screen so that it is *seen against* the darkest part of the room may help. A high-gain screen, however, will produce the best results when placed *opposite* the darkest area. In that position, it can reject most of the nonimage light and provide a satisfactorily bright image.

It may also be possible to increase image brightness and obtain better rejection of stray light by using a lenticular screen. Most lenticular screens are highly directional, and your projector and screen must be placed and aimed very carefully to take advantage of the special screen characteristics.

Reduced Image Size

With no change in the projector light output, image brightness increases conversely with image area. An image 5 feet (1.5 metres) high will be approximately twice as bright as an image 7 feet (2.1 metres) high and four times as bright as an image 10 feet (3 metres) high.

Psychological and Physiological Factors

To make images *appear* brighter, you can improve the image contrast and color saturation. Control the room light and the reflectance of objects so that no light in the screen area is brighter than the image highlight areas. Reduce (or eliminate, if possible) stray light falling on the screen. Finally, when you are involved with rear projection, substitute a *dark* projection screen for a light one.

Type of Slides

If you can be involved in the planning of the photography, remember that high-contrast and high-key transparencies provide greater highlight and overall brightness. A *KODACHROME* or *EKTACHROME* Film transparency that has been underexposed one-half stop yields a screen image only about one-half as bright as one that was fully exposed. If the subject matter can tolerate exposure one-half stop greater than normal, the resulting screen image will be approximately 100 percent brighter than from a transparency that was exposed normally. Projection from a slide mounted in glass will be about 15 percent less bright than the same transparency in an open-frame mount.

Lens Choice

EKTAGRAPHIC Slide Projectors use light most efficiently when they are equipped with a lens of 4- to 7-inch (102- to 178-mm) focal length, and $f/3.5$ (or greater) aperture. Lenses of shorter or longer focal lengths almost always reduce light output. A lens having an aperture larger than $f/3.5$ may be used, but usually will not increase light output as much as f/number calculations would indicate. For example, the *KODAK* Projection *EKTAGRAPHIC* FF Lens, 124 mm $f/2.8$, transmits 27 percent more light than the former *KODAK* Projection *EKTANAR* Lens, 5-inch $f/3.5$ (no longer manufactured). The increase predicted on the basis of aperture alone would be about 55 percent.

Elimination of Dirt in the Projection System

Dirt, dust, and smudges in the projection system (on lamp envelope, condensers, heat absorber, projection lens, any mirrors involved, or screen) can reduce brightness by 50 percent or more. Clean these surfaces carefully, but clean the lenses *only* when examination indicates the need. Too frequent cleaning of optical surfaces can cause even worse problems by producing microscopic scratches that can degrade image sharpness as well as brightness.

Each front- or rear-surface mirror, even if in optimum condition, reduces brightness about 13 percent. However, if a mirror permits use of a 4- to 7-inch (102- to 178 mm) lens instead of a very short focal-length lens, the loss of light from the mirror may be more than offset the gain from the longer lens.

Light Source

Tungsten-halogen lamps normally supplied with currently manufactured *EKTAGRAPHIC* Slide Projectors are rated at 300 W or less. Do *not* equip any of these projectors with a lamp that consumes 500, 750, 1000, or 1200 W; increase in light output will not be substantial and the projector and slides will be liable to damage. Note that we said "consumes 750," etc; wattage measures the quantity of electricity consumed by a lamp, not the amount of light it provides.

Suppliers other than Eastman Kodak Company modify *KODAK* Slide Projectors to accept "nonstandard" lamps, external lamps, special lenses, etc. These modifications are not serviced by Kodak. Any inquiries about such equipment should be directed to the supplier, *not* to Kodak.

Lamp Voltage

The use of voltage lower than that for which the projector and lamp are rated means reduced light output. For example, a 120 V lamp provides one-third less light at 110 V than at 120 V. Voltages outside the range indicated on the nameplate or in the instruction manual for the projector can also cause the motor to operate erratically, to overheat, or to even burn out.

Low voltage at the lamp socket may result from inadequate supply at the electrical outlet or from long, lightweight, or faulty extension cords. Use a voltmeter at the outlet and at the projector position to determine whether voltage is low and where to apply any needed remedy.

Frequently, it is practical to bring voltage up to par by using a variable autotransformer with a minimum rating of 3.3 A for projectors with 300 W lamps and a 0 to 140 V adjustment range. Voltage should be determined by meter, not by transformer-control calibration (it asumes the existence of normal line voltage). The projector lamp should be operating at high brightness, and the voltage range for which the projector is rated should not be exceeded. Suitable transformers are obtainable from electrical and electronic suppliers; manufacturers include such companies as General Electric, Standard Electronics, Superior Electric, and General Radio (Variac).

Image, Image on the Wall, What's the Best Paint of Them All?

Here's a popular question:

"What's the best kind of paint for a projection surface such as a wall?" This question presupposes that you've chosen to project on a matte surface and are willing to forego using a commercial screen.

The image quality you get on a painted surface is about the same as that of a good matte front-projection screen, as long as the surface is reasonably smooth, free of large cracks and seams, and painted properly. Here are some tips on choosing paint:

Choose from dry—not wet—samples. Pick a paint that's flat, not semigloss or glossy, and as white as the white side of a *KODAK* Neutral Test Card or a sheet of good bond typing paper.

Make sure that you compare different shades of white under incandescent rather than fluorescent light, since some paints include fluorescent materials that won't be activated by the incandescent lamp in your projector.

And don't forget to take the paint's other qualities into consideration. Is it easy to apply? Can it be washed? Is it the right paint for the surface? Can it be retouched without your having to repaint the whole wall?

We don't know of any additives that can improve brightness or color quality. But you may want to consider painting a flat-black mask around the painted "screen" image area to better define the projected image areas and provide sharp edges for motion picture images.

**KODAK EKTAGRAPHIC CT1000
16 mm Projector**

Reducing Image Brightness

In some applications, you may need to *decrease* the light output of your slide projector to reduce image brightness on the screen. Overbright images can cause a bothersome dazzle effect in the projected slides. Some of the reasons for reducing brightness apply when

- Projecting small images.
- Using the projector in a telecine chain.
- Matching image brightness with that of another projector that has less light output.

On the positive side, reductions in light output normally extend lamp use beyond its rated life.

On the negative side, the same reduction decreases the color temperature of the projected image resulting in warmer tones. Factors that can affect light output include the choice of lamp, projector lamp setting (HIGH/LOW), slide aperture size, and line voltage.

How to Decrease Light Output

One good way to decrease light output is to substitute lower wattage lamps in your projector. The ANSI Code ENH lamp that is suitable for Models E-2, B-2, B-2AR, AF-1, AF-2, and AF-2K is appropriate; so are the ANSI Code FHS or EXY lamps for Models III E, III ES, III B, III A, III AS, and III AT. In addition, if you run your projector at its LOW setting, instead of HIGH, the light output will be lowered by about 30 percent.

Reducing lamp voltage or using a lamp intended for a higher line voltage are also satisfactory ways of reducing light output, up to a point. Reducing the lamp voltage 10 to 15 percent will reduce light output 30 or 40 percent and prolong lamp life 3 to 5 times. But reducing the lamp voltage much more can result in an objectionable shift in color quality toward yellow and red, and shorten the life of tungsten-halogen lamps.

IMPORTANT: Remember that only the lamp voltage should be reduced. Reducing the voltage to a projector motor below its minimum design rating can cause overheating, unsatisfactory operation, and damage.

You can easily control the brightness of a projected image by moving the projector farther from the projection surface or simply put a piece of paper over the front of the lens barrel. As the paper width increases, the image brightness decreases.

Raising the general room illumination will often serve the same purpose as reducing image brightness, since it is the brightness *ratio*, rather than absolute image brightness, that is pertinent. Increasing the room illumination is especially useful in reducing the dazzle effect caused by bright negative or reverse-text slides.

On a matte screen or lenticular screen, the light output can be four times the minimum optimum brightness, giving an image brightness from all viewing angles about four times as great as specified. Normally this differential is acceptable. However, because of the variable image brightness (depending on the viewing angle) of beaded screens, you should not accept that great an excess in lumen output on a beaded screen. An excess of 50 percent in lumen output should be the maximum for a beaded screen. This will give an image approximately four and one-half times as bright near the projection axis as the desired brightness reflected at 20 degrees off axis.

Controlling Light Output Through the Projector Remote-Control Receptacle

For those *KODAK EKTAGRAPHIC* Slide Projectors that have a seven-contact remote-control receptacle (the exceptions are Models S-AV2030 and S-AV2050), it is relatively simple to control light output. The reason is that external control of the lamp circuit is accomplished through two contacts in the receptacle. (For more details on this method of projector light control, write to Eastman Kodak Company, Dept. 625, Motion Picture and Audiovisual Markets Division, 343 State Street, Rochester, NY 14650.)

Lenses

Just as there may be a need to modify your slide projector's lamp output, there also are unique conditions that require a special projection lens to compensate for either or both the curvature of the slide surface or an extremely long or short projection distance.

If you consistently view projected images from glass-mounted slides, a flat-field lens such as one of the many sizes available for your *EKTAGRAPHIC* III or *EKTAGRAPHIC* Slide Projector is recommended. On the other hand, if an open-frame slide with the emulsion toward the lens (camera-original transparencies or duplicates made by most laboratories) is the type of slide predominant in your collection and assuming, of course, that the projection screen is flat, then a curved-field lens will provide the sharpest image obtainable.

When you encounter very long projection distances, a long focal-length lens must be found that will accommodate both the projection screen size and the projector-to-screen distance. Most *KODAK* Projection Lenses can be adapted to special applications. When

they cannot, however, appropriate lenses are available from other manufacturers with focal lengths up to 559 millimetres (22 inches) or more. Some of those companies include

- Buhl Optical Company
 1009 Beech Ave.
 Pittsburgh, PA 15233
 (412) 321-0076
- D.O. Industries, Inc.
 317 East Chestnut St.
 East Rochester, NY 14445
 (716) 385-4920
- Optical Radiation Corp.
 1300 Optical Dr.
 Azusa, CA 91702
 (213) 969-3344
- Tamron Industries, Inc.
 24 Valley Rd.
 Port Washington, NY 11050
 (516) 883-8800

Don't Do a Slow Burn

Ever watch a slide image wiggle, creep, warp, scorch, or burn? Unfortunately, it sometimes happens in front of a large and important audience. And it can happen even to good projectionists using well-designed projectors.

These problems are most likely to occur when using xenon or other high-intensity projector lamps, and glass-mounted, dense, silver-image slides (such as those made on *KODALITH* Film).

The reasons are many. High-intensity projectors generate more visible light, which, when absorbed by the slide and its image, turns to heat. Silver in images blocks infrared, so the infrared is absorbed and heats the slide further.

To reduce high-intensity projection problems—both excess heat and eventual fading of originals—use color film duplicates of your color or silver-image originals. These images are photographic dyes, which allow infrared to pass through without adding heat. (Kodak color slide duplicates can be made from black-and-white originals.) If possible, use open-frame mounts. Or compromise—use a single sheet of glass against the base (convex) side of the slide film to improve flatness and leave the emulsion open for air cooling. When possible, use less-dense slides (a medium-color background, instead of solid black).

Adjusting the projector for lower intensity and adding more infrared filtration may help diminish creeps, warps, and burns but also will reduce image brightness. A combination of the methods outlined above may be your best solution.

CHOOSING BETWEEN CURVED-FIELD AND FLAT-FIELD PROJECTION LENSES

This section is intended to help you make the best choice between curved-field and flat-field projection lenses for particular projection conditions. Curved-field lenses can provide greatly improved image sharpness for most projection situations. But you should also realize that they can provide *less* sharp images if used inappropriately.

Slide projector lenses have traditionally been the flat-field type. If the slide truly is flat, the lens provides a flat image of it on the flat projection screen. Often, however, the transparency is not flat because of certain characteristics of photographic film.

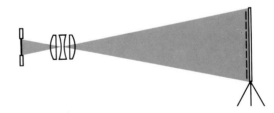

The transparency is basically a sheet of clear acetate with the image-bearing gelatin emulsion on one side. The acetate base and the gelatin emulsion have different rates of expansion and contraction with heating and cooling, particularly when changes in humidity or moisture occur in the transparency.

Many slide-show enthusiasts will remember the "popping" of their slides during projection.

If the transparency was in an open-frame mount, it would often spring from being curved one way to the opposite curvature as the radiant energy from the projection lamp was absorbed by the dyes or silver in the image and moisture was dried by the resulting heat. More recently, improved filmmaking and better mounts have virtually eliminated the tendency of a slide with a cardboard or other open-frame mount to pop. Instead,

only a slight change in the film curvature may result. Often the change is so slight that the image does not appear to go out of focus, especially with projectors that warm the film before it is projected or those that have automatic-focusing mechanisms. Even with the improvements in filmmaking and slide mounts, however, film will still curve to some extent when used in an open-frame mount.

Screen image quality can be improved and at the same time the film curvature can be overcome. This drawing illustrates that a curved transparency, when it is projected with a flat-field lens, results in a curved image at the screen. Practically, this means that if you move up close and focus critically, you can have the center of the image sharp or the corners and edges sharp—but not both at the same time.

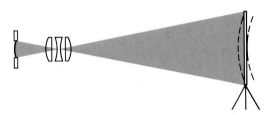

Kodak investigated this situation, determined the average curvature of slide transparencies, and designed projection lenses to compensate. The result was a family of "curved-field lenses." This drawing illustrates that although the film is curved, a curved-field lens provides a flat image, permitting improved center-to-corner sharpness on the screen. The improvement can be dramatic, particularly with subjects characterized by extremely fine detail and texture.

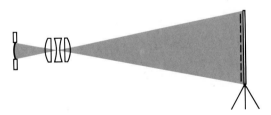

Two other conditions should be mentioned concerning slide projection with curved-field lenses. The first condition occurs when the slide is actually flat, as shown here. If a curved-field lens is used with a flat transparency, the image will be curved. The result is about the same as the second drawing except that the image in this case is curved in the opposite direction.

The second condition occurs if the transparency curves the opposite way from normal, *toward the lens.* (Normally the film curvature is toward the lamp.) Projection of reverse-curl transparencies with curved-field lenses will provide an even more deeply curved image with the center noticeably out of focus when the corners are sharp, or vice versa.

RECOMMENDATIONS

KODAK Curved-Field Lenses can be used for 2 x 2-inch slides in any *EKTAGRAPHIC* III or *EKTAGRAPHIC* Slide Projector made in the United States or Canada, and also in the *EKTAGRAPHIC* S-AV2050 Projector made in West Germany.

The table below will help you to determine whether a curved- or flat-field lens is the better choice:

	IMAGE QUALITY	
SLIDE TYPE	**FLAT-FIELD LENS**	**CURVED-FIELD LENS**
Open-frame, emulsion toward lens	Acceptable	**Recommended**
Glass-mounted Cemented to glass Glass plate	**Recommended**	Acceptable
Open-frame, emulsion away from lens	Acceptable	Not Recommended

The major question to be answered is what type of slides will be shown. Most slides are in open-frame mounts and curve away from the lens. Such slides are made from reversal film (such as *KODACHROME* and *KODAK EKTACHROME* Films) and from normally printed *KODACOLOR* Slides (made from color negatives), all of which have the emulsion toward the lens and the curvature toward the lamp. *KODAK* Color Slide Duplicates and duplicates produced by most photofinishing laboratories are also made so that the emulsion is toward the lens and the film has the usual away-from-the-lens curvature.

For mixed slides (glass and open-frame mounts, or slides having the emulsion toward the lamp), flat-field lenses are preferable.

The advantages of curved-field lenses lie primarily in the use of these lenses with 135- and 126-size original slides or with 31 mm square *KODACOLOR* Slides and duplicate slides.

There is little or no advantage in using curved-field lenses with larger transparencies (such as 38 x 38 mm super-slides) or smaller ones (such as half-frame 135- or 110-size transparencies).

135

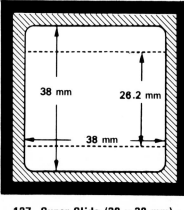

127—Super-Slide (38 x 38 mm)
828 (26.2 x 38 mm)

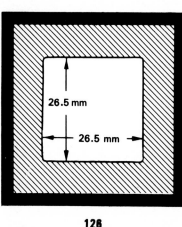

126

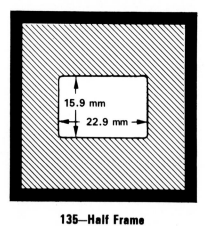

135—Half Frame

**KODAK Color Slide Duplicate from
127, 620, or 120 Slides**

**KODAK 2 x 2 Adapter
for 110 Slides***

SPECIAL PROJECTION SITUATIONS

As stated earlier, most slide transparencies are made so that they will be projected with the emulsion toward the lens. In certain applications, however, the film is oriented so that the emulsion is facing the lamp. Film with this reversal orientation (the film curl also reverses) is normally projected in one of two ways.

First are slides used in rear-screen projection. They are turned around in the slide tray so the screen image will have the normal left-to-right orientation for the viewer. This reversing of slide orientation is usually necessary for rear-screen projection when no mirror, or an even number of mirrors, is used in the projection beam.

REAR PROJECTION SCREEN

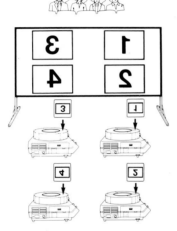

The second way involves certain slide-production techniques. For example, when a negative is contact-printed onto print film, the two emulsions are in direct contact for the printing operation. Such transparencies provide a right-reading normal image for front projection when the emulsion is toward the lamp and the film curves toward the lens. But if this type of transparency is used for rear projection without a mirror or an even number of mirrors, then, of course, it should be inserted into the tray in its reverse position and projected with a curved-field lens as shown in the drawing at bottom left.

There is little advantage in using curved-field rather than flat-field lenses of small apertures (*f*/5.6, *f*/8, and smaller) because with the smaller aperture there is usually enough depth of focus (even with curved film) to provide sharp screen images.

Short-focal-length, flat-field lenses (3-inch [75 mm] or less) are frequently used for rear-screen projection, for projection of glass-bound slides, or for other projection situations where the curved-field design is not an advantage.

If the recommended lens type is not available when mixed slide types are to be shown or if the image is brighter than necessary, center-to-edge sharpness differences can be reduced or eliminated by stopping down the lens (either flat- or curved-field). A thin metal or opaque paper diaphragm can be placed against either the front or back lens element to mask it.

NOTE: The opening in such a diaphragm should not be smaller than about one-half to two-thirds the diameter of the lens opening, or uneven illumination can result.

A Brief Description of the Autofocus Mechanism of the *EKTAGRAPHIC* III Projector

A beam of infrared light that originates at the projection lamp is defined in shape and position by an orifice in a sheet metal part. It is reflected off a mirror to change its direction and is then passed through a special lens to the front surface of the slide. The beam reflects off the slide, through a second lens and filter, and is reflected off another mirror to a photocell. The photocell is wired to a solid-state amplifier, which controls the focus motor.

The autofocus mechanism is designed to maintain a constant distance between the center of each slide and the projection lens. For example, if a slide moves in the gate or is in a different position from the previous slide, the light beam movement is immediately detected by the photocell. The photocell then electrically turns on the focus motor, which mechanically moves the lens to maintain the predetermined focus distance.

If the lamp module is removed, the energy source necessary to operate the autofocus will no longer exist.

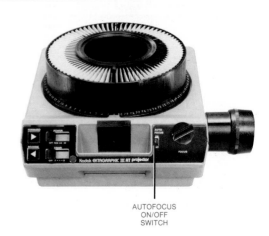

AUTOFOCUS
ON/OFF
SWITCH

Focusing on Lenses

Why is it that you spend a lot of money (let's say $300 each) for a good camera and camera lens, and only about $40-$75 for a lens to project your slides?

A good camera lens needs many things: precision mount and focus scale, and probably an $f/1.4$ aperture. Lots of glass; precision ground, polished and precisely mounted. Couplings to mate with exposure controls. Depth-of-field scale. Iris diaphragm; precisely placed and calibrated. And focusing and zoom controls.

Now consider a slide projector lens. It's much less complicated, with fewer pieces of glass and an $f/3.5$ or $f/2.8$ aperture. It simply doesn't require the refinements a camera lens does. It must achieve the best visual image—but it doesn't need the near infrared and near ultraviolet corrections required to record the best image on film.

Because Eastman Kodak Company makes so many of them, we can turn out high-quality projection lenses, which do their jobs well, at reasonable cost.

There are lots of fine specialized projector lenses available made by suppliers other than Kodak. These longer- and shorter-focal-length lenses fill a special need on the part of some projector users; they frequently have higher price tags because they can be more complicated to make.

Matching the Sizes of Projected Images

Q. When is it important to match the sizes of projected images?

A. In multi-image and two-projector dissolve presentations, images must match almost perfectly so they'll join or blend without abrupt discontinuities.

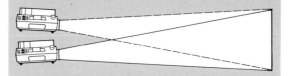

Q. Are there other situations?

A. Yes. When people want matching images from different pieces of equipment because they want the screen neatly filled; or, more importantly, they want a given image size for good legibility.

Q. What is involved in determining image size?

A. Four factors:
- Size of the transparency
- Lens focal length
- Projection distance
- Image size

When you have determined three of the four factors, the fourth is automatic.

Q. Suppose that we want all the images the same size—say, 4 feet (1.2 metres) high. How do we achieve that image size when using a 16 mm motion picture projector, an overhead projector, a filmstrip projector, and a slide projector with 135-size slides?

A. The easiest way is to set the projectors up at experimental distances from the screen and move each one closer to the screen to make the image smaller or further from the screen to make the image larger until all the images are 4 feet high. (Of course, that is not a realistic answer because the projectors would be at different locations.)

Q. What if we wanted all the projectors except the overhead projector to be at the back of the room?

A. Now, you've specified three factors: the projection distance, the image size, and the size of material to be projected. So in order to obtain the image size we want, we must choose...

(CONTINUED)

Q. . . . the correct combination of lens focal lengths?

A. Correct. But we do not have to experiment. We can choose a set of lenses that will provide matching image sizes on the screen with different projected materials at the *same* projection distance. That is what the table shown below is for.

	Lens Focal Lengths for:	
	Equal Height	Equal Width
super slides	10 in (250 mm)	10 in (250 mm)
vertical 135 slides	9 in (229 mm)	6 in (150 mm)
126 slides	7 in (178 mm)	7 in (178 mm)
35 mm filmstrips	6 in (152 mm)	4.5 in (113 mm)
16 mm movies	1.9 in (48 mm)	1.4 in (35 mm)

The principle for finding the proper set of lenses is simple: Lens focal lengths should have the same ratio as actual sizes of images on the film. Here is a set of lens focal lengths to provide matching image sizes at any particular distance. (Usually you can pick the nearest available focal length and "fine tune" by moving the projector a little closer or farther away, or perhaps use a zoom lens covering that focal length.)

Q. Great! But what about the overhead projector?

A. Usually you don't match it up for projection distance. An overhead projector is normally used at the front of the room while other projectors are used at the back of the room. Most overhead projectors with a 10 x 10-inch (250 mm) stage require a projection distance about 1½ times the image height or width.

Q. You've stressed image height. What about image width?

A. In AV applications, height is usually the most important dimension because it is the height of lettering on the screen that often determines readability, rather than image width. This is particularly true if you are planning to use both wide screen and conventional projection.

The Right Angle on Sharpness

As you may know, many things affect projected image sharpness. The projector must be aligned perpendicular to the screen; the transparency must be sharp; the lens elements must be precisely located; and the slide mount must keep the film flat.

But a factor often overlooked is projector gate squareness. For true sharpness, slide and screen must be parallel, and the lens axis exactly perpendicular to them.

To test gate squareness, sandpaper smooth the edges and corners of a 2 x 2-inch slide cover glass (to protect the gate), and then scratch or mark a large "X" on one surface of the glass from corner to corner. Put the glass in the gate and focus an $f/2.8$ lens. If scratches at all four corners come into focus together, your setup is square.

If all four corners are not sharp at the same time, something is probably out of alignment. Check projector alignment with the screen and also test several lenses. If the image still is not sharp at all four corners, your gate may need aligning. This is a job for a professional. Contact your local Kodak Equipment Service Center (addresses on inside back cover).

KODAK INSTAGRAPHIC CRT
Print Imager

The all-new *KODAK INSTAGRAPHIC* CRT Print Imager enables users to easily make instant color prints of images displayed on any 9-, 12-, 13-, or 19-inch cathode-ray tube. The print imaging outfit can also be used to produce conventional color slides and prints of CRT displays by using a 35 mm single-lens-reflex camera (not provided with the outfit). Excellent reproductions of monochrome and color computer graphics displays can be produced.

Modular Design

The modular design enables the user to photograph computer graphics displayed on today's four most widely used CRT sizes. For example, the outfit can be used with the 9-inch CRT's found with many portable computers, built-in and stand-alone 12- or 13-inch monochrome and color monitors used in home, personal, and business microcomputers, and also 19-inch color CRT's employed in professional CAD/CAM design and engineering systems for industry.

Easy-to-Use

Although the print imager offers the user a wide variety of CRT screen sizes to match particular imaging assignments, the outfit is both simple in design and easy to operate.

Once the Imager has been assembled with the appropriate *INSTAGRAPHIC* CRT Cone Adapter, the user aligns the unit to the individual terminal screen. (The Imager has a focus knob that must be set for the appropriate adapter used.) If necessary, the user can insert a *KODAK WRATTEN* filter to color balance for the phosphors of a particular CRT. Then the user simply presses the exposure button.

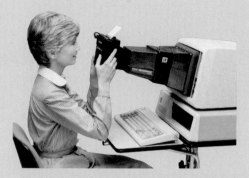

The outfit does the rest. After the shutter is released, the instant color print is ejected from the *INSTAGRAPHIC* Camera back. After an hour, the print made on *INSTAGRAPHIC* Film can be separated from the backing. The resulting prints can be easily cut to a smaller size, slipped into project folders or files, or mounted on master documents and copied on most office copiers.

Components

- *KODAK INSTAGRAPHIC* Camera back, designed for professional use. It holds a power supply and ten-exposure pack of *KODAK INSTAGRAPHIC* Color Print Film.

- *KODAK INSTAGRAPHIC* Print Module. It includes the shutter and an optical element with a 74 mm *f*/12.8 lens. It also provides the correct lens-to-screen focal length and partially corrects for screen distortion.

- *KODAK INSTAGRAPHIC* CRT Cone. This component shields the CRT and lens of the *INSTAGRAPHIC* Print Module from unwanted stray light and reflections.

- CRT Cone Adapters, sized specifically for 9-, 12-, 13- and 19-inch video or computer screens. The *INSTAGRAPHIC* Cone Adapter conveniently attaches to the *INSTAGRAPHIC* CRT Cone. Once in place, the *INSTAGRAPHIC* Cone Adapter is the base of the outfit and is placed over the screen before the exposure is made.

- *KODAK INSTAGRAPHIC* Color Print Film. This high-quality film is manufactured to industry tolerances and has a long shelf life when properly stored. Moreover, prints made with this film can be separated from their backing after one hour, if desired.

- 35 mm camera bracket for mounting a 35 mm SLR camera.

INTRODUCTION

KODAK EKTAGRAPHIC Slide Projectors have a long history of being adapted for out-of-the-ordinary projection requirements. This part of *The Source Book* covers in detail the wiring and operation of the internal electrical controls for all current *EKTAGRAPHIC* III and *EKTAGRAPHIC* Slide Projectors so that your modifications will be based upon a better understanding of the electrical and mechanical characteristics of these projectors.

Eastman Kodak Company does not offer special modification services, nor does it recommend them. Such modifications may invalidate the projector warranty or the Underwriters Laboratories, Inc. (UL) and Canadian Standards Association (CSA) approvals.

This radiograph of an *EKTAGRAPHIC* Slide Projector visually summarizes the purpose of this part of *The Source Book*—to provide you with a wealth of information about our projectors.

SLIDE PROJECTOR WIRING AND INTERNAL OPERATION

This information is intended to assist you in connecting a variety of external controls to your *KODAK EKTAGRAPHIC* III or *EKTAGRAPHIC* Slide Projector, or to modify your projector for particular uses.

An analysis of the operation of the internal electrical components will be provided in detail for three slide projector models:

Each model represents the "top-of-the-line" in its own grouping, and each one is equipped with more sophisticated features and controls than other models in its line (with the exception of a few minor, nonelectrical features—i.e., the III AT Projector does not have a built-in viewing screen).

At all times, your projector should be operated within the voltage range and frequency specified in the operator's manual. The use of voltages other than those specified generally will cause damage.

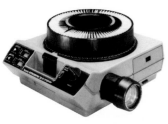
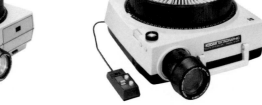

• *EKTAGRAPHIC* III AT Projector • *EKTAGRAPHIC* Slide Projector, Model AF-2 • *EKTAGRAPHIC* Slide Projector, Model S-AV2050

KODAK EKTAGRAPHIC III AT Projector

NOTE: All component references for the III AT Projector relate to the schematic diagram below.

Schematic and Reference List
KODAK EKTAGRAPHIC III AT Projector

A-1	Component Board	**J-1**	Remote-Control Receptacle	**L-2**	Combination Relay and Clutch Solenoid
B-1	Mechanism Motor			**R-2**	Variable Electronic Timer Resistor
B-2	Permanent-Magnet DC Motor	**J-3**	Special-Application Receptacle	**R-3**	Current-Limiting Resistor
DS-1	Projection Lamp	**J-5**	Special-Application Receptacle	**S-1**	Main Power Switch
DS-2	Standby Light			**S-2**	Autofocus On/Off Switch
F-1	Lamp Thermal Fuse	**L-1**	Cycle Solenoid	**S-3**	Projector Reverse Switch
F-2	Motor Thermal Fuse				
F-3	Internal Fuse				

S-4 Forward Slide Change Cycle Switch
S-5 Select Switch
V-1 Photo Cell
VR-1 Varistor

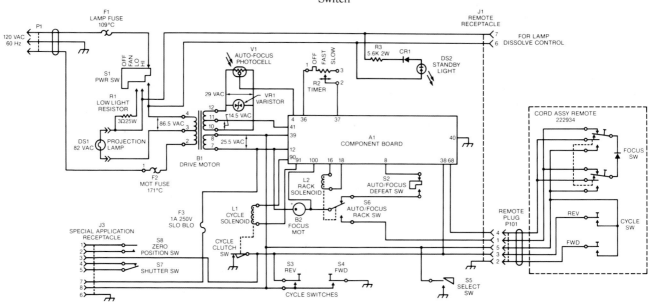

The main power switch (S-1 PWR SW) is shown in the OFF position. As the switch is moved progressively to the right from the OFF position detent, it performs the following functions:

FAN detent: Power is supplied to the mechanism motor (B-1 DRIVE MOTOR) that drives the fan and the slide-change mechanism, and it also (through secondary windings) provides low-voltage isolated power for the remote control and focus, and for the special-application receptacle (J-3 SPECIAL-APPLICATION RECEPTACLE).

In addition, power is supplied to the lamp-circuit access contacts on the remote-accessory receptacle (J-1 REMOTE RECEPTACLE) at the rear of the projector, by means of a tap on the motor primary. (The open circuit voltage at the motor tap is approximately 86.5 V with 120 V across the entire primary, but this drops to 82 V under the load of the lamp.)

LOW detent: The same conditions exist as in the FAN position except that the lamp-circuit contacts of receptacle J-1 are connected through resistor R-1. Power supplied to the projector lamp (DS-1) is reduced to approximately 71 V, reducing light output approximately 30 percent and increasing lamp life to about three times rated life expectancy.

HIGH detent: Conditions are the same as for LOW except that the lamp circuit access contacts of receptacle J-1 are connected together, and 82 V is supplied to the lamp.

The lamp circuit access is primarily for use with external circuit control by the *KODAK EKTAGRAPHIC* Programmable Dissolve Control, Model 2, or dissolve controls and programming devices made by other manufacturers. Connecting the two contacts through a switch, resistor, or rheostat permits external projection lamp control when the function switch is in the FAN position. The dropping resistor is not in the circuit. Note that power is supplied from within the projector to avoid the possibility of operating the lamp with the fan switched off. Any control device should be capable of handling the load of a 3.66 A tungsten lamp at 82 V.

A thermal fuse (F-1 LAMP FUSE) is mounted just in front of the projector lamp module, toward the center of the projector, where it can be seen by removing the lamp module. If the area overheats, the temperature-sensitive element in the fuse will melt and open the power circuit for the entire projector. A second thermal fuse (F-2 MOT FUSE) is mounted adjacent to a winding of the motor-transformer (B-1 DRIVE MOTOR) and will shut off the motor if it overheats. *The opening of either fuse is a positive indication that some abnormal condition needs to be corrected.*

IMPORTANT: Check the projector and the operating conditions thoroughly before replacing a fuse and using the projector again.

Replacement of either fuse requires partial disassembly of the projector, a procedure that should be done *only* by a qualified technician such as found at your nearest Kodak Regional Equipment Service Center.

The forward slide-change cycle switch on the projector is S-4 (S4 FWD). There is a switch with the same function on the remote control. When pressed, either switch will energize the cycle solenoid (L-1 CYCLE SOLENOID), which operates the cycle lever. The switches control alternating current which is rectified by a bridge circuit on the component board (A-1 COMPONENT BOARD), so the solenoid operates on direct current.

The cycle lever releases a spring clutch that engages the slide-change mechanism. The cycle-clutch switch is formed by the combination of the cycle lever and the spring clutch. As soon as the contact between the cycle lever and the spring clutch is broken, the clutch switch opens, de-energizing the solenoid and returning the lever to its normal position. In addition to releasing the clutch, the cycle lever provides two pivot points for the indexer lever that drives the slide tray forward or inreverse. If the cycle lever is returned to its normal position immediately after being actuated (as when the cycle clutch switch de-energizes the solenoid), the forward pivot is used. When the solenoid and the cycle lever remain actuated, the indexer lever pivots at the alternate point and the tray is driven in reverse.

The reverse switch on the projector is S-3 (S3 REV), and there is a parallel switch on the remote control. They operate in the same manner as the forward switches except that they bypass the cycle clutch switch so that the solenoid and cycle lever remain actuated and the direction of the tray is reversed.

NOTE: For reliable reverse operation, the reverse contact should be maintained for at least 70 milliseconds. An extremely short reverse-circuit closure can result in a forward cycle, but this is not a reliable method of cycling the projector. It is possible to obtain cycling with less closure than the time given above; however, those specified provide greater reliability. To avoid multiple cycling, maximum closure should be no more that 750 milliseconds (0.75 seconds) for either forward or reverse.

The select switch (S-5 SELECT SW) operates like the forward slide change switch, except that it is mechanically coupled to the mechanism in such a way that the tray is not moved. As long as it is held down, the slide-change mechanism is halted in midcycle with the slide lift lever raised, so the tray can be turned manually. When the switch is released, the mechanism completes the cycle, lowering the slide-lift lever (and any slide it supports) into the gate. If the select lever is operated when the main power switch is off, the slide lift lever is raised mechanically, the locator lever is withdrawn from the tray, leaving the tray free to turn manually. When the select lever is released, the slide-lift lever lowers, and the locator lever again locks the tray in position.

In earlier *EKTAGRAPHIC* Slide Projectors, shutting off the current to the cycle solenoid L-1 would result in

an inductive pulse which could cause arcing, shortening the life of the cycle clutch switch, and possibly feeding a pulse into electronic equipment connected to the projector. In *EKTAGRAPHIC* III Projectors, the problem is reduced significantly because of the dc solenoid, plus a resistor-capacitor (R-C) circuit in the component board to further control switching current in the clutch contact.

B-2 is a permanent-magnet dc motor that operates the automatic and remote-focus mechanisms. It contains varistors that control electromagnetic interference (EMI) which might otherwise cause noise in some audio systems, and possibly cause erratic operation of projector-control equipment. For automatic focus maintenance, a small opening is provided in the wall just ahead of the lamp module in the projector: about $^1/_{16}$ x $^3/_8$ inches (1.5 x 10 mm). Some of the infrared (plus a small amount of visible) radiation passes through this slot. A mirror-lens combination forms an image of the slot at the center of the front surface of the slide. The image is reflected onto a photo cell (V-1 AUTO-FOCUS PHOTOCELL). The cell is center-tapped. When the beam of light results in a balanced resistance on both halves of the photocell, the motor is not driven. However, if the slide surface moves slightly, the reflected light beam will move also. This unbalances the circuit and, through the component board circuit (A-1), drives the motor until balance is restored. That happens when the lens carriage has been moved forward or backward to maintain the distance between the lens and the slide surface, and thus also to maintain focus. The varistor (VR-1) protects the photo cell from electrical "spikes" that might damage it.

The autofocus on/off switch (S-2) permits turning off the autofocus function without disturbing the remote-focus control.

The manual focus knob is used to position the lens within the lens carriage. It does not move the lens carriage or turn the focus motor, because of a friction clutch.

An unusual switch is used in the remote focus assembly. Mechanically, it is simpler than the schematic diagram indicates. The two "switch leaves" attached to the terminals of the diode are independent. One leaf operates when the focus is moved in one direction, and the other operates when the lever is moved in the opposite direction. This arrangement is the same as on models of *EKTAGRAPHIC* and *EKTAGRAPHIC* III Projectors that have remote focus, but not automatic focus. In the schematic diagram, the other (lower) leaves involved in the focus circuit are shown linked mechanically to the upper focus leaves. When either focus leaf is operated, the connection between the lower leaf and the unused focus leaf is broken. Therefore, when the focus switch is used, two switch contacts are maintained; the third is open; the fourth is closed. Two functions are served:

• Direct current is supplied through the component board assembly to a combination relay and clutch solenoid (L-2). Through its relay function, L-2 switches

the focus motor from the automatic-focus circuit to the remote-focus circuit. The clutch function of L-2 locks the focus-motor-drive clutch so that the focus motor will move the lens within the lens carriage (as does the focus knob) without moving the automatic focus components.

• The diode between the leaves of the remote focus switch provides pulsating dc to the focus motor to drive it in either direction, depending on which direction the lever is moved.

The variable electronic timer resistor (R-2) is part of a conventional capacitor charge-discharge timing circuit on the component board. It provides continuously adjustable advance cycling from about 3 to 22 seconds. The sliding contact does not continue to make contact with the resistance element beyond the fast end of the element, turning the timing circuit off. The timing circuit triggers a solid-state switch (SCR) that is connected between the forward and common of the remote-control circuit. The circuit is essentially the same as that in the *KODAK* EC Automatic Timer, Model III.

VARIABLE ELECTRONIC TIMER

The standby light (DS-2) is a green light-emitting diode (LED), in series with a diode and current-limiting resistor (R-3) across the lamp-control contacts in the remote-control receptacle (J-1). It lights when voltage appears across these terminals, indicating that the projector is receiving power and that the projection lamp (DS-1) is ready to light as soon as it is switched on through the remote receptacle (or by moving the main power switch to LOW or HIGH). When the projection lamp is lighted at less than full brightness (as on LOW, or when controlled by a dimmer), the standby light will be lighted less brightly.

The special-application receptacle (J-5) provides access to circuits and components in the projector for connection to external control or other devices. The zero-position switch is operated by a sensing lever at the tray index point on the projector. It is open when the tray is at the zero position, or when no tray is on the projector. It is closed by the skirt on the tray whenever the tray is at a position other than zero. The shutter switch is operated by the shutter mechanism of the projector, and is closed when the shutter is closed, and open when the shutter is open. Thus, this switch is closed for about 0.8 second during each forward or reverse change cycle; and also at any time the shutter is latched closed because there is no slide in the gate. The current being switched by either switch should be limited to 3 A and 30 V ac, maximum.

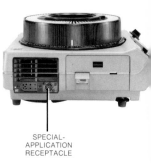

SPECIAL-APPLICATION RECEPTACLE

The power provided at terminals 7 and 8 of the special-application receptacle is 25.5 V ac, supplied by the remote control secondary winding of the drive motor (B-1). To prevent an electrical overload, this circuit is protected by an internal fuse (F-3) rated at 1 A. However, we recommend that power drawn continuously from this outlet be limited to $^1/_2$ A.

KODAK EKTAGRAPHIC Slide Projector, Model AF-2

NOTE: All component references for the Model AF-2 Projector relate to the schematic diagram below.

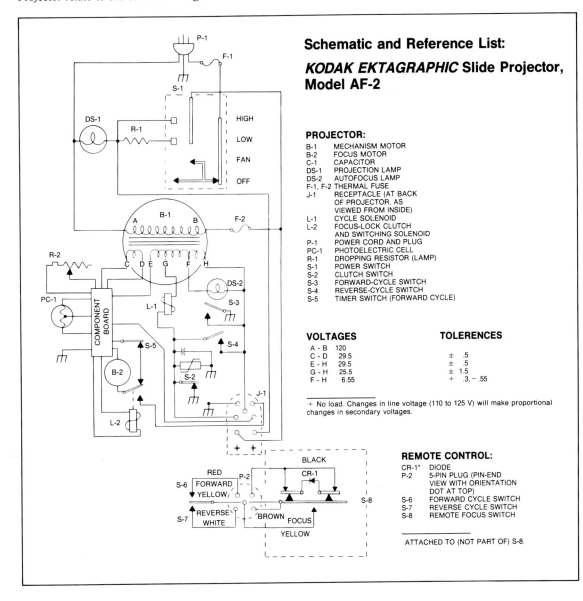

Schematic and Reference List:

KODAK EKTAGRAPHIC Slide Projector, Model AF-2

PROJECTOR:

B-1	MECHANISM MOTOR
B-2	FOCUS MOTOR
C-1	CAPACITOR
DS-1	PROJECTION LAMP
DS-2	AUTOFOCUS LAMP
F-1, F-2	THERMAL FUSE
J-1	RECEPTACLE (AT BACK OF PROJECTOR, AS VIEWED FROM INSIDE)
L-1	CYCLE SOLENOID
L-2	FOCUS-LOCK CLUTCH AND SWITCHING SOLENOID
P-1	POWER CORD AND PLUG
PC-1	PHOTOELECTRIC CELL
R-1	DROPPING RESISTOR (LAMP)
S-1	POWER SWITCH
S-2	CLUTCH SWITCH
S-3	FORWARD-CYCLE SWITCH
S-4	REVERSE-CYCLE SWITCH
S-5	TIMER SWITCH (FORWARD CYCLE)

VOLTAGES		TOLERENCES
A - B	120	
C - D	29.5	± .5
E - H	29.5	± .5
G - H	25.5	± 1.5
F - H	6.55	+ .3, − .55

+ No load. Changes in line voltage (110 to 125 V) will make proportional changes in secondary voltages.

REMOTE CONTROL:

CR-1*	DIODE
P-2	5-PIN PLUG (PIN-END VIEW WITH ORIENTATION DOT AT TOP)
S-6	FORWARD CYCLE SWITCH
S-7	REVERSE CYCLE SWITCH
S-8	REMOTE FOCUS SWITCH

*ATTACHED TO (NOT PART OF) S-8.

The main power switch (S-1) is shown in the OFF position. As the switch is moved progressively upward from the OFF position detent, it performs the following functions:

FAN detent: Power is supplied to the mechanism motor (B-1) that drives the fan and the slide-changing mechanism, and that also (through a secondary winding) provides low-voltage isolated power for the remote control and focus systems. In addition, power is supplied to the lamp-circuit-access contacts on the remote-accessory receptable (J-1) at the rear of the projector.

LOW detent: The same conditions exist as in the FAN position except that the lamp-circuit-access contacts of receptable J-1 are connected through resistor R-1. Power supplied to the projector lamp (DS-1) through the resistor is approximately 12.5 volts less than the line voltage; light output of the lamp is approximately 70 percent of rated value, and lamp life is about three times normal expectancy.

HIGH detent: Conditions are the same as for LOW except that the lamp-circuit-access contacts of receptacles J-1 are connected together, and they supply full line voltage to the lamp.

The lamp-circuit access is intended primarily for use with the external circuit of the *KODAK EKTAGRAPHIC* Programmable Dissolve Control, Model 2, or dissolve controls and programming devices made by other manufacturers. Connecting the two contacts through a switch, resistor, rheostat, or other control device will permit the projection lamp to be switched or controlled when the function switch is in the FAN position. The dropping resistor is not in this circuit. Note that power is supplied from within the projector to avoid the possibility of operating the lamp with the fan switched off. Any control device used should be capable of handling the load of a 2.6 A tungsten lamp at 125 V.

A thermal fuse (F-1) is mounted on a small wafer between the lamp and back panel of the projector. If the projector lamphouse area overheats, the temperature-sensitive element in the fuse will melt and open the power circuit for the entire projector. A second thermal fuse (F-2) is mounted adjacent to a winding of motor-transformer (B-1) and will shut off the motor if it overheats. The opening of either fuse is a positive indication that some abnormal condition needs to be corrected. Check the projector and the operating conditions thoroughly before replacing a fuse and using the projector again.

NOTE: Replacement of either fuse requires partial disassembly of the projector, a procedure that should be attempted *only* by a qualified technician, such as found at your nearest Kodak Regional Equipment Service Center (listed on the inside back cover).

S-3 is the forward slide-change cycle switch on the projector. S-6 is the forward slide-change cycle switch on the remote-control unit. When actuated, either switch will energize the cycle solenoid (L-1), which operates the cycle lever. The cycle lever releases a spring clutch that engages the slide-changing mechanism. The clutch switch (S-2) is formed by the combination of the cycle lever and the spring clutch. As soon as the contact between the cycle lever and the spring clutch is broken, the clutch switch opens, de-energizing the solenoid and returning the lever to its normal position. Ordinarily the solenoid operates on low-voltage alternating current, but it can also be operated satisfactorily on pulsating direct current (as when the projector is cycled by a *KODAK* EC Sound-Slide Synchronizer). In addition to releasing the clutch, the cycle lever provides two pivot points for the indexer lever that drives the slide tray forward or in reverse. If the cycle lever is returned to its normal position immediately after being actuated (as when S-2 deactivates the solenoid), the forward pivot is used.

When the solenoid and the cycle lever remain activated, the indexer lever pivots at the alternate point and the tray is driven in reverse.

S-4 and S-7 are the reverse switches on the projector and remote control respectively. They operate in the same manner as the forward switches (S-3 and S-6) except that they bypass the clutch switch (S-2) so that the solenoid and cycle lever remain activated and the direction of the tray is reversed. For reliable reverse operation, the reverse wire should be closed to the common for at least 200 milliseconds. An extremely short reverse circuit closure can result in a forward cycle, but this is not a reliable method of cycling the projector. The required length of such a closure (for forward cycling by the reverse wire) will vary from one projector to another and will also change as the projector ages. It is possible to obtain cycling with less closure than the time given above; however, those specified provide greater reliability. To avoid the possibility of multiple cycling, maximum closure should be no more than 750 milliseconds (0.75 second) for either forward or reverse.

The clutch switch (S-2) serves a secondary function when the projector is controlled by the *KODAK* EC Sound-Slide Synchronizer. The synchronizer circuit includes a silicon-controlled rectifier (SCR) that acts as a forward cycle switch when the unit detects an actuation signal from a tape recorder. When S-2 is opened, the current flow through the SCR (as well as through L-1) is broken, and this allows the SCR to revert to a nonconductive state in the absence of a continuous actuation signal.

When current is cut off from cycle solenoid L-1, an inductive pulse is created that may cause arcing at the switching point—usually at the clutch switch S-2 (for forward actuation) or at the control switch (for reverse actuation).

In the circuit shown, a varistor and capacitor are used to control arcing and thus prolong the life of the contacts. They also reduce any "pulse" that might be picked up by sensitive amplifiers or other electronic circuits.

B-2 is a permanent-magnet dc motor that operates the automatic and remote focus mechanisms. It has varistors to control electro-magnetic interference (EMI) which otherwise might be heard as noise from sensitive audio amplifiers, or might cause erratic operation of the projector-control equipment.

The manual focus knob is used to position the lens within the lens carriage, but it does not move the lens carriage or turn the focus motor, because of a friction clutch.

An unusual switch form is used in the remote-focus switch. Mechanically, this switch is much simpler than the schematic diagram indicates. The two switch leaves attached to the terminals of the diode are independent. One leaf operates when the focus lever is moved in one direction, and the other operates when the lever is moved in the opposite direction. This arrangement is the same as on other models of *EKTAGRAPHIC* Slide Projectors that have remote focus, but not automatic focus. In the schematic diagram, the other (lower) leaf involved in the focus circuit is shown linked mechanically to the standard focus leaves. When either focus leaf is operated, the connection between the lower leaf and the unused focus leaf is broken. Therefore, when the focus switch is used, two switch contacts are maintained; the third is open; the fourth is closed. Two functions are served by this arrangement:

• Direct current is supplied through the component board assembly to a combination relay and clutch solenoid (L-2). Through its relay function, L-2 switches the focus motor from the automatic focus circuit to the remote-focus circuit. The clutch function of L-2 locks the focus motor drive clutch so that the focus motor will move the lens within the lens carriage (as does the focus knob) without moving the automatic-focus lamp bracket.

• Diode CR-1 provides pulsating dc to the focus motor to drive it in either direction (depending on which direction the remote-focus lever is moved and which way the diode is oriented in the ac remote control focus-motor circuit). Paralleling the forward and reverse switches on *KODAK* EC Remote Controls is permissible, since they are normally open switches. However, the focus switches should not be paralleled.

An analysis of the switch contacts will show that a short will result if the focus switches are paralleled, and one of the focus levers is activated. If you want remote controls paralleled (for instance, at the front and back of a room), the focus and focus-lock wires can be omitted at one outlet, special controls can be built which will have only normally open switches for focus, or the remote controls can be modified by taking them apart and carefully bending the focus leaves of the switch so they do not touch either the top or bottom fixed contact when it is in rest position.

With the modification, two or more of the EC Remote Controls can be used in parallel with no problems—but each control must have the center switch leaf modified (bent, so they do not touch) as indicated above.

The variable electronic timer (R-2) is a conventional capacitor charge-discharge timing circuit that is controlled by a variable resistor on the back of the projector. This provides continuously adjustable advance cycling from about 4 to 15 seconds. The timing circuit triggers a solid-state switch (SCR) that is connected between the forward and common of the remote-control circuit and conducts momentarily to change slides. (The circuit is essentially the same as that in the *KODAK* EC Automatic Timer, Model III.)

MANUAL
FOCUS
KNOB

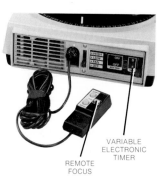

VARIABLE
ELECTRONIC
TIMER

REMOTE
FOCUS

KODAK EKTAGRAPHIC
Slide Projectors—Elapsed Times

Sophisticated multi-image presentations are generally controlled by electronic programming devices and minicomputers. Such presentations must be carefully planned to achieve the desired effect on the audience. However, before the planning of the program can begin, the operational sequence of the projectors should be studied. When such data are available, special effects, such as dissolves, projector start and stop, and other projection modes can be properly programmed for maximum visual effect on the screen.

The following information will help you to plan the programming of your audiovisual show so that you can produce the best screen effects possible.

NOTE: The "Elapsed Time" for each "Action" in the table below is an approximation and may vary somewhat with adjustment of the individual projector, and with such variables as voltage, temperature, weight of the loaded slide tray, age of the projector, and so forth.

KODAK EKTAGRAPHIC
Slide Projectors

Elapsed Time (Milliseconds)	Action
0	Cam stack begins rotation when clutch contact lever is pulled from contact with clutch spring.
120	Indexer starts toward lugs on tray bottom; shutter starts to close.*
150	If select button is being held down, indexer movement stops and indexer snaps back to rest position and remains there.
160	Shutter fully closed; slide lever starts upward; registration lever starts to retract.
170	Indexer stops moving outward.

200	Registration lever fully retracted.
230	Pressure pad starts to open.
320	Locater starts to move out from between tray lugs.
330	Pressure pad completely open.
360	Indexer starts moving again; slide lever fully up.
420	Locater fully out from between lugs.
430	Indexer starts to move tray forward (or reverse).
500*	If select button is being held down, cams stop rotating.
560	Locator starts to return to tray lugs.
580	Indexer stops moving tray; starts to return to rest position.
590	Slide lever starts down.
630	Locator is fully back in position between lugs.
820	Slide lever fully down.
850	Registration lever starts moving in.
870	Pressure pad starts to close.
890	Shutter starts to open; registration lever is fully in.
900	Pressure pad is fully closed.
920	Indexer is completely returned to the rest position.
950	Shutter fully open.
1000	Cycle complete; cam rotation stops.

*If the select button is depressed, only the indexer assembly is affected until the cam stops rotating at the half-cycle position. Then, when the button is released, the rest of the cycle is completed (with the indexer remaining in the rest position).

(CONTINUED)

KODAK EKTAGRAPHIC III
Projectors—Elapsed Times

Elapsed Time (Milliseconds)*	Action
0	Electrical signal to commit.
10	Cam stack released.
25	Shutter starts to close.
45	Indexer starts toward tray.
80	Indexer snaps back (manual select) and registration lever starts to retract.
110	Indexer stops.
140	Shutter fully closed.
145	Slide-lift lever starts to lift slide.
160	Registration lever fully retracted.
290	Pressure pad starts to open.
330	Pressure pad fully open.
335	Slide-lift lever fully up.
340	Locator starts to retract and indexer resumes motion.
360	Indexer contacts tray.
410	Locator fully retracted.
560	Cam stack stops rotating (manual select)
580	Locator starts to return.
590	Indexer stops moving tray.
620	Slide-lift lever starts to lower slide.
650	Locator fully engaged.
820	Registration lever starts to move in.
855	Slide-lift lever fully down.
870	Pressure pad starts to close.
880	Registration lever fully engaged.
890	Pressure pad fully closed and shutter starts to open.
910	Indexer returned to rest.
965	Shutter fully open.
1000	Cycle complete.

*The elapsed time intervals listed above were obtained by using a high-speed video camera and were rounded off to the nearest 5 milliseconds.

"We the Creators"

Q What is the greatest number of projectors you've used in a multi-image show?

A. More than 20 projectors have been used for special occasions. However, 18 *EKTAGRAPHIC* III Projectors are used to present a show entitled *"We the Creators,"* produced for Kodak by Alden Butcher Productions of Los Angeles and available for rent. Over 900 representational and abstract slides appear in this 8-minute multi-image tribute to audiovisual professionals. The projectors are arranged in three banks of six each with a 3-to-1-screen format with center-screen overlap. AVL playback equipment and a 4-channel reel-to-reel tape deck are required. Shown above is a full-screen panorama from the show photographed directly from a 6 x 18-foot front-projection screen. For more information, contact Eastman Kodak Company, Motion Picture and Audiovisual Markets Division, Dept. 641, 343 State Street, Rochester, NY 14650.

How to Deactivate the Projector's Dark-Screen Shutter

The dark-screen shutter was added to *EKTAGRAPHIC* III and *EKTAGRAPHIC* Slide Projectors as a convenience to users so that opaque (dark or blank) slides won't be needed for a dark screen during audiovisual presentations. The shutter prevents projector lamp light from reaching the screen and reflecting into the eyes of the audience. It is actuated when the projector is on and the gate is empty (no slide).

Some people prefer to deactivate the dark-screen shutter of their projectors because they need to see the projection beams when programming a multi-image show.

Eastman Kodak Company offers no service for deactivating the dark-screen shutter. However, it can be done in the following way:

• Locate the metal linkage (or finger) that latches the shutter closed when no slide is in the gate. With the projection lens pointed away from you, the link is on the right outside of the shutter. It catches the shutter to hold it closed, and it releases when the pressure pad opens to admit a slide, which allows the spring-loaded shutter to pop open.

NOTE: Opening the pressure pad opens the shutter; cycling the projector closes it.

• Unplug the projector. With a pair of long-nose pliers, reach into the gate area of the projector and bend the link *up* enough so that it releases the shutter. *Be careful not to bend the link in a direction that will cause it to interfere with adjacent moving parts.*

• Plug in and turn the projector on. Check the shutter action by cycling the projector several times. Projector lamp light should now come through the lens when a slide is *not* in the gate.

KODAK EKTAGRAPHIC S-AV2050 Slide Projector

NOTE: All component references for the S-AV2050 Slide Projector relate to the schematic diagram on page 111.

Internal Electrical Controls

The *KODAK EKTAGRAPHIC* S-AV2050 Slide Projector is delivered with a detachable 3-wire power cord that has a 3-prong plug to fit the grounded power outlets found in the U.S. and Canada, and on the other end a 3-contact European standard connector that fits the plug on the back of the projector. When plugged into a grounded outlet, it provides an automatic safety ground for the projector chassis.

If the projector is to be used where other types of power outlets are found, a 3-wire grounding power cord with a local-format plug on one end and the projector-fitting European connector on the other can usually be obtained locally. If you use an adapter instead, choose one that will provide a grounding connection for the projector, as well as operating power. A third approach involves cutting off the U.S. plug and installing a local one.

NOTE: This modification should be done only by a qualified electrician who can make the proper connections.

The main power switch (b) is shown in the off position. Depending on the position of the lamp-control switch and external connections to the 12-connector receptacle, the projection lamp may turn on with the projector when the main power switch is turned on.

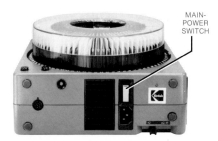

MAIN-POWER SWITCH

The thermal overload switch (c) is located inside the projector near the lamp. If the projector overheats, this cutout shuts off power to the projector. Although the switch resets automatically once the projector has cooled, the cause of the overheating should be found and corrected.

The fuse (a) will open if a short or other circumstances cause the projector to draw too much

current. This is a slow-blowing fuse (*KODAK* Part No. 4516091), accessible through the bottom of the projector. For operation on the lower voltage ranges, 110 or 130 V, a 3.2 A slow-blowing fuse should be used. *Check for the proper fuse before the projector is turned on.* If the 1.6 A fuse is used on the low-voltage ranges, it will burn out as soon as the lamp is turned on. If the 3.2 A fuse is used on the high-voltage ranges, it will not provide as much protection as would the 1.6 A fuse (*KODAK* Part No. 225185).

FUSE COVER

The power is supplied to the transformer and the main motor. The transformer provides the proper voltage for the various circuits by means of different connections selected by setting the main voltage-selector switch. This switch, located on the bottom of the projector, should be set for the voltage to which the projector will be connected — *before the projector is plugged in and turned on.* The instruction manual gives information on the ranges covered by each switch position.

The main motor turns the ventilating fan attached to its shaft and the gears that drive the slide-change mechanism. The cams that perform the slide-change operations are coupled to the drive train by a ratchet clutch, actuated by a solenoid. When the forward contacts are closed — by a button on the remote control or by a button on the projector — the solenoid remains activated until the cycle is complete, at which time a cam opens a switch to shut off the solenoid, releasing the clutch.

The forward button — on the projector, but not on the remote control — can also serve as a select button. If the projector forward button is held down, it interrupts the change cycle at midpoint through an additional switch operated by the cam stack. At that time, the tray can be turned manually to any position, after which the forward-select button can be released. The completion of the change cycle will advance the tray one more position forward, counterclockwise. *Thus, if slide 40 is wanted, the advance-select button should be released with the tray set at 39.* To return the tray to zero position, set the tray at 80 and release the button.

The reverse cycle is initiated by closing the contacts operated by the reverse button on the remote control or on the projector. This activates a reverse solenoid (f),

which determines that the slide tray transport lever will move the tray in reverse, clockwise. The reverse solenoid also operates a switch which activates the clutch solenoid (i), engaging the cam stack to make the slide change.

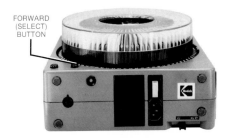

FORWARD (SELECT) BUTTON

The single tray-transport lever on the S-AV2050 Projector performs the functions of both the locator lever and the index lever on North American Kodak projectors. That is, it locks the tray in position while slides are being lowered into the gate, raised into the tray, or projected, and it also moves the tray forward or backward.

Electrical control of the shutter position is achieved by means of the reverse solenoid. The shutter in this projector (as well as in the Model S-AV2030 Projector) is located between the lamp and the gate, rather than between the gate and lens as in North American projectors. In normal slide change, the shutter, operated mechanically by a cam, closes to prevent light from reaching the screen during slide change. The shutter is coupled to the cam stack and the reverse solenoid in such a way that either one can close the shutter; it remains closed as long as either one calls for it to be closed. Contacts on the 12-contact socket, on the side of the projector, provide external electrical control of the shutter. Connecting the contacts activates the reverse solenoid, but disables the reverse-solenoid switch that activates the clutch solenoid. The result is that the shutter will close, but the clutch will not operate. This allows you to flash an image on and off the screen for testing or special effects.

This feature, together with the zero-positioning switch, makes possible an automatic-return-to-zero control for the S-AV2050 Projector. The zero-position switch lever is located under the index tab, beside the projector gate. When the tab is pressed down by the skirt of a slide tray, it closes the double-pole single-throw zero-position switch. When the tab is not pressed, the switch remains open — indicating that the tray is at the zero position, or that there is no tray on the projector.

As in North American *EKTAGRAPHIC* III and *EKTAGRAPHIC* Slide Projectors, there is a registration lever that provides repeatable horizontal registration of the screen image. This lever, at the inner side of the projector gate, pushes each slide to the outside of the gate; mechanically coupled to this lever is the slide-sensor switch that is open when the lever is held

against the edge of a slide, but closed when the lever has entered the gate without encountering a slide. The switch contacts are connected to the 12-connector socket on the side, and can be used for detecting the end of a slide series, by the absence of a slide in the gate. A special slide with a notch at the registration lever position can be used to permit the switch to close while cutting off light to the screen.

Remote focusing requires a separate accessory, the *EKTAGRAPHIC* S-AV Remote Control.

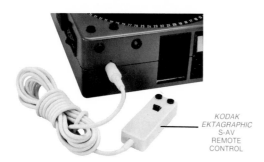

KODAK
EKTAGRAPHIC
S-AV
REMOTE
CONTROL

A double-pole double-throw center-off switch in the S-AV Remote Control connects direct current to the low-voltage dc permanent-magnet EMI-suppressed remote-focus motor in the projector. For use with lenses having a spiral-focusing groove, the motor drives a circular gear, and an eccentric connector on the gear moves a lever on which is located the lens-positioning pin.

NOTE: Although the remote-focus switch controls the polarity of the current to the motor, and thus the direction of motor and gear rotation, lens movement will reverse itself when the focus switch is held long enough in either position.

Even though the motor and gear continue to rotate in the same direction, the eccentric connector will move through a 0- or 180-degree relationship with the lever, and lever movement will change 180 degrees causing the lens-positioning pin and the lens to reach the end of their travel in one direction and reverse themselves. Because of this, the remote-focus motor can be used for minor lens movement only, about $^1/_8$ inch (3 mm), and rough focusing must be done by turning the lens barrel manually.

The motor also drives the focus thumb wheel and the attached pinion to focus North American rack-focus lenses (such as the *KODAK EKTAGRAPHIC* FF Zoom Lens, 100 to 150 mm *f*/3.5 lens shown here).

KODAK EKTAGRAPHIC
FF Zoom Lens,
100 to 150 mm
f/3.5 Lens

External Electrical Controls

The S-AV2050 Projector has receptacles for two different external control plugs, and these may be used independently or simultaneously.

The 6-pin receptacle on the back of the projector accepts a 6-pin plug, MAB 6/DIN 45322, such as the one on the projector remote control. All six pins are functional. The sixth pin, compared with the five-pin EC Remote Control used on U.S. and Canadian projectors, is required because the remote-control circuit for the S-AV2050 Projector operates on direct current. There is one common wire, a second wire for forward slide tray cycling, a third for reverse cycling, and three more wires to permit reversing the low-voltage direct current so the focus motor can be operated in both directions.

The connections on the receptacle are:

1. Slide Reverse (when closed to 3).

2. Slide Forward (when closed to 3).

3. Common (plus 20 V).

4. Focus Motor

5. Focus Motor

6. Negative (O V).

 • Connecting 3 to 4 and 5 to 6 will run the focus motor in one direction.

 • Connecting 3 to 5 and 4 to 6 will run the focus motor in the opposite direction. Switching capacity required for slide change in either direction, or the focus motor, is about $^1/_2$ A.

Terminals 3 and 6 can be used as a source for dc power for such things as external relays, pilot lights, and so on. The power is pulsating (full wave rectified), dc, approximately 20 V, and the power drawn should not exceed 750 mA, (0.75 A), or an internal fuse (F2, fast acting, 1.25 A) , might blow. Replacing this internal fuse requires removal of the projector bottom to gain access to the fuse clip, located on a circuit board at the front corner opposite the lens side of the projector. Only a technician familiar with the internal workings of the projector, and its disassembly and reassembly, should attempt to replace this fuse.

Twelve-Pin Receptacle

The 12-pin receptacle at the side of the projector accepts a 12-blade plug (J2), DIN 41622, such as *KODAK* CAT No. 141 4937.

12-PIN RECEPTACLE

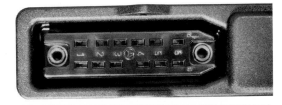

12-PIN RECEPTACLE (CLOSE-UP)

Schematic Diagram Reference List: *KODAK EKTAGRAPHIC* S-AV2050 Slide Projector

Wiring Diagram

a) Mains fuse
b) Mains switch
c) Thermal overload
d) Voltage selector
e) Shaded pole motor
f) Switch for internal or external lamp control
g) Rectifier
h) Forward slide change and select
i) Clutch solenoid
j) Secondary fuse
k) Switch for lamp changeover
L1 Lamp in Circuit
L2 Spare lamp

m) Switch for snap change
o) Reverse slide change
p) Reversing solenoid for forward/reverse slide change and snap change
q) LED for zero-position
r) Zero reset switch in slide gate
s) Slide tray zero-position switch
t) Focusing motor
u) Remote control forward
v) Remote control reverse
w) Remote control focusing

110/120 V	11-12	1-2	2-7	
130 V	11-12	1-2		6-7
220/230 V	12-1		2-7	
240/250 V	12-1			6-7

The connections on the 12-pin receptacle are

- **a 1** Common, 24 V ac (lamp current; isolated from the power line).

- **a 2** Not used (no connection).

- **a 3** For external lamp control (dissolve, lamp switching, etc). Connects to "a 1" to turn lamp on; "a 3" is "live" only when the INT-EXT lamp switch on the side of the projector is in the EXT position. The lamp current is aproximately 10.5 A, so approximate switching and current capacity is required. Total resistance added between "a 1" and "a 3" for lamp switching should not exceed 0.1 ohm when the lamp is fully on.

- **a 4** Can be used with "a 1" to supply 24 V ac to an external device. Do not exceed a 750 mA, 0.75 A, load.

- **a 5** 0 V dc. Same as "6" on the 6-pin receptacle at the back of the projector.

- **a 6** Gate slide-sensing switch; can be used to initiate automatic return to zero or detect end of program by absence of slide in gate.

- **b 1** Operates shutter. Connect to "b 4" to close shutter by operating reverse solenoid without activating slide change.

- **b 2** Same as "1" on back receptacle. Initiates reverse slide change when closed to "b 4."

- **b 3** Same as "2" on back receptacle. Initiates forward slide change when closed to "b 4."

- **b 4** Same as "3" on back receptacle. Common for forward and reverse slide change circuits, plus 20 V dc, pulsating. Can be used with "a 5" to provide approximately 20 V dc, 750 mA maximum for external use.

- **b 5** Zero-position switch. Single-pole single-throw normally open. Connects to "b 6" when tray on projector is not at zero position. No contact when tray is in zero position or no tray is present.

- **b 6** Zero-position switch.

The zero-position and slide-detection switches built into the projector must be used only for low voltage and low current. They have enough capacity to control slide advance and reverse functions, but must never be used for switching the projection lamp current directly or for switching line voltage. Such functions, if controlled by these switches, must be performed through isolating relays having contact capacity sufficient to handle the current and/or voltages involved. With the exception of lamp switching ("a 1" and "a 3"), values in circuits connected to the back and side receptacles should be

limited to 750 mA and 30 V maximum. Any equipment connected to the projector should have UL requirements for class 2 photographic equipment. When the zero-position switch is closed and the projector is turned on, an LED (light-emitting diode) is lit on the back of the projector, indicating the tray is at zero.

The remote-control circuits of the S-AV2050 Projector are floating; that is, they are not grounded to earth ground or the chassis. The 12-pin plug that fits the side connector can be used to provide a ground to the chassis of the projector by using the two round pins supplied with it for assembly. Insert these into the round holes at either end of the banks of flat connector pins.

The remote-control circuits of the S-AV2050 Projector should *not* be connected in parallel. (Under some circumstances such parallel connection is permissable with North American projectors.) If it is necessary to cycle two or more S-AV2050 Projectors together, use isolating contacts.

Electric Current Abroad

Q. I realize that the *EKTAGRAPHIC* Slide Projector, Model S-AV2030 and Model S-AV2050, are "world travelers." But I want more information on various countries' electrical requirements for using slide projectors overseas. Is there such a source?

A. Yes. "Electric Current Abroad" (1984 Edition, Stock No. 003 008 00193-9) is a publication of the U.S. Government Printing Office, Washington, DC 20402. This booklet lists by country and city the following information:

- Type of current (alternating or direct)
- Frequency (hertz-per-second)
- Number of phases
- Nominal voltage
- Number of wires to a commercial or residential installation
- Frequency stability

CORDS, PLUGS, AND RECEPTACLES

Some applications for *KODAK EKTAGRAPHIC* Slide Projectors made in North America require the interconnection of specialized control devices with one or more projectors. To reduce the possibility of improper electrical connections, which could result in damage to your slide projectors, you should use cords, plugs, and receptacles specifically designed for the projector. While these are not always standard commercial components, they are available either as accessories sold by suppliers of Kodak products or as parts (identified by part numbers) that can be ordered through electronics suppliers or directly from:

Eastman Kodak Company, Parts Services,
800 Lee Road, Rochester, NY 14650
Phone (716) 724-7278.

The following descriptions will help you identify the items needed for installation.

Remote Control Cord and Cable Specifications

The *KODAK* EC Remote Extension Cord (25-foot) (*KODAK* CAT No. 140 1363) is available from dealers selling Kodak products. It extends the range of the 12-foot (3.7 metre) EC Remote Control cord and contains 5 No. 22 wires.

Depending on the remote-control capability, a slide projector will require one conductor for common, one for forward, one for reverse, and either one or two for focus.

Many types of cables and cords can be used, but the ones you select should have wires that are color-coded or otherwise identified.

Solid wires can be used for permanent installations; stranded wire should be used when flexibility will be required.

Recommended Wire Size		
Maximum Cable Length feet (metres)	Conductor Size (AWG)	Diameter (millimetres)
65 (19.8)	24	0.5
100 (30.5)	22	0.6
160 (48.8)	20	0.8
250 (76)	18	1.0
400 (122)	16	1.2

Projector Receptacle for *KODAK EKTAGRAPHIC* Remote Control Cords

In a permanent projection installation where a remote control panel is used, one of the receptacles below can be installed at the point at which the projector remote-control cord is connected.

Eight- and Nine-Contact Receptacles

KODAK Part No. 185631 (as shown)

KODAK Part No. 185651 (without pins in bottom--used in projectors with attached power cords.)

CAUTION: The bottom four contacts of the 9-contact receptacle may carry line voltage and lamp current. Any wires connected to them should therefore be adequate for 5 A of current and will need insulation adequate for 125 V. All wiring should conform to good practice and any special local code or other requirements.

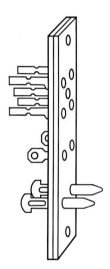

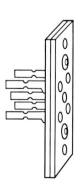

Five-Contact Receptacle
KODAK Part No. 188747

Twelve-foot (3.7 metre) Cord for *KODAK* EC Remote Control Cord Assemblies; cord with plug only; without switch assembly; terminates in bared wires.

KODAK Part No. 181376
3-wire cord (as in *KODAK* EC-1 Remote Control)

KODAK Part No. 169826
4-wire cord (as in *KODAK* EC-2 Remote Control)

KODAK Part No. 185630
5-wire cord (as in *KODAK* EC-3 Remote Control)

Cable Clamp

Used to mount round molded plugs to an electrical-outlet box or control panel. Standard cable clamp, such as Thomas and Betts No. 3300, is available from electrical supply houses.

Plugs and Sockets

Many standard plugs and sockets (Cinch-Jones, Amphenol, Eby, etc) with a contact rating of approximately 0.5 ampere or greater, can be used in pairs but will not mate with standard *EKTAGRAPHIC* Projector plugs and receptacles.

A few plugs or sockets, however, will mate satisfactorily with *EKTAGRAPHIC* Projector plugs and receptacles. Examples are the Eby 119-5M plug and the 119-5F saddle-mount socket.

Pin length on the 119-5M plug is not exactly the same as on the *EKTAGRAPHIC* Projector plugs, but it will mate with corresponding *EKTAGRAPHIC* Projector receptacles; and the 119-5F socket will receive *EKTAGRAPHIC* Projector 5-prong projector plugs. Eby connectors can be obtained from:

- J. T. Simpson, 188 Elizabeth St., NY, N.Y. 10012, industrial electronics suppliers. (Also available from J. T. Simpson are Eby connectors mounted on wall plates, for use in conference rooms or auditoriums.)
- In quantity from the distributor, Eby Sales Company, 148-05 Archer Ave., Jamaica, NY 11435.
- From Radio Shack is a suitable plug without a wire (Radio Shack Catalog No. 274-1210), a plug with a 1-foot wire attached (Catalog No. 270-041), and a chassis mount socket (Catalog No. 274-1212).

Custom-Made or Locally Fabricated Plug (For Access to Lamp Circuit of North American-made *KODAK* Slide Projectors)

This custom-made plug inserts into the 2-hole receptacle directly under the 5-hole receptacle that accepts the *KODAK* EC Remote Control. If the 2 pins are shorted together or connected by means of a switch, the lamp circuit will go to HIGH when the projector switch is in the FAN position. (With the *EKTAGRAPHIC* Slide Projector, Model AF-2K, the circuit will go to LOW.) The plug body must be insulated for line voltage, and it must not interfere mechanically with other plugs connected to the receptacle. Dimmers or switches used with the new plug must have minimum ratings to handle the projection lamp voltage and load.

IMPORTANT: The power provided for the new plug is from the internal circuit of the projector. Do not connect the pin wires to an external power source.

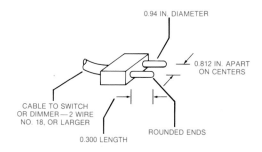

One suitable plug can be obtained from Radio Shack (Catalog No. 274-342), in a set of six 2-pin plugs and sockets. You must insert this plug carefully to avoid breaking the plug body, since the pin spacing is slightly less than 0.312 inch (7.9 millimetres) on centers.

Plugs and Remote Extension Cables for *KODAK EKTAGRAPHIC* Slide Projectors, Model S-AV2030 and Model S-AV2050

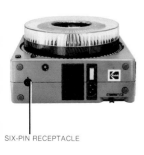

SIX-PIN RECEPTACLE

6-Pin DIN Plug

The 6-pin receptacle on the back of the S-AV2030 and S-AV2050 Projectors accepts a 6-pin plug, MAB 6/DIN 45322, such as the one on the projector remote control. All six pins are functional. The sixth pin, compared to the 5-pin remote control used on U.S. and Canadian *KODAK* Projectors, is required because the remote-control circuit for the S-AV2030 and S-AV2050 Projectors operates on direct current. There is one common wire, a second wire for forward slide-tray cycling, a third for reverse cycling, and three more wires to permit reversing the low-voltage direct current so the focus motor can be operated in both directions.

Twelve-pin DIN Plug

12-PIN RECEPTACLE

The 12-pin receptacle at the side of the S-AV2050 and S-AV2030 Projectors accepts a 12-blade plug, DIN 41622, such as *KODAK* CAT No. 141-4937.

S-AV Remote Control Extension Cable

A remote extension cable is available that is compatible with the S-AV Remote Control used on Models S-AV2050 and S-AV2030. It is the *KODAK CAROUSEL* Remote Control Extension Cable, 4 metres (13 ft), *KODAK* Part No. 7863N.

Eight-Pin Male Plug for 8-Contact Special-Applications Receptacle on *EKTAGRAPHIC* III Projectors

This is an 8-pin male plug cord assembly for the 8-contact special-applications receptacle on the projector, *KODAK* Part No. 205339; also available as Type MAS-80S, CAT No. 930 298-117, from Rye Industries, 125 Spencer Place, Mamaroneck, NY 10543, and from Marshall Electronics, Inc., PO Box 2027, Culver City, CA 90230.

Eight-Contact Special-Applications Receptacle on *EKTAGRAPHIC* III Projectors

Eight-contact special-applications receptacle—with *KODAK* Part No. 204722 (supplied along with grille assembly); also available as Type MAS EI8S), CAT No. 930396-100, from Rye Industries; also available from Marshall Electronics, Inc.

USING *EKTAGRAPHIC* PROJECTORS IN TELEVISION MULTIPLEXING SYSTEMS (SELECTING THE LENS AND LAMP)

KODAK EKTAGRAPHIC III and *EKTAGRAPHIC* Slide Projectors, when equipped with a *KODAK EKTAGRAPHIC* FF Lens, 178 mm *f*/3.5 and an extended barrel, provide acceptably uniform illumination over the area of a 35 mm slide that is scanned by most television film cameras. However, since the projectors also provide approximately ten times the illumination required by such formats, they are generally modified with some light-attenuating arrangement to adjust the projector light output to that of other projectors providing input to the same television camera. Use of either the 175-hour ENH lamp (in Models E-2 through AF-2K) or the 200-hour EXY lamp (in *EKTAGRAPHIC* III Projectors) will reduce the light output of these projectors.

Using Inconel Alloy-Coated Filters

To further reduce the light output of these projectors, we recommend that you place a neutral-density filter in front of the projection lens and that you also use an iris diaphragm to make minor illumination adjustments. Inconel alloy-coated filters are recommended for this application because gelatin filters absorb the projection lamp heat and can warp.

The iris diaphragm should not close to a diameter less than 1¼ inches (32 millimetres); about 1.4 inches (36 millimetres) is best to produce evenness of illumination and to avoid creating a depth of focus in the projector that will permit imaging of the dark central zone of the lamp reflector. Such a condition is observable as uneven illumination across the scanned area, usually darker in the center than on the edges.

A gelatin filter can be used to color balance a projector if you position the filter so that the Inconel alloy-coated filter is situated between the projection lamp and the gelatin filter. This arrangement permits only attenuated light to pass through the gelatin filter with little possibility of heat buildup.

The amount of filtering required will depend on the characteristics of the projection multiplexing system and the brightness of the projector lamps. These two factors provide the input to the television camera. The following table shows the amount of light transmission of gelatin filters with densities of 0.01 through 2.00:

Density	% Transmission	Density	% Transmission
0.01	97	0.60	25
0.10	80	0.70	20
0.20	63	0.80	16
0.30	50	0.90	13
0.40	40	1.00	10
0.50	32	2.00	1

One source of iris diaphragms for the projection lens is Edmund Scientific Co., 101 East Gloucester Pike, Barrington, NJ 08007. They have a diaphragm (Stock No. 30,118) that has a maximum opening of about $1\frac{5}{8}$ inches (42 mm) and a minimum opening of $\frac{1}{16}$ inch (2 mm). This could be used for fine adjustment when the projector light sources are being balanced, but as indicated above, the minimum aperture should not be as small as the diaphragm permits, or uneven illumination will result.

There are no provisions on the 178 mm lens for attaching either the diaphragm or a filter holder. You will need to glue the attachments to the lens barrel with epoxy glue or employ a filter holder that will fit the lens and hold the iris diaphragm, Inconel alloy-coated filter, and color-correction filter.

Sources of Nickel Alloy-Coated Filters

Sources	Densities of Stock Filters		Sizes
Baird Atomic, Inc. 125 Middlesex Turnpike Bedford, MA 01730	0.01 0.1 0.2 0.3 0.6 0.7	0.8 1.0 1.2 1.3 1.6 2.0	51 x 51 mm
Bausch & Lomb, Inc. 1400 N. Goodman St. Rochester, NY 14609	0.7 1.0 1.3	0.3 0.6 0.9 1.2	2-inch (51-millimetre) diameter 3-inch (76-millimetre) diameter 2 x 2 inches (51 x 51 millimetres)
Eastman Kodak Company Special Products Sales USAD, Elmgrove Plant Rochester, NY 14650	Available in most densities up to 4.0		Available in sizes up to 10-inch (254-millimetre) squares and circles on either glass or quartz
Special Optics Box G-T Little Falls, NJ 07424	0.01 0.1 0.2 0.3 0.6 0.7	0.8 1.0 1.2 1.3 1.6 2.0	2 x 2 inches (51 x 51 millimetres)

*One source of a suitable filter holder is the Tiffen Manufacturing Co., 71 Jane St., Roslyn Heights, NY 11577.

VENTILATION AND NOISE CONTROL

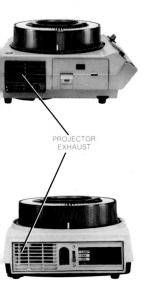

PROJECTOR
EXHAUST

Most of the inquiries Kodak receives about projector ventilation and noise control concern the use of slide projectors in front- and rear-projection enclosures, blimps to muffle projector noise, cabinets to house a projector that must operate continuously for extended periods, and so on. The following information should answer most of these questions and will be very useful if you plan to install a slide projector in a booth or projection room.

Most electrical energy consumed by tungsten projection lamps is converted into heat. No more than about five percent of the energy used by these lamps leaves a slide projector as light. Additionally, much of the energy used by programmers, dissolve controls, and lighting rheostats becomes heat. When this happens in a projection enclosure, the elevated temperature can shorten the normal operating life of your slide projectors.

Ventilation of Small Enclosures

KODAK EKTAGRAPHIC III and *EKTAGRAPHIC* Slide Projectors incorporate fans or blowers to move fresh air through heat-producing areas of the projector. If the air supply or exhaust is blocked, the projector will overheat. Too many projection cabinets permit little or no air intake and exhaust, and the projector merely recirculates heated air inside the cabinet. The resultant overheating can often damage both the slides and the slide projector.

An air intake opening *at least* equal in area to the slide projector air intake *plus* an exhaust port of the same size *must* be provided in a projection cabinet. In addition, the cabinet air intake and exhaust opening should be adjacent to the respective projector openings. You should install a filter over cabinet air intakes, if the atmosphere contains quantities of dust and dirt. In some cases, the slide projector may not have enough power to pull sufficient air through a filter for proper cooling; small, quiet fans equipped with filter boxes are available for this purpose. There are various models capable of moving about 50 to 600 cubic feet (approximately 1.5 to 18 cubic metres) of air per minute. Even a *confined* space, such as a study carrel, may limit proper projector ventilation. For example, if you place a *KODAK EKTAGRAPHIC* Slide Projector with its back against the side of a carrel shelf, the exhaust will be partially blocked and the projector may overheat. (A projector backed into a corner may also cause warm airflow back under the projector to intakes where it may be recirculated.) To avoid these situations, place a spacing device (such as a block of wood) on the shelf to keep the projector exhaust at least 2 inches (51 mm) from the side of the carrel.

As discussed earlier, thermal fuses on the motors and in the lamp compartments of *EKTAGRAPHIC* Slide Projectors are designed to prevent dangerous overheating. These fuses should *never* be removed or bypassed. The fact that such fuses do not open (thus shutting off the projector) does not mean, however, that the projector is not overheating. Restricted airflow or other conditions can cause the temperature of the projector to rise well above normal without the danger of fire and without causing the thermal fuses to open. Such overheating will shorten motor life and may also reduce lamp and slide life.

Ventilation of Projection Rooms or Booths

The same ventilation principles apply, but on a larger scale, when you install slide projectors in a projection room or booth. In such an area, adequate ventilation is needed not only for the projectors but also for the maximum number of occupants. Although a filtered intake fan is usually sufficient for a small cabinet, *both* forced exhaust and filtered power intake may be necessary in booths and large rooms. Ideally, these areas should be air-conditioned; while fans and filters can circulate fresh, dust-free air, efficient air conditioning can do this and control humidity as well.

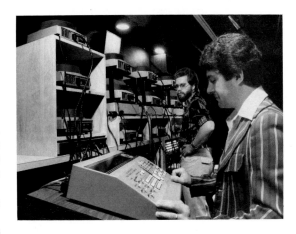

Providing Positive Pressure

Whenever possible, the filtered air-intake system should maintain a slightly positive pressure in the projection room or booth. That is, air should be *forced in* rather than pulled out. The air pressure at the intake should at least equal the pressure at the exhaust. If air is exhausted faster than it is supplied by the intake system, dust and dirt may be sucked into the projection area through unfiltered openings—the space under doors and around window casings, slits and gaps in partitions, and so on.

Although it seldom happens, it is possible to overventilate an area. Excessive cooling of tungsten-halogen lamps can lead to interruption of the halogen cycle and a shortened lamp life. High-speed streams of unfiltered air can also carry quantities of dust and dirt into slide projectors and onto the slides.

Amount of Ventilation Required

A heating or air-conditioning engineer or consultant can calculate ventilation and heat disposal requirements on the basis of room occupancy and electrical requirements. However, the engineer may need to know from you the total amount of heat generated by the slide projectors, as well as any additional audiovisual equipment. This heat is governed largely by the wattage of equipment components that will be used in combination. Thus, if two slide projectors are available but only one is used at a time, there is no need to provide cooling or ventilation for two projectors. On the other hand, if the two projectors are used simultaneously but only for a few minutes or seconds out of an hour, it is not necessary that you provide ventilation and cooling for both projectors. However, if both are consuming maximum power (even though one is not actually projecting), ventilation for both must be supplied.

Determining the Amount of Heat Produced

To compute the heat produced per hour by any piece of audiovisual equipment, the power consumption (watts, kilowatts, or amperes) must be converted to Btu's (British Thermal Units). The power rating can usually be found on the nameplate of the AV equipment. For example, the *EKTAGRAPHIC* III Projector uses a total of 400 watts. Multiply 400 by 3.4 (each watt the projector uses generates 3.4 British Thermal Units) and the heat output is 1,360 Btu's per hour.

In the following examples, these facts are necessary for the calculations of Btu's:

- 1 kilowatt (1000 watts) generates approximately 57 Btu's (60,000 joules*) per minute or about 3400 Btus (3608 kilojoules) per hour.

- 1 watt (0.001 kilowatt) generates about 3.4 Btu's (3608 joules) per hour.

- To convert amperes to watts, multiply amperes by voltage (either the power source operating voltage or the maximum required voltage as stated on the equipment nameplate).

Examples:

- Component uses

$$\begin{array}{r} 700 \ \text{W} \\ \times \ 3.4 \\ \hline 2380 \ \text{Btus generated per hour} \end{array}$$

or

$$\begin{array}{r} 0.7 \ \text{kW} \\ \times \ 3400 \\ \hline 2380 \ \text{Btus generated per hour} \end{array}$$

- Component power requirement—110 to 125 volts ac, 3 amps

$$\begin{array}{r} 3 \ \text{A} \\ \times \ 125 \ \text{V} \\ \hline 375 \ \text{W} \\ 375 \ \text{W} \\ \times \ 3.4 \\ \hline 1275 \ \text{Btus generated per hour} \end{array}$$

One cubic foot (0.03 cubic metre) of air per minute should be circulated in the projection area for each 10 W of power used by a projector. When calculating the total heat load for the projection room or booth, remember to include (besides the audiovisual equipment) such things as lights, rheostats, and the number of people that will occupy the room during a slide presentation.

Ventilation, although extremely important, is only one of the many factors you should consider in the design of a projection area. Before you begin construction, be sure to check your local building codes for specifications on the type of wiring required, the use of fireproof building materials, and soundproofing.

*1 Btu equals approximately 1055 joules.

PART VI
Detailed Plans for Helpful Home-Built AV Projects

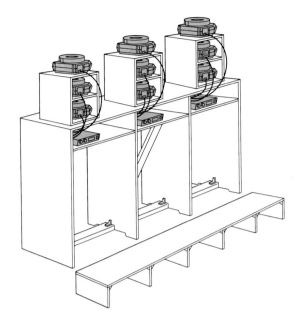

INTRODUCTION

In Part VI of *The Source Book*, we have provided easy-to-understand plans for the construction of the following useful items:

- Sound-deadening projector blimps
- Two-projector piggyback stands
- A convenient, easy-to-build projection table (with a step-up bench)
- A companion shelf unit

MAKING BLIMPS FOR *EKTAGRAPHIC* SLIDE PROJECTORS

The blimp designs that follow should be used only as examples; the dimensions shown apply to typical *EKTAGRAPHIC* Slide Projectors.

NOTE: No blimp plan exists that can accommodate every projector under all conceivable operational conditions.

These two drawings show a blimp that can be placed over a *KODAK EKTAGRAPHIC* Slide Projector, Models E-2, B-2, B-2AR, AF-l, AF-2, or AF-2K. This blimp permits adequate ventilation and provides access to the projector controls and projector remote-accessory receptacle.

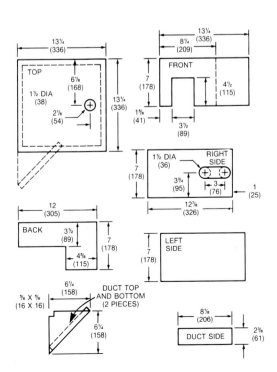

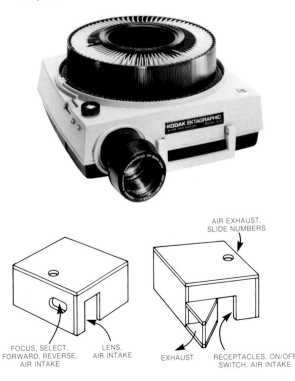

FOCUS, SELECT, FORWARD, REVERSE, AIR INTAKE — LENS, AIR INTAKE

AIR EXHAUST, SLIDE NUMBERS

EXHAUST — RECEPTACLES, ON/OFF SWITCH, AIR INTAKE

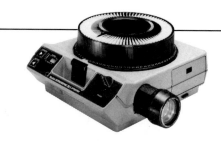

MAKING BLIMPS FOR *EKTAGRAPHIC* III PROJECTORS

HINGED DOOR PROVIDES ACCESS TO CONTROLS

NOTCHES PERMIT USE OF BUILT-IN PREVIEW SCREEN

FOR LENS, LIGHT BEAM

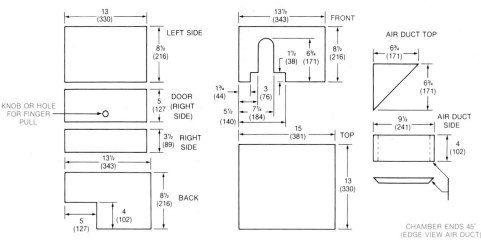

LEFT SIDE

13 (330)

8½ (216)

KNOB OR HOLE FOR FINGER PULL

DOOR (RIGHT SIDE)

5 (127)

RIGHT SIDE

3½ (89)

13½ (343)

BACK

8½ (216)

5 (127)

4 (102)

FRONT

13½ (343)

8½ (216)

1½ (38)

6¾ (171)

1¾ (44)

3 (76)

5½ (140)

7¼ (184)

15 (381)

TOP

13 (330)

AIR DUCT TOP

6¾ (171)

6¾ (171)

9½ (241)

AIR DUCT SIDE

4 (102)

CHAMBER ENDS 45° (EDGE VIEW AIR DUCT)

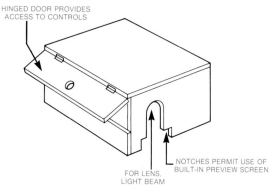

AIR DUCT ADDED IN BACK REDUCES NOISE FROM FAN AREA CONSIDERABLY.

The air duct in back reduces noise from the projector fan considerably. The duct can be hinged to permit raising it for access to the projector receptacles or it can be permanently attached (requiring lifting the entire blimp off for access to the projector).

The two notches at the bottom of the arch permit using the built-in viewing screen of *EKTAGRAPHIC* III Projectors having that feature. If the built-in viewing screen of the projector will be used, the front wall thickness of the blimp should not exceed ³/₄ inch (19 mm). The elevation foot must be retracted if the built-in screen is used.

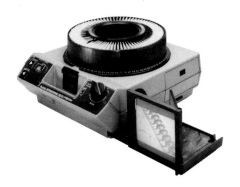

The inside of the blimp should provide a space 11¹/₂ inches (292 mm) long, front to back; 13¹/₂ inches (343 mm) wide; and 8¹/₂ inches (216 mm) high. These dimensions will permit using the leveling foot and will allow full elevation of the projector, if desired.

If only slight projector elevation or no elevation is required, the height can be reduced 1 inch (25 mm) to 7¹/₂ inches (191 mm), and the height of the door can be reduced from 5 to 4 inches (127 to 102 mm).

The arched opening in the front can be squared off, if desired; it will fit over lenses that extend from the front of the projector. The opening provides space for the projector light beam.

NOTE: A few commercially available very large diameter lenses (not manufactured by Kodak) may require that you enlarge the opening.

The primary air intake for these projectors is located at the front; the primary exhaust is at the back, with the projector exhaust airstream exiting at approximately a 45-degree angle from the back grill.

IMPORTANT: Do not allow either opening in the blimp to be obstructed or restricted.

The two-piece optional air duct at the back will provide additional silencing. Hinging the duct permits raising it for access to the receptacles at the back of the projector, and for viewing the green standby light on *EKTAGRAPHIC* III Projectors.

Opening the side door allows direct access to the projector control panel. Use of a remote control for forward, reverse, and focus will allow the door to remain closed for maximum sound deadening.

High-density materials are generally the best for preventing sound transmission. Plywood or chipboard ³/₄ inch (19 mm) thick will provide appreciable quieting.

Normally, the projector will be set up for operation and the blimp will then be put over it. The top of the blimp (or a portion of it) can be left unattached or hinged to permit changing trays without removing the blimp. The exterior surfaces of the blimp can be painted, stained, or finished as desired. If the interior has loose particles on the surface (as some insulation board and plywood does), paint it to reduce the chance of dust and particles getting in the slides and into the projector.

SIMPLE PIGGYBACK PROJECTION STANDS

We suggest that you include in your plans for your next two- or three-projector, single-screen, dissolve show (or two-screen, side-by-side show) a piggyback stand. These stands conserve table space, reduce keystoning, and simplify image alignment.

Building a Metal Piggyback Stand

A three-legged piggyback stand can be made from a piece of soft aluminum, 0.25 in. x 1 in. x 6 ft (6 mm x 25 mm x 1.8 m). This material is available at most hardware stores and can be cut with woodworking tools. If you are inexperienced in metalworking, make the pieces a little too long, bend them, and saw them off to fit.

Dimensions for the stand shown here appear in the table below. The dimensions apply to most current projectors.

Either rivet the two pieces together permanently or use a single bolt and wing nut that can be loosened to permit folding the stand. Cups for the projector feet should be at least 0.88 in. (22 mm) in diameter and 0.13 in. (3 mm) deep and riveted or bolted to the bar stock; metal or plastic sliding-door pulls or bottle caps can be used.

Accuracy to within 0.03, or $\frac{1}{32}$ inch (1 mm), will be sufficient.

Putting slots in the bar and fastening the cups with screws, washers, and wing nuts will allow you to adapt the stand for all three body styles.

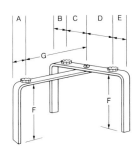

Projector Style	Dimensions						
	A	B	C	D	E	F	G
KODAK EKTAGRAPHIC III *Projectors*	1.19 (30)	1.38 (35)	4.52 (115)	4.23 (107)	1.38 (35)	8.80 (224)	8.69 (220)
Most KODAK EKTAGRAPHIC Slide Projectors	1.50 (38)	1.75 (44)	3.38 (86)	4.63 (118)	1.75 (44)	8.00 (203)	8.31 (211)
KODAK EKTAGRAPHIC S-AV Projectors	1.56 (40)	0.88 (22)	4.87 (124)	4.87 (124)	0.88 (22)	8.00 (203)	8.25 (210)

Dimensions are in inches and (millimetres).

If you do not intend to use S-AV Projectors, you can make the L-shaped front leg 0.25 in. (6 mm) shorter than the back legs, giving a slight downward tilt to the projector.

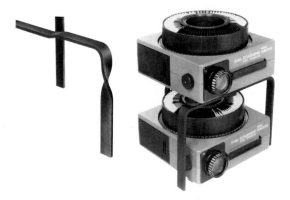

When using the *EKTAGRAPHIC* Slide Projector, Model S-AV2030 or Model S-AV2050, reverse the position of the stand so that the single leg is located at the back. This is necessary because there are two leveling feet at the front of these projectors, while there is just one at the front of Kodak slide projectors made in the U.S. and Canada. (If you turn the stand around for S-AV Projectors, put something under the short leg and twist the short leg 90 degrees as shown, to prevent blockage of the projector exhaust.)

To prevent the stand from scratching the surface of the table or counter, file the leg ends smooth, cover them with tape or 0.25 in. (6 mm) channel (used to set plate-glass windows), or dip them in air-curing plastic.

For two-screen (side-by-side) projection (instead of single-screen projection with superimposed images), *be sure to align the top projector for the left screen.* The space under the stand permits aligning the lower projector for the right screen and changing trays from the rear. (If you attempt to align the lower projector for the left screen, the front leg of the stand may get in the way.)

Building a Wooden Stand

The top of the wooden stand is an equilateral triangle, approximately 17.25 in. (438 mm) on each side, made of 0.75 in. (19 mm) plywood. The legs are 0.75 in. (19 mm) hardwood dowel, each 9.38 in. (238 mm) long. Drill 0.75 in. (19 mm) holes through the top for the legs; glue the legs in with a 0.13 in. (3 mm) recess on top if you want to stack a second stand on top (for a three-projector dissolve show, or a two-projector show with a third projector for background or title slides, etc).

The dimensions appear below.

Dimensions for Wooden Stand

Projector Model	Style	Distance (in./mm)
KODAK EKTAGRAPHIC III Projectors	A-C	8.75 (222)
Most KODAK EKTAGRAPHIC Slide Projectors	A-B	8 (203)
KODAK EKTAGRAPHIC S-AV Projectors	A-D	9.75 (248)

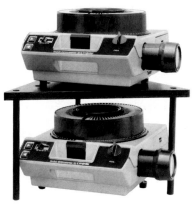

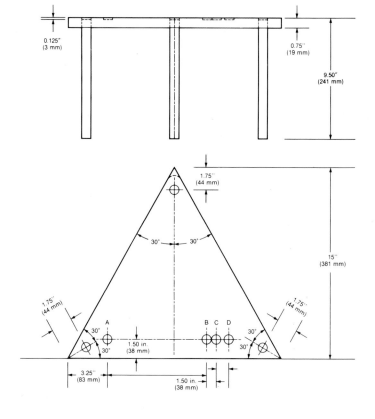

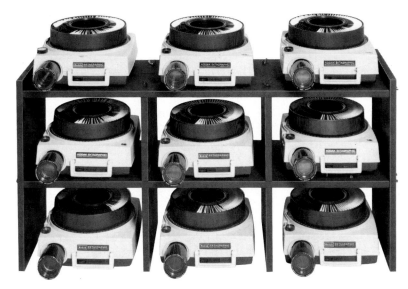

Wooden stands can also be made for large multi-image presentations.

Commercially Available Projector Piggyback Stands

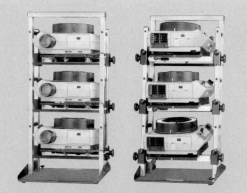

Piggyback stands for *KODAK* Slide Projectors are made and distributed by these companies. (Not all stands will accommodate S-AV models.)

NOTE: Check to see if your projectors will need to be stacked close to or against a back wall, requiring projector alignment (piggyback-stand adjustment) from in front of the stand. (Not all stands have projector-alignment controls in back *and* in front of the stand.)

Two- and three-projector piggyback stands are available in designs similar to the one shown here, manufactured by Chief Manufacturing, Inc.

American Professional Equipment Co.
2802 South MacDill Ave.
Tampa, FL 33609

Audio Visual Contractors Co.
6875 Evans Ave., East
Denver, CO 80224

Buhl Optical Co.
1009 Beech Ave.
Pittsburgh, PA 15233

Chief Manufacturing Co.
12002 Riverwood Dr.
Burnsville, MN 55337

Da-Lite Screen Co.
P. O. Box 137
3100 State Rd. 15 North
Warsaw, IN 46580

General Audio-Visual, Inc. (GAVI)
333 West Merrick Rd.
Valley Stream, NY 11580

Harry Joseph and Assoc.
110 West 94th St.
New York, NY 10025

Kimchuck, Inc., AV Division
34 Del Mar Dr.
Brookfield, CT 06804

MacKenzie Laboratories, Inc.
P. O. Box 3029
5507 North Peck Rd.
Arcadia, CA 91006

Media Equipment, Inc.
7326 East 59th Pl.
Tulsa, OK 74145

Optisonics HEC Corp.
1802 West Grant Rd., 101
Tucson, AZ 85745

Sauppe Media, Inc.
13034 Saticoy St.
North Hollywood, CA 91605

Singer Education Systems
P. O. Box 1371
3750 Monroe Ave.
Rochester, NY 14603

Welt/Safe-Lock, Inc.
2400 West 8th La.
Hialeah, FL 33010

WTI, Incorporated
22951 Alcade Dr.
Laguna Hills, CA 92653

A TABLE AND STEP-UP BENCH
FOR MULTI-IMAGE PROJECTION

This projection table can be used almost anywhere that a number of slide projectors are needed to present an audiovisual presentation—from a simple two- or three-projector dissolve show to a dazzling multi-image presentation using 15 projectors.

Of course, any table of sufficient height and length would be acceptable, but such tables are usually hard to find.

If a very wide projection screen is being used (such as 40 feet [1.22 metres]), more than one of these tables will be needed—unless curved screens are being used.

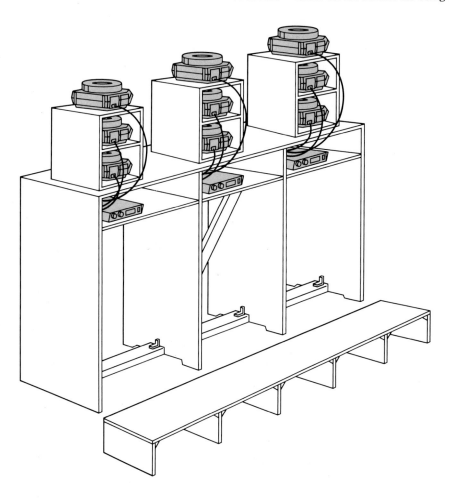

Materials:

- Two sheets of plywood, 4 x 8 ft. x ³/₄ in. (1.22 m x 2.44 m x 19 mm)

- One 2 x 4 (nominal) x 95¹/₂ in. (38 mm x 76 mm x 2.42 m)

- One 2 x 4 (nominal) x approximately 49 in. (12.45 m) for the brace.

- glue, nails, screws, six angle irons.

The table top will be 48 in. (1.22 m) above the floor. The shelf is normally used for the dissolve-control equipment. The rabbeted joints should be glued and nailed. If desired, enclose the front of the table and paint it; or drape the front and ends.

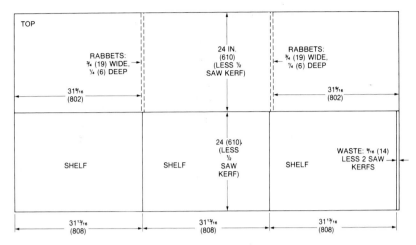

TOP

RABBETS:
¾ (19) WIDE,
¼ (6) DEEP

24 IN.
(610)
(LESS ½
SAW KERF)

RABBETS:
¾ (19) WIDE,
¼ (6) DEEP

31⁹⁄₁₆
(802)

31⁹⁄₁₆
(802)

SHELF

SHELF

24 (610)
(LESS
½
SAW
KERF)

SHELF

WASTE: ⁹⁄₁₆ (14)
LESS 2 SAW
KERFS

31¹³⁄₁₆
(808)

31¹³⁄₁₆
(808)

31¹³⁄₁₆
(808)

**MULTI-IMAGE PROJECTION TABLE: CUTTING DIAGRAM
FOR ¾ IN. X 4 FT. X 8 FT. PLYWOOD SHEETS**

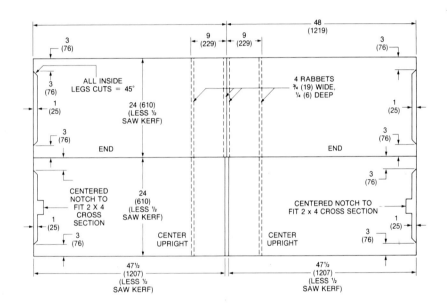

48
(1219)

3
(76)

9
(229)

9
(229)

3
(76)

3
(76)

ALL INSIDE
LEGS CUTS = 45°

4 RABBETS
¾ (19) WIDE,
¼ (6) DEEP

1
(25)

24 (610)
(LESS ½
SAW KERF)

1
(25)

3
(76)

3
(76)

END

END

CENTERED
NOTCH TO
FIT 2 X 4
CROSS
SECTION

24
(610)
(LESS ½
SAW KERF)

CENTERED NOTCH TO
FIT 2 x 4 CROSS SECTION

3
(76)

1
(25)

1
(25)

3
(76)

CENTER
UPRIGHT

CENTER
UPRIGHT

3
(76)

47½
(1207)
(LESS ½
SAW KERF)

47½
(1207)
(LESS ½
SAW KERF)

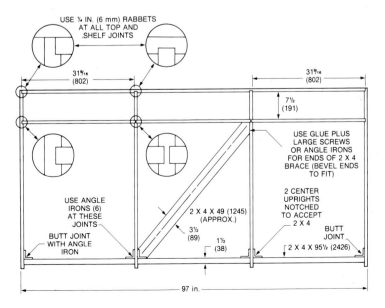

USE ¼ IN. (6 mm) RABBETS
AT ALL TOP AND
SHELF JOINTS

31⁹⁄₁₆
(802)

31⁹⁄₁₆
(802)

7½
(191)

USE GLUE PLUS
LARGE SCREWS
OR ANGLE IRONS
FOR ENDS OF 2 X 4
BRACE (BEVEL ENDS
TO FIT)

2 CENTER
UPRIGHTS
NOTCHED
TO ACCEPT
2 X 4

USE ANGLE
IRONS (6)
AT THESE
JOINTS

2 X 4 X 49 (1245)
(APPROX.)

3½
(89)

1½
(38)

BUTT
JOINT

BUTT JOINT
WITH ANGLE
IRON

2 X 4 X 95½ (2426)

97 in.

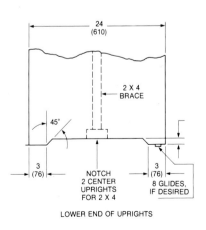

24
(610)

2 X 4
BRACE

45°

3
(76)

NOTCH
2 CENTER
UPRIGHTS
FOR 2 X 4

3
(76)

8 GLIDES,
IF DESIRED

LOWER END OF UPRIGHTS

NOTE: All dimensions are in inches and (mm).

Step-Up Bench

This $10\frac{1}{2}$-inch (267 mm) high step-up bench allows a sufficient height for the projectionist to reach the top-most stacked projectors for alignment and focusing, changing trays, operating projector controls, etc. Obviously, the height of the step-up bench can be modified depending upon how high the projectors are stacked, how tall the projectionists are, etc.

Materials

- One piece of plywood, 2 ft. x 8 ft. x $\frac{3}{4}$ in. (6.10 m x 2.44 m x 19 mm)
- One piece of 2 x 4 (nominal) x 42 in. (1.06 m)
- glue, nails
- paint, if desired

NOTE: The height of the bench can be modified, depending upon how high the projectors are stacked.

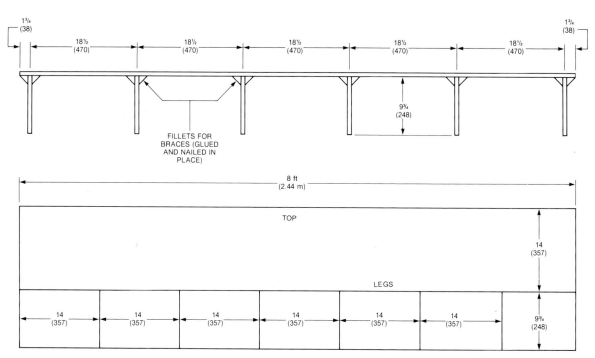

FILLETS FOR BRACES (GLUED AND NAILED IN PLACE)

CUTTING DIAGRAM FOR ½ SHEET OF 4 X 8 FOOT SHEET OF PLYWOOD RIPPED LENGTHWISE

NOTE: Rip 2 X 4 X 42 inch (1067 mm) as indicated to make fillets for bracing the legs. Twelve pieces are needed, each approximately 14 inches (357 mm) long.

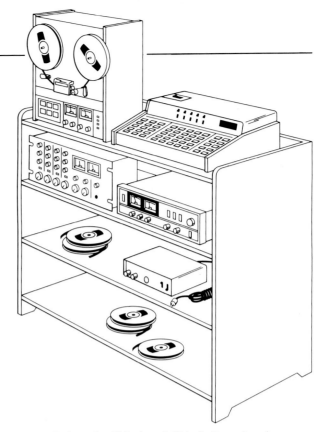

A COMPANION SHELF UNIT FOR SUPPORT EQUIPMENT

The top of this shelf unit is approximately 42 in. (1.06 m) above the floor—a convenient height for most projectionists sitting on a tall stool or standing.

The top shelf provides enough space for a multi-image computer programmer and a large reel-to-reel tape recorder. The 2-inch (50.8 mm) wall at the sides and back will prevent the equipment from being accidentally pushed off and damaged.

There is also ample space on the second shelf for an audio preamplifier and power amplifier, and two additional shelves for any other audio components—such as a signal processor, equalizer, etc.

The shelves are open in the back to permit equipment cables to pass from one shelf to another.

The third and fourth shelves can be used to hold additional equipment or smaller items such as slide-tray boxes, extra lenses, spare lamps for projectors, audiotapes, alignment slides, and other supplies.

Reduce the 24 inch and 48 inch dimensions by one-half saw kerf* to permit economical cutting of the shelf unit from 1½ sheets of 4 ft. x 8 ft. x ¾ in. plywood.

If desired, the unit can be backed by ¼ in. (6.3 mm) plywood or ⅛ in. (3.2 mm) hardboard to increase rigidity and to eliminate the need for braces under the shelves; but large holes will be needed either in the back or in the shelves for the interconnection of equipment cables.

The bottom shelf (or a brace across the bottom) is needed for rigidity. Obviously, the shelf spacing and overall size can be changed as needed. For ease in moving, heavy-duty casters can be added.

Attach shelves with 2 in. (51 mm) screws and glue; or ⅜ in. (9.5 mm) dowel and glue.

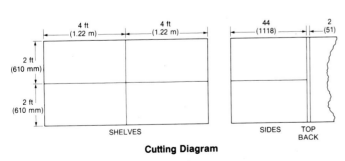

Cutting Diagram

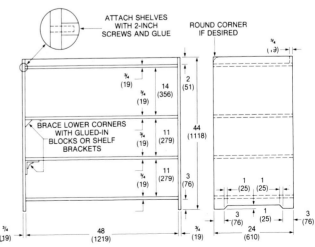

*Saw kerf: The width of the cut that a saw makes in the wood.

Mirror, Mirror, on the Floor

Using mirrors for viewing a projected image has some interesting possibilities for application in exhibits, planetarium programs, multi-image displays at expositions, and disco and light shows.

To illuminate the point, Kodak used projectors and mirrors in an audiovisual program called "The Image Pit," at the National Audiovisual Association and Association for Education Communications and Technology conventions in recent years.

The Image Pit takes advantage of a basic characteristic of flat mirrors: They create an illusion of depth equal to the distance between a mirror and a mirrored subject. Slides are projected onto the ceiling, but the audience sees them on mirrors placed on the floor.

The Image Pit consisted of a mirrored floor (with a railing around it) 9 feet (2.74 m) square, and 12 *EKTAGRAPHIC* Slide Projectors in the center. Spectators looked over the railing and into the mirrors to see the reflection of a multi-image slide program, "Reflections on Professionalism," projected by the 12 projectors onto mirrors located in front of the lenses and then onto a ceiling screen. Because of the mirrored floor, images *appeared* to be projected on a screen 12 feet (3.6 m) *below* the floor. (Audio was provided by a four-channel reel-to-reel tape played through loudspeakers located near the ceiling and aimed down toward the audience.)

Planning and building such a mirrored viewing area is adaptable for smaller single-projector and two-projector dissolve programs as well as for more complex multi-image presentations.

Here are the most important considerations to keep in mind when determining mirror sizes and locations for a projection system that uses mirrors for viewing a projected image.

The important dimensions and locations are the viewers' eyes and the apparent image position. (The apparent image position will remain the same, regardless of viewer position.)

The size of the mirror required is determined by where lines from the observer's eyes cross the apparent image location.

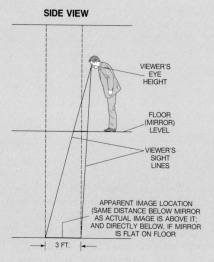

SIDE VIEW

VIEWER'S EYE HEIGHT

FLOOR (MIRROR) LEVEL

VIEWER'S SIGHT LINES

APPARENT IMAGE LOCATION (SAME DISTANCE BELOW MIRROR AS ACTUAL IMAGE IS ABOVE IT; AND DIRECTLY BELOW, IF MIRROR IS FLAT ON FLOOR)

3 FT.

If the minimum-size mirror were used, head movement would cut off at least some of the image. The solution is to diagram the *extreme* eye positions expected, and then determine mirror size and location from them, as shown here.

The other dimension of the mirror is determined in the same way.

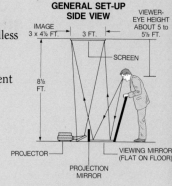

GENERAL SET-UP
SIDE VIEW

IMAGE 3 x 4½ FT. 3 FT. VIEWER-EYE HEIGHT ABOUT 5 to 5½ FT.

SCREEN

8½ FT.

PROJECTOR

VIEWING MIRROR (FLAT ON FLOOR)

PROJECTION MIRROR

SCALE: APPROX. ⅛ IN. = 1 FT.

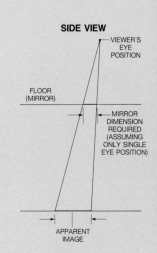

SIDE VIEW

VIEWER'S EYE POSITION

FLOOR (MIRROR)

MIRROR DIMENSION REQUIRED (ASSUMING ONLY SINGLE EYE POSITION)

APPARENT IMAGE

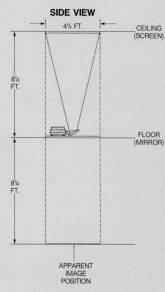

SIDE VIEW

4½ FT. CEILING (SCREEN)

8½ FT.

FLOOR (MIRROR)

8½ FT.

APPARENT IMAGE POSITION

(CONTINUE

Again, only the *viewers'* eye position, the mirror plane (floor), and the apparent image position are necessary for the diagram.

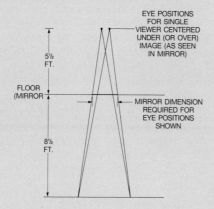

The mirror size is calculated in the same way. If the mirror is 4 ft above the floor, the screen will be 4½ ft from the mirror, so the apparent image position will be 4½ ft behind (below) the mirror, or 6 inches under the floor.

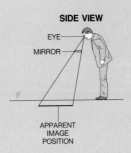

Note that because the mirror is relatively close to the viewer's eyes, his or her height will have relatively more effect on the mirror size required. Thus, a short person would require only a very small mirror; a taller person would require a larger one.

The mirror width can be calculated the same way, remembering that our eyes are about 2½ in. apart, so the mirror will need to be a little wider because of the two different eye locations affecting width.

With several smaller mirrors, keeping the plane of each mirror parallel to the plane of the screen is preferable, to avoid apparently skewed viewing of the image.

Multiple viewing positions can be indicated, with the extreme positions determining mirror size and location. Note that if the extreme positions are directly over the ends of the apparent image, the mirror needs to be as large as the image. If eyes are outside of the apparent image area, the mirror must be larger than the image dimension in order for the complete image to be seen by people standing to one side.

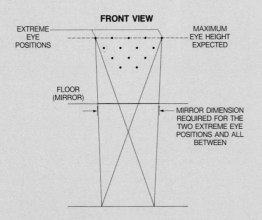

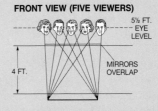

If several viewing positions are located close together, a single wide mirror may be required, since all the small mirror positions would overlap. But if the viewing positions are spaced more widely, several small mirrors may be used. The other dimension of the mirror or mirrors would be about the same in either case.

Making the mirrors a couple of inches or so larger than calculated is desirable, to allow for small misalignments in various system components. Note that raising the mirror will reduce the size required somewhat—but this will also mean a new location for the apparent image position (because the mirror-to-screen distance will be reduced). If the mirrors are angled, calculating apparent image position requires somewhat more complicated diagrammatic solutions.

Another possibility is to use several small mirrors—one for each viewer. Each viewer would be positioned to see the complete image in "his" or "her" mirror.

For example, with the same image size (3 ft x 4½ ft) and screen height (8½ ft) a small mirror at a 4 ft height would permit a viewer to see the whole image. Another small mirror, a little further to one side, would accommodate another viewer.

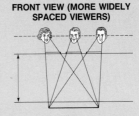

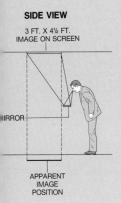

KTAGRAPHIC Slide Projectors were used in The Image Pit.''

129

Keystoning

Wherever multiple projectors are used to display images, keystoning will always be a consideration.

Keystoning is the result of projecting an image onto a screen that is not perpendicular to the light path. It is defined by the angle between a normally rectangular oriented image and the actual one. The resulting image can appear in many forms of geometrical distortion.

Three factors responsible for the amount of keystoning of by an image:

- The angle between the screen and the projection beam.
- The angle of light spread, which is determined by lens focal length.
- The image format (square or rectangular).

In both cases involving angles, the smaller angle gives less keystoning. In the case of the image format for images the same height, the more nearly square the image, the less keystoning there will be.

The mathematical relationship between the parameters is complex, but may be summarized as follows:

- For images of the same height, the more nearly square they are, the less the keystoning. A slide image with a height-to-width ratio of 2:3 can increase keystoning by 50% over a square image. In other words, an image that keystones 5° for a square image will keystone 7.5° for a 2:3 image.
- Lenses decrease keystoning in proportion to their focal length. A 4-inch lens will keystone half as much as a 2-inch lens.
- Changing the angle between the projection beam and the screen has an effect equal to equivalent changes in focal length. Halving the angle from 20° to 10° for a 3-inch lens used with a slide projector changes the keystoning from 4.4° to 2.2°, while doubling the lens focal length to a 6-inch lens at 20° gives the same result: 4.4° to 2.2°. Both halving the angle *and* doubling the lens focal length decreases keystoning from 4.4° to 1.1°.

How much keystoning is tolerable? There is a tendency to answer this question with another one: compared with what?

Keystoning may be quite noticeable where images are projected side by side. However, it may not be noticeable for conventional single-image projection. Keystoning can be masked (or hidden) by spilling the image off the screen onto a matte-black border. This technique is often used in large theatres to mask the keystoning caused by high-elevation projection booths. In situations where the keystoning is well masked by overspilling the screen, often the only way to detect the effect is by the subject matter in the image (i.e., the exaggerated lean of a picket fence running across an image could indicate keystoning).

Here are the most important keystoning considerations:

- If the center of the projector beam is at 90° to the screen surface, the image will be rectilinear (correctly appearing).

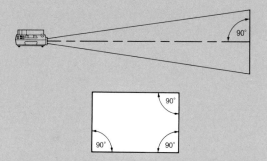

- If the projector is tilted up or down, or angled sideways, the sides of the image will no longer be parallel.

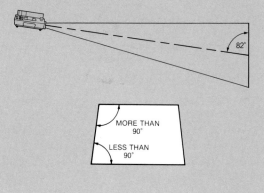

(CONTINUED)

If, as before, the projector is tilted downward, the distance from the lens to the bottom of the screen will be greater than the distance to the top, so the bottom of the image will be magnified more, just as if the projector were moved farther from the screen. If the projector is tilted up, the top of the image will be magnified or enlarged more, and so on. So long as the angular difference between the screen surface and beam center is close to 90°, the differences will not be great.

With three stacked projectors, there will be minimum keystoning if the center projector is at 90° to the screen as shown here, and the other two projectors are located as close above and below it as possible, to keep the angles of all three beam centers as close together as possible.

The greater the projection distance, the less beam angle variance, and the less keystoning will take place.

The amount of keystoning can be calculated by laying out the projection distance and angles as shown here. This is a projector with a 135-size slide, 4-inch lens, and 14-foot projector-to-screen distance.

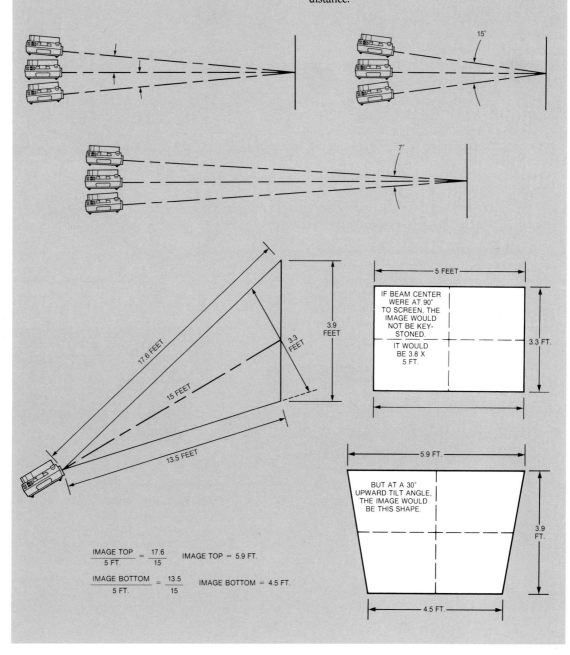

$$\frac{\text{IMAGE TOP}}{\text{5 FT.}} = \frac{17.6}{15} \qquad \text{IMAGE TOP} = 5.9 \text{ FT.}$$

$$\frac{\text{IMAGE BOTTOM}}{\text{5 FT.}} = \frac{13.5}{15} \qquad \text{IMAGE BOTTOM} = 4.5 \text{ FT.}$$

IF BEAM CENTER WERE AT 90° TO SCREEN, THE IMAGE WOULD NOT BE KEY-STONED.

IT WOULD BE 3.8 X 5 FT.

BUT AT A 30° UPWARD TILT ANGLE, THE IMAGE WOULD BE THIS SHAPE.

PART VII
Projector Remote Control

INTRODUCTION

In much new construction, as well as in the remodeling of older buildings, projection facilities are often provided as an integral part of the meeting rooms. The necessity for acoustical isolation and security of the equipment and the emphasis on a professional presentation dictate that remote controls be included as part of the design.

Many projector remote controls are commercially available that have a wide range of sophistication, portability, and suitability for particular applications. A number of remote controls are described in the Program Control Devices section of the *Audio-Visual Equipment Directory.*

NOTE: The *DIRECTORY* is published annually by the National Audio-Visual Association, Inc., 3150 Spring St., Fairfax, VA 22031; phone: (703) 273-7200. Copies of the *DIRECTORY* are often available in large libraries or from dealers in audiovisual products.

Eastman Kodak Company does not offer a service for making the modifications suggested in this section of *The Source Book,* nor do we customarily make available specifications for special remote-control wiring or other devices. This information is presented only to help you determine the feasibility of using projector remote controls and to devise them if you see the need.

KODAK EC REMOTE CONTROLS

Since the introduction of the original *EKTAGRAPHIC* Slide Projector, many improvements have been made to successive projector models to satisfy the growing requirements of audiovisual professionals. Some of these improvements have involved the *KODAK* EC Remote Control units intended for use with the projectors (and the corresponding wiring in the projectors).

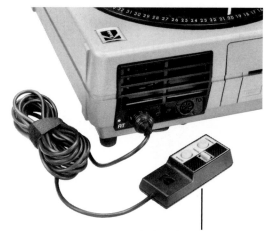
KODAK EC-2 Remote Control

KODAK EC-3 Remote Control

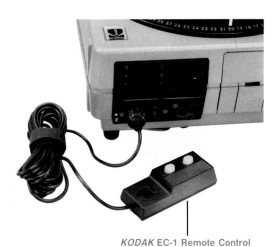
KODAK EC-1 Remote Control

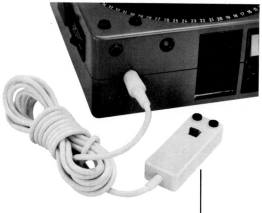
EKTAGRAPHIC S-AV Remote Control

NOTE: There is no single, universal remote control that can be used to operate all built-in operating features of all *EKTAGRAPHIC* III and *EKTAGRAPHIC* Slide Projectors.

If you use a *KODAK* EC-2 or EC-3 Remote Control in conjunction with an external projector-control device (such as a dissolve control or sound-slide synchronizer), the remote control will generally advance or reverse the projector through the control device, but will not remotely focus the projector, even if the projector has built-in remote-focus capability. (Most dissolve controls and sound synchronizers are not wired for all of the control connections that are provided in the EC Remote Control; one or more of the remote-control functions usually will not operate through the external-projector control device.)

SCHEMATIC DIAGRAMS FOR *KODAK* EC REMOTE CONTROLS

Shown here are schematic diagrams for the *KODAK* EC-1, EC-2, and EC-3 Remote Controls. All forward, reverse, and focus switches are momentary contact, 24 V, 0.5 A maximum, and spring loaded; they are shown in the inactive position.

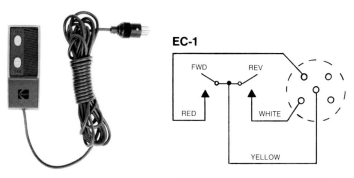

KODAK EC-1 REMOTE CONTROL

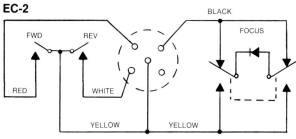

KODAK EC-2 Remote Control

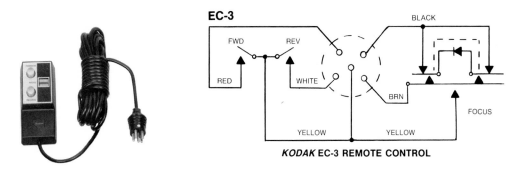

KODAK EC-3 REMOTE CONTROL

REMOTE CONTROL FOR *EKTAGRAPHIC* III AND *EKTAGRAPHIC* SLIDE PROJECTORS

The *KODAK* EC Remote Extension Cord, 25-foot, can be used to extend the operating range of a *KODAK* EC Remote Control. The extension cord is available from dealers in Kodak audiovisual products. Up to four extension cords can be linked together.

MAKING REMOTE EXTENSION CORDS

Remote extension cords of the required lengths can also be made. The remote circuits of *EKTAGRAPHIC* III and *EKTAGRAPHIC* Slide Projectors are low-voltage and isolated from the power line; heavy wiring and insulation are therefore unnecessary. Intercom cable or the equivalent can be used. Refer to the following table for the gauge of wire required for various cable lengths.

- For projectors that have only remote forward and remote reverse capability, three-wire cable can be used.

- Four-wire cable can be used for projectors that have remote forward and reverse as well as remote focus.

- If the extension cord is to be used for projectors that have remote forward, reverse, focus, *and* automatic focusing, five-wire cable is necessary.

NOTE: Five-wire cable for the initial installation is often advisable to provide for future needs; the additional cost is usually negligible.

Recommended Wire Gauge for Remote-Control Extension Cables

Maximum Cable Length in feet (metres)	AWG Conductor Size
65 (19.8)	24
100 (30.5)	22
160 (48.8)	20
250 (76.2)	18
400 (121.9)	16

BUILT-IN REMOTE CONTROL

Mounting a *KODAK* EC Remote Control into a lectern, table, cabinet, on a wall, and so forth, is usually easier and less expensive than finding and buying the special wire and switches needed to duplicate the functions of the remote control.

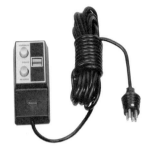

REMOTE PROJECTOR-POWER ON/OFF DEVICES

Remote on/off power control can be achieved with the *EKTAGRAPHIC* Slide Projector, Models E-2, B-2, B-2AR, AF-1, AF-2, AF-2K, and all six models of the *EKTAGRAPHIC* III Projector.

Most slide projectors can be switched on and off remotely by leaving the projector power on and inserting a relay or switch between the power outlet and the projector, using one of the following three methods:

- **Ratchet Relay**. A two-step (on/off) ratchet relay permits two-wire operation with momentary push-button switches and multiple control points. Use a relay that has a 3.7 A (minimum) tungsten contact rating for slide projectors equipped with 250 or 300 W lamps.

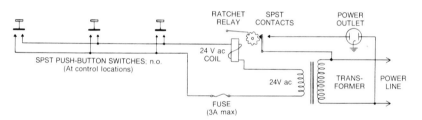

- **Two-Coil Latching Relay**. A two-coil, low-voltage latching relay permits the use of momentary push-button switches, lightweight control wires, and multiple control points, if needed.

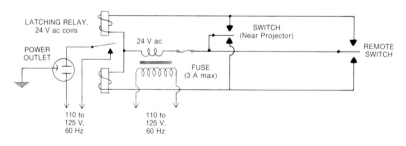

The four primary advantages of these two 24 V ac relay systems are as follows:

1. Low voltage at the switches provides adequate safety at less expense than high voltage.

2. Long wire lengths between the controlled projector outlet and the remote switch will not affect the line voltage of the projector.

3. Smaller diameter control cable can be used.

4. The addition of extra switching points is easier than in other systems.

The primary difference between the two methods (ratchet relay vs two-coil latching relay) is that the first method requires two wires and the second method requires three.

Use a control transformer such as the GE No. RT1 as a source of 24 V ac power, which can accommodate several control circuits. Specify 24 V ac coils for the relays. Most electrical codes limit 24 V ac control circuits to 3 A. (Use a Littelfuse, Type 3AG Slo-Blo fuse, or the equivalent).

• **Direct Power Control.** A common on/off wall switch of adequate capacity can be used to control the power outlet from a remote location. A pair of three-way switches is preferable since you can then turn the projector on or off near the projector as well as at the remote location.

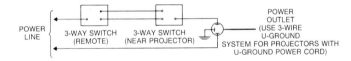

To turn the slide projector on or off at more than two locations, include as many four-way switches in the control line as necessary.

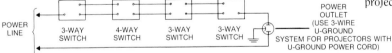

Maximum current requirements can be found printed on a plate or label on the slide projector. If given in watts, the ampere load can be determined by dividing watts by 120 for 120 V projectors.

Often the current listed is considerably more than actual, particularly when lower-wattage lamps are used. However, power line capacity should be based on maximum requirements.

Of the three systems described above for controlling projector power, the direct-power method is the least expensive if only one or two nearby control points are necessary. If distances are long, however, heavy wire will be required to prevent loss of power to the projector.

A PORTABLE REMOTE CONTROL BOX

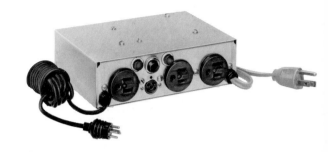

A presenter can use the portable remote-control box when he or she wants to maintain control of the projection equipment during the narrative.

As described earlier, almost any projector can be turned on and off from a remote position by leaving the projector power switch on and remotely controlling the power supplied to it.

This can be accomplished with a switch on the front panel of the portable remote control box between the power source and the projector.

The portable remote control box shown on page 136 allows electrical power to be switched from one outlet to the other, permitting audiovisual equipment connected to these two outlets to be alternately switched on and off. The relay to the switchable outlets is remotely actuated by the reverse button of a *KODAK* EC Remote Control plugged into the box.

NOTE: The tray reverse feature of slide projectors connected to the box is sacrificed so that power can be switched between the outlets. The remote-forward and remote-focus features are not sacrificed; however, appropriate wiring from the *KODAK* EC Remote Control is fed through the remote control box for normal projector operation.

Parts List for the Assembly of the Remote Control Box

Code	Description
—	Bud chassis base and bottom plate (7 in. (178 mm) L x 5 in. (127 mm) W x 2 in. (51 mm) H); AC 402 and BPA 1589 or CB-628 and BP 705.
DS-1, DS-2	Pilot lamp assembly, 115 V (Leecraft 36N2315 or equivalent).
J-1, 2, 3	Power receptacle, three-conductor (Leviton, Hubbel, or equivalent) to mate with P-1.
J-4	Receptacle, five-conductor (*KODAK* Part No. 166703* or equivalent) to mate with P-2.
K-1	Relay, SPDT, 24 V ac coil, 12.5 A contacts, impulse rachet type; alternate open and close with each actuation (Guardian 660-C or equivalent).
P-1	Power cord, three-conductor (*KODAK* Part No. 174752* or equivalent) to mate with H-1, J-2, and J-3; # 16 wire, 6 to 12 ft (1.8 to 3.6 ms) outside of box.
P-2	Projector cord, five-pin with cable (*KODAK* Part No. 185630*) to mate with J-4 orientation dot at top, 3 to 10 ft (0.9 to 3 metres) of cable outside of box.
SW-1	Activate Button, SPST, normally open (Switchcraft 101, 201, or equivalent).
T-1	Secondary Transformer, 24 V ac, 1 ampere (Triad F-45X or equivalent).
—	Miscellaneous nuts, bolts, wire, etc.

*These parts can be purchased from Eastman Kodak Company, Parts Services, 800 Lee Road, Rochester, NY 14650. Order Desk Telephone: (716) 724-7278. Parts not available from Kodak can be purchased from an electronics supplier.

COMPONENTS OF THE PORTABLE REMOTE CONTROL BOX

- **Power Cord**—Connect the three-prong plug on the power cord (P-1) to a 110 to 125 V, 60 Hz grounded outlet.

- **Controlled Outlets**—Connect a projector (or allied equipment) to either of the controlled outlets on the front of the remote-control box. Leave the projector switches turned *on* so that each projector will turn on or off when switched remotely.

- **Remote-Control Cord Receptacles**—The *KODAK* EC Remote Control can be plugged into the receptacle (J-4) on the front of the remote-control box. (Use one or more of the *KODAK* EC Remote Extension Cord, 25-foot, if desired.)

- **Control Cable**—If a slide projector or a dissolve control is to be used, insert the plug of the remote-control cable (P-2) into the receptacle on the projector or dissolve control.

- **Relay Activate Button**—The relay activate button (K-1) will control the power to the switched outlets or the reverse button on the slide projector. A *KODAK* EC Remote Control can be used from a remote position. The pilot lights (DS-1) will show you which controlled outlet is "live."

- **Live Outlet**—Use the live outlet (J-1) for other AV equipment requiring continuous power, such as a tape recorder, a worklight, etc. Since no currently manufactured projector is equipped with remote control of projector power on/off, turn the projector on and keep the screen dark prior to projection.

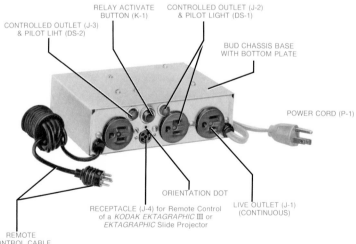

RELAY ACTIVATE BUTTON (K-1)

CONTROLLED OUTLET (J-2) & PILOT LIGHT (DS-1)

CONTROLLED OUTLET (J-3) & PILOT LIHT (DS-2)

BUD CHASSIS BASE WITH BOTTOM PLATE

POWER CORD (P-1)

ORIENTATION DOT

RECEPTACLE (J-4) for Remote Control of a *KODAK EKTAGRAPHIC* III or *EKTAGRAPHIC* Slide Projector

LIVE OUTLET (J-1) (CONTINUOUS)

REMOTE CONTROL CABLE & PLUG (P-2) FOR CONNECTION TO SLIDE PROJECTOR, OR *KODAK EKTAGRAPHIC* PROGRAMMABLE DISSOLVE CONTROL

EQUIPMENT COMBINATIONS

Some of the equipment combinations that can be controlled by the portable remote-control box are shown here:

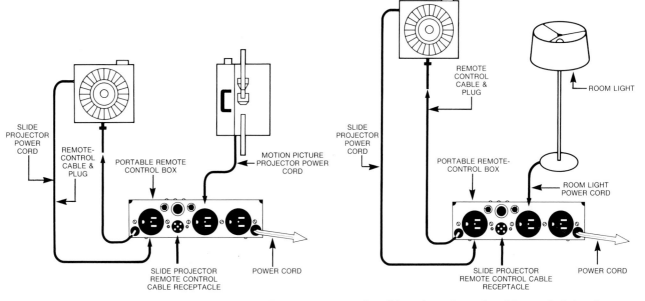

One Slide Projector and one Motion Picture Projector

One slide projector (or motion picture projector) and a room light.

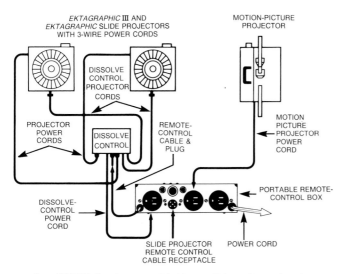

One *KODAK* dissolve control (with two slide projectors) and a motion-picture projector.

Important Operating Tips

- When starting and stopping projectors by switching from one power outlet to the other, the projector motors start under load. To be sure of sufficient power, the voltage supplied *at the projector power cord* (and thus the outlets on the remote-control box) must be at least 115 V with the projector operating.

- The power required from the live outlet (J-1) *plus* the maximum required of a switched outlet (J-2 and J-3), should not exceed the total capacity of the power supply circuit being used.

- Do not overload the portable remote-control box. No more than a 12.5 A load (1500 W at 117 V) should be connected to either of the switched outlets.

- When projectors are switched on and off by the portable remote-control box, the projection lamp and fan are switched on and off together.

NOTE: All wiring should conform to good practice and local electrical codes. If required, wiring should be inspected by the proper authority. Bare switch terminals or connections should be taped or covered to prevent shock hazard.

Controlling a Slide Projector or Dissolve Control with the Built-In Tape Deck of an *EKTAGRAPHIC* AudioViewer/Projector (Using a Home-Built Interconnect Device)

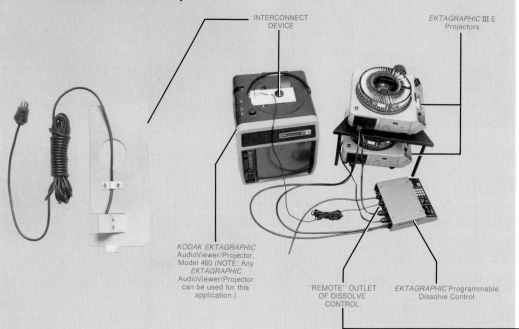

INTERCONNECT DEVICE

EKTAGRAPHIC III E Projectors

KODAK EKTAGRAPHIC AudioViewer/Projector, Model 460 (NOTE: Any *EKTAGRAPHIC* AudioViewer/Projector can be used for this application.)

"REMOTE" OUTLET OF DISSOLVE CONTROL

EKTAGRAPHIC Programmable Dissolve Control

REMOTE OUTLET

If your AV cassette machine is not available to control your sound-slide program, think about using the built-in tape deck of an *EKTAGRAPHIC* AudioViewer/Projector instead.

The tape deck built into the AudioViewer/ Projector has the same tape track configuration as most AV cassette players and can be used to play your show tapes (if the control track of the tape is recorded with ANSI standard 1000 Hz signals). The audio track of the tape can be reproduced over the loudspeaker in the AudioViewer/Projector (or it can be fed to a separate sound system). Detection of the recorded 1000 Hz signals on the control track of the tape will cause the slide-lift lever of the AudioViewer/Projector to cycle in the normal manner. However, an interconnect device mounted on the AudioViewer/Projector (in place of the slide tray) is used to advance any projector connected to it. The interconnect device has a switch on it that

responds to the pressure of the slide-lift lever; the resulting switch "closure" advances the external projector (or dissolve control).

NOTE: The interconnect device can be linked to the "REMOTE" outlet of the *EKTAGRAPHIC* Programmable Dissolve Control for playback of conventional 1000 Hz (with 1-second fade-rate) dissolve programs.

For a complete description of the interconnect device and detailed construction plans with life-size template, write to Eastman Kodak Company, Dept. 412L, 343 State St., Rochester, NY 14650, and ask for a single free copy of *KODAK* Publication No. S-80-23—*An Interconnect Device that Enables a KODAK EKTAGRAPHIC AudioViewer/Projector, Models 210, 260, 410, or 460, to Control an External KODAK Slide Projector or Dissolve Control.*

An AV Cassette machine.

138

PUSH-BUTTON START AND AUTOMATIC SHUTOFF

When using slide projectors for educational, advertising, or exhibit use, starting an automatic program by means of a person-actuated push button, timer, or other device, and having the program stop automatically at the end is often desirable.

Methods for providing these features for *EKTAGRAPHIC* III and *EKTAGRAPHIC* Slide Projectors (but not for S-AV Models) are described below.

Automatic program start and shutoff can be accomplished by mounting two roller-actuated switches on the projector and attaching one or more cams to an *EKTAGRAPHIC* Slide Tray. The cams will operate the switches as the tray rotates. A push button (or other external control) can be used to start the slide program;

at the end of the show, the cams and switches will cause the projector to advance to the next point in the program, and then shut off. The projector can be cycled by its own timer (on Models AF-2, AF-2K, and AT), an external timer, a manual remote control, or a tape recorder used with a synchronizing device (such as the *KODAK* EC Sound-Slide Synchronizer).

Two switches can be mounted on the body of the projector in almost any convenient location where they will not interfere with the projector controls. They should be the roller-actuated, single pole, double-throw type; since one of them will be used for direct switching of the power circuit, the switches must have a contact rating of 6 A or more at 125 V ac. Among the snap-action switches suitable for this application are Microswitch BA-2RL2-A2 or BA-2RV2-A2 and Acro FAD2-2M-1S or FAD2-LV2-1S.

The power-control switch should be wired to use the normally closed contacts, as shown here.

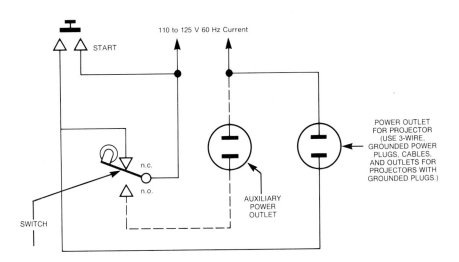

The push button, relay, or switch for program start should be the momentary-contact type, rated at 3.3 A or more at 125 V ac, for projectors with 300 W lamps. Acceptable push buttons are manufactured by Acro (3D05-5p), Cutler-Hammer (8444K4), and Arrow-Hart and Hegeman (80630).

NOTE: An auxiliary power outlet (for a lamp or other equipment), connected as shown by the dotted line, will be turned *on* when the projector is turned off; *off,* when the projector is turned on.

Tray advance from the end of one program to the beginning of the next one is controlled by the other roller-actuated switch. This switch should be connected as shown, using normally-open circuit contacts. It requires a contact rating of only 1/2 A at 24 V ac; but for convenience, a switch identical to the power switch can be used.

NOTE: To allow for use of the remote-control unit, connect the switch without cutting the red and yellow wires in the remote-control cable.

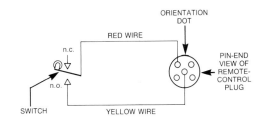

CAMS

The cams that are used to actuate the roller switches on the projector can be made of styrene plastic, self-sticking foam tape ⅛ in. or ¼ in. (3.17 or 3.65 mm) thick, or similar material and cemented or glued to the side of the tray. (Most hardware and grocery stores have adhesive-backed rubber or plastic bumpers that can be used as cams.) For the switches to function properly, the cams must be sufficiently thick and placed in the proper locations.

The power-switch cam should be attached to the tray at a location that will cause a power shutoff when the tray advances to the last position before the first slide to be projected.

A cycle cam should be located so that it will close the circuit immediately before the power switch is actuated, which will cause a change cycle to be started just as the power is shut off. (If less than a full tray of slides is being shown, the cycle cam should be made longer so that the projector will cycle through the empty slide slots (or dark slides) to the end of the presentation, at which time the power cam will shut off the projector on the last blank.)

The switch and suitably bent film holder clip are attached to the mounting plate. A 2-inch-long spring (ends formed into hooks) stabilizes the unit.

If a program contains fewer than 41 slides, we suggest that enough duplicate sets of slides be used, with dark slides between sets, to fill an 80-slide tray.

For example, if two sets of 35 slides each will be used, five dark slides should be inserted after one set and six after the other (a total of 81 slides, including blanks). The use of two cycling cams will cause the projector to advance rapidly through the dark slides after each set; two shut-off cams will stop the projector on the final dark slide after each set.

ADDITIONAL APPLICATIONS

A roller-actuated switch, in conjunction with cams on the slide tray, can be used for other purposes, as described below.

• **To Turn the Projector Lamp On or Off (*EKTAGRAPHIC* Slide Projectors only)**—Connect the switch contacts to the two bottom contacts of the remote-accessory receptacle on the slide projector. When the projector power-selector switch is in the FAN position, closing of the contacts will turn the lamp on; opening them will turn the lamp off. To make this connection, use a Projector Cord, *KODAK* Part No. 215420, or make up a two-contact plug that has contacts .094 in. (2.4 mm) in diameter, .350 in. (8.9 mm) in length, and spaces .312 in. (7.9 mm) from center to center. Suitable plugs are available in sets of six plugs and sockets from Radio Shack stores, Catalog No. 274-342.

• **To Turn Auxiliary Equipment On or Off**

1. The switch used to turn the projector power off can also be used to divert the power to a service lamp near the projector, or to room lights (within switch capacity). When the projector is started, the lamp or room light will shut off.

2. A separate switch and cam can be used to operate other audiovisual equipment while a show is in progress. For example, it can be used to control a spotlight that highlights a portion of a diorama related to the slide; or the projection of a motion picture film loop. (If one screen will be used for all projection, a slide projector should be used that keeps its shutter closed when no slide is in the gate, or an opaque (dark) slide should be inserted into the proper tray slot.

3. An additional power outlet wired in parallel with the one for the projector can be used to operate other equipment simultaneously with the projector (provided that the switch has sufficient capacity).

PART VIII
Maintenance and Care of *KODAK* AV Equipment and Slides

INTRODUCTION

In this section of *The Source Book* we discuss the heavy-duty use of *EKTAGRAPHIC* III and *EKTAGRAPHIC* Slide Projectors in ideal as well as adverse projection conditions (maximum-life conditions versus extremes of voltage and temperature). We outline routine projector-maintenance procedures, including the proper care and maintenance of *KODAK* Slide Trays. We show you how to examine your trays for damage, how and where to get replacement parts, and even provide hints on shipping them. Finally, we discuss the storage and care of slides, including factors that effect the useful life of a projected or stored transparency.

EKTAGRAPHIC III **Projectors can withstand the workload of continuous heavy-duty operation.**

Packing and Shipping Your Show

Someday you may face the challenge of getting your audiovisual show from your home site to a distant one. Moving AV equipment across country requires the specialized knowledge of people who work for freight-delivery organizations; individuals in your shipping department are also reliable contacts. Tell whomever you talk to what, when, and where to make shipment and when you must have delivery. They will decide how to ship it. Then leave the details to that person—but check back periodically to be sure it is running on schedule. Also write down the bill-of-lading number and the flight number (if shipping by air); you will need to refer to these numbers later if your equipment doesn't arrive on time.

Some manufacturers of AV equipment provide shipping cases for their own gear to reduce the possibility of damage in transit. Check to be sure ample soft packing material lines the interior surfaces of the case—especially if it is intended to hold a reel-to-reel tape deck, computer programmer, or other delicate equipment. Usually, double packing is a good idea for sensitive equipment. (The component is placed inside its own special case which is surrounded by plastic foam inside a larger crate.)

Sturdy shipping cases and trunks can be constructed to the dimensions of your equipment and lined with foam rubber with "pockets" for projectors, lenses, trays, dissolve modules, piggyback projector stands, reel-to-reel tape decks and cassette decks, multi-image computer programmers, amplifiers, loudspeakers, and the boxed AV show itself. (Be sure your cases and trunks will be light enough, when fully packed, so that two people can handle them without strain.)

When packing equipment for an out-of-town show, ask yourself, "What will I do if this component is damaged in transit or fails during rehearsal?" Shipping backup equipment not available locally can be crucial to the success of your show. (If your four-channel reel-to-reel tape deck is damaged, don't assume you can find another easily. Pack a cassette deck and backup cassette show tape.)

Also know how your equipment will be treated on delivery. Usually, it will be shipped to the receiving department of the facility where the presentation will be shown—or to one close to it. Contact an individual at the receiving area to be sure your equipment will be accepted and held in a secure area until you arrive—and that you will have immediate access to it.

HEAVY-DUTY OPERATION

EKTAGRAPHIC III and *EKTAGRAPHIC* Slide Projectors can withstand the workload of continuous, heavy-duty operation because they are ruggedly built. (Such use often consists of long hours of operation with frequent slide changes and/or dirty operating conditions.)

The projector parts that are subject to wear have about equal life expectancy. Very little maintenance is required other than periodic cleaning and lamp replacement. This built-in durability makes these projectors an excellent choice for exhibits, displays, study carrels, and other specialized applications requiring dependable projection.

Operating Conditions

Ideally, our projectors should be used in a well-ventilated, low-dust environment at normal room temperature—approximately 74°F (22°C). Maximum life for slides and projectors can be expected with ambient temperatures ranging from 40 to 85°F. High ambient temperatures, however, will shorten the life of both. Alternatively, no particular advantage is gained from providing operating temperatures below about 70°F (21°C).

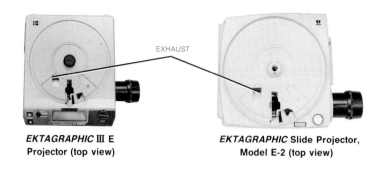

EKTAGRAPHIC III E
Projector (top view)

EKTAGRAPHIC Slide Projector,
Model E-2 (top view)

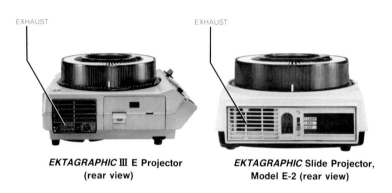

EKTAGRAPHIC III E Projector
(rear view)

EKTAGRAPHIC Slide Projector,
Model E-2 (rear view)

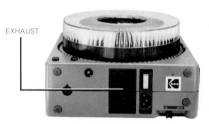

EKTAGRAPHIC Slide Projector,
Model S-AV2050 (rear view)

The parts of an EKTAGRAPHIC III or EKTAGRAPHIC Slide Projector that are subject to wear have about equal life expectancy. Very little maintenance is required other than periodic cleaning and lamp replacement.

Although projector life expectancy decreases gradually as incoming air temperature increases, there usually will not be sudden machine failure or dramatically shortened slide and projector life if the room temperature is a few degrees higher than 85°F (30°C). If the temperature rises considerably higher than this, however, the projector thermal fuses will eventually open (to prevent dangerous overheating) and the projector will stop.

Projectors operated near the ceiling in very warm rooms or where hot air is drawn in from nearby radiators, light fixtures, or other heat sources will probably have shortened life.

Check the temperature of ambient air near a projector being used in an open-air environment by taking a temperature reading on the right side of the projector close to the base (as seen from behind the projector). Take another reading in front of the projector. *These readings must be taken while the projector is operating normally.*

If a projector is housed in an enclosure, or if ducts are used for ventilation, also check the projector-exhaust temperature.

NOTE: This must be done under actual operating conditions—tray of slides in place, lamp on, and enclosure doors closed.

Use a bulb thermometer, which will not drastically restrict the airflow. Hold the bulb against the center of the exhaust grill and allow the thermometer to stabilize.

For best projector life, the exhaust air temperature should not exceed 160°F (71°C).

Do not allow any of the projector air passages to become blocked. The principal air intake is in the opening between the housing and the base cover. Another important intake is in the cord-compartment area (not applicable to *EKTAGRAPHIC* III Projectors).

IMPORTANT: *EKTAGRAPHIC* **Slide Projectors having a cord compartment should not be operated unless the cord compartment is empty. (Withdraw the entire length of the projector power cord.)**

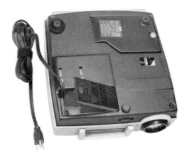

Air intakes are also located in the base cover, and small amounts of air are drawn in at other locations.

The primary air outlet is through a vent in the rear of the projector. A secondary outlet is located in the top under the slide tray (for slide pre-projection warming).

ROUTINE MAINTENANCE

EKTAGRAPHIC III and *EKTAGRAPHIC* Slide Projectors require little maintenance other than replacement of burned-out lamps and an occasional cleaning of the lenses.

If the projector is operated in an enclosed area, clean the enclosure (and any mirrors, screens, ducts, and air filters). The projectors do not require lubrication during their normal life expectancy.

CAUTION: Before you attempt any maintenance or cleaning of a projector, make certain the machine is cool. Disconnect the power cord from its outlet. Removing the slide tray and the remote control is also a good idea.

The optical system of the projector must be kept clean for best results. Fingerprints or smudges on the lenses will reduce the brightness and clarity of screen images; a little dust will not. Clean the lens surfaces with a clean, soft, lint-free cloth moistened with a *single* drop of *KODAK* Lens Cleaner or with *KODAK* Lens Cleaning Paper or equivalent.

CAUTION: Heat-absorbing glass may shatter unexpectedly. Therefore, always wear safety glasses and handle heat-absorbing glass with care and follow these recommendations.

- For personal safety, use a piece of cloth or a glove while handling the glass.
- Place the glass on an insulating material, such as wood, rubber, or cardboard.
- Keep the glass covered so that shattering, should it occur, will be confined.

Voltage and Current

Most *EKTAGRAPHIC* III and *EKTAGRAPHIC* Slide Projectors made in the United States and Canada are for use with 60 Hz and 100 to 125 V, single-phase electric current only. A plate (located on the bottom of most Kodak slide projectors) lists the frequency and voltage for which the projector is intended.

The information is also provided in the instruction manual packed with the projector model.

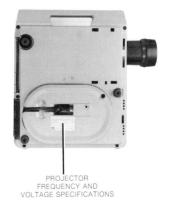

PROJECTOR
FREQUENCY AND
VOLTAGE SPECIFICATIONS

NOTE: If possible, check the wiring of the 2-wire or 3-wire receptacle supplying power for the projector, particularly if the installation will be unattended. Improperly wired receptacles can cause projector malfunction and can contribute to potential hazards. Simple outlet testers are available from electrical and tool suppliers, ranging from $6 to $20.

The projector will operate satisfactorily if the supply voltage deviates slightly from the value shown on the data plate on the bottom of the projector. For instance, if the plate listing is 120 V, 60 Hz, the projector will operate satisfactorily on 60 Hz power throughout a range of 110 to 125 V. If you suspect that the supply voltage is not within the recommended range, proceed as follows:

- Connect the power cord from the projector to a 2-receptacle outlet.
- Turn on the projector and set the power-selector switch at HIGH.
- Turn on any other equipment that will be used on the same circuit.
- Using the other receptacle of the 2-receptacle outlet mentioned, check the voltage with an accurate meter.

IMPORTANT: Voltages greater or less than those recommended can cause overheating and erratic operation, and can result in costly damage to the projector.

CARING FOR YOUR SLIDE TRAYS

The following information can help you get more dependable operation and maximum life from trays and projectors made by Kodak, even in heavy-duty or specialized applications.

Periodic Tray Inspection

KODAK Slide Trays are molded from a material that retains its strength and rigidity at temperatures as high as 180 F (82 C). **Higher temperatures can deform the trays;** consequently, any warpage of the molded parts of an *EKTAGRAPHIC* Slide Tray indicates that operating temperatures were excessive for the safety of trays, slides, and projectors. High temperatures may occur when projectors are operated in small, inadequately ventilated areas.

Your trays should also be checked for damage following any period in which they have been transported, handled roughly, stacked unboxed, or used extensively.

NOTE: This inspection can be performed without removing the slides from the tray.

Normal use of *EKTAGRAPHIC* Slide Trays is discussed in the user's instruction manual packed with the projector.

144

KODAK EKTAGRAPHIC Universal Slide Tray, Model 2, and KODAK CAROUSEL TRANSVUE 80 Slide Tray

Examine the tray for cracks, warpage, broken parts, or other damage. After making sure that the lock ring is secured (if the tray contains slides), turn the tray upside down and check the cylindrical pegs around the tray bottom. Damaged pegs can cause the tray to operate erratically and can prevent it from locking properly into position. Since repairing damaged pegs is impractical, replace the tray if any of the pegs are broken.

Also check to see if the metal slide-retainer plate on the bottom of the tray is damaged. A damaged plate usually will not rotate freely, possibly causing slide-change failures. Hold the inverted tray with one hand, extend a finger through the hole in the center, and retract the spring-loaded latch. Then check to see if the slide-retainer plate rotates freely by turning it 360 degrees. Release the latch and position the plate so that the slide-change slot is adjacent to the No. 0 peg. The latch must engage the notched inner edge of the plate.

KODAK EKTAGRAPHIC Universal Slide Tray, Model 2

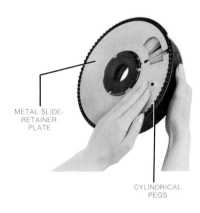
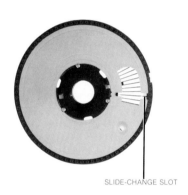

METAL SLIDE-RETAINER PLATE

CYLINDRICAL PEGS

SLIDE-CHANGE SLOT

Preventive Maintenance

In most cases, the 80-capacity slide trays are easier to maintain than the 140-capacity trays; they present less power load for the projector mechanism (except when glass-mounted slides are used) and they function well under more adverse operating conditions, such as with damaged or worn slide mounts and extremes of humidity.

When used on an *EKTAGRAPHIC* III or *EKTAGRAPHIC* Slide Projector for many hours with frequent slide changes, an *EKTAGRAPHIC* Universal Slide Tray, Model 2, loaded with metal- and glass-mounted slides will sometimes require attention.

KODAK EKTAGRAPHIC Universal Slide Tray, Model 2

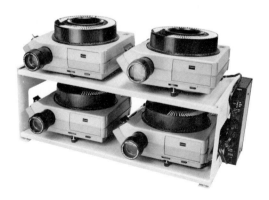

The factory lubrication on the upper side of the metal slide-retainer plate sometimes wears away and the selected slide fails to project because of a slight malpositioning of the tray. (This condition usually occurs only after many hours of prolonged use with heavy glass-mounted slides.)

The best solution to the problem is to replace the tray with a new one. However, replacing the slide-retainer plate or cleaning and lubricating the plate as suggested in the next section often helps.

Damage will seldom occur during the storage or transportation of trays, provided that the tray is packed in a box, such as that provided with each *EKTAGRAPHIC* Universal Slide Tray, Model 2 (*KODAK* Part No. **229918** for the box) and the *KODAK EKTAGRAPHIC* Universal Deluxe Covered Slide Tray (*KODAK* Part No. **229016**.) These boxes contain a pad that supports the tray base plate and relieves the strain on the screws. Similar support can be provided in the containers for the *CAROUSEL TRANSVUE* 80 and *CAROUSEL TRANSVUE* 140 Slide Trays (*KODAK* Part No. **219981** for the 80 Slide Tray and **226805** for the 140 Slide Tray) by the insertion of a soft foam-rubber or urethane pad, about ³/₈-in. (9.5 mm) thick and 9 in. (229 mm) square, in the bottom of each box. *Cardboard or other rigid material should not be placed over the pad.*

The slide-retainer plate is often damaged. *Damage usually occurs when a tray full of slides is taken off the projector and dropped, stacked unboxed under other unboxed (unprotected) trays of slides (such as after a multi-image presentation) or subjected to other forms of rough handling.* When the tray is not on the projector, the weight of the slides on the plate is supported only by three screws.

The slide-retainer plate is coated with a dry lubricant. After several hundred hours of operation, however, the plate should be cleaned and lubricated--particularly if metal- and glass-mounted slides are cycled frequently.

Turn the tray upside down (making sure that the lock ring is in place if the tray contains slides), remove the slide-retainer plate (see "Parts Replacement and Repair Procedures for *KODAK* Slide Trays" next), and clean and lubricate it with a dry aerosol spray or silicone. (Do not use powder or oil-base lubricants.) This will lubricate the two major friction areas: the top surface of the slide-retainer plate (on which the slides move) and the inner edge of the plate around the retainer. Replace the plate by reversing the disassembly procedure.

Parts Replacement and Repair Procedures for *KODAK* Slide Trays

Replacement parts may be ordered through your dealer in Kodak products or directly from Eastman Kodak Company, Parts Services, 800 Lee Road, Rochester, NY 14650. Specify the part name, part number and color, and quantity desired. Tray bodies are not available separately.

EKTAGRAPHIC **Universal Deluxe Covered Slide Tray**

EKTAGRAPHIC **Universal Deluxe Covered Slide Tray used with an** *EKTAGRAPHIC* **Slide Projector, Model S-AV2050.**

EKTAGRAPHIC **Universal Deluxe Covered Slide Tray (disassembled)**

KODAK EKTAGRAPHIC Universal Deluxe Covered Slide Tray

Part Numbers

- **Locking Transparent Cover**, *KODAK* Part No. **600 6100.** If protection for slide corners is not required, the Lock Ring for *KODAK EKTAGRAPHIC* Universal Slide Tray, Model 2, Part No. 209062, may be substituted.

- **Lever (latch)** — *KODAK* Part No. **603 6321.** (The latch for the *KODAK CAROUSEL TRANSVUE* 80 Slide Tray cannot be used.)

- **Spring (latch)** — *KODAK* Part No. **603 6331.** (The spring for the *KODAK CAROUSEL TRANSVUE* 80 Slide Tray cannot be used.)

- **Slide-Retainer Plate** — *KODAK* Part No. **603 6311.** (The Slide-Retainer Plate for the *KODAK EKTAGRAPHIC* Universal Slide Tray, Model 2, *KODAK* Part No. **203978,** can be used in an emergency, but is not recommended because it changes the amount of friction; that for the *KODAK CAROUSEL TRANSVUE* 80 Slide Tray should not be used because of slightly different dimensions.
- **Flat Springs** (3) — *KODAK* Part No. **603 6341**

Slide-Retainer Plate Repair Procedure

- Turn the tray upside down and retract the latch by pressing down on it through the hole in the center of the tray. Press inward on the plastic retainer clip nearest the opening in the retainer plate, and lift the plate up slightly until it is free of the clip. Note the position of the flat friction spring under the clip. Release the tray latch, rotate the retainer plate and release it from the other two latches in the same way.

- Straighten any small dents in the plate or install a new plate.

- Replace the bottom by reversing the procedure above. Make sure the three flat springs are properly in place, with the end tabs located in the recesses provided, and the side tab of each spring under its plastic retainer. If the center portions of the springs, which bear on the retainer plate, are dry, put a small amount of light grease on the bearing surface of the plate. The bottom plate can be pressed on, so the plastic catches snap into place. Rotate the plate a full turn to distribute the lubricant, and check for proper operation. Considerably more frictional drag than is present in North American-made *KODAK* slide trays is normal.

- Rotate until the latch locks the retainer in position for use.

Latch Replacement

- In the center well of the tray, find the latch retaining catch and hinge point at the top of the latch. Press it counterclockwise to release the latch for removal. Note the coil spring in the formed guides toward the outer end of the latch, and remove it. To reassemble, insert the spring (or replacement) back in the guides, and slide the latch into place between the spring guides and the guides extending upward from the bottom of the tray, until it snaps into place.

KODAK EKTAGRAPHIC Universal Slide Tray, Model 2

The Universal Slide Tray, Model 2, has superceded the earlier Universal Slide Tray (provided with a red plastic center latch); the Model 2 Tray has a metal latch. It also has a white bar at the number 20 slide position that provides for tray alignment from behind the projector.

Replacement parts may be ordered either from your audiovisual dealer or directly from Kodak. However, you should note these important differences, in both the part numbers and repair procedures necessary for the Model 2 Tray.

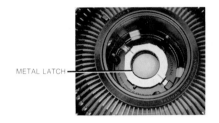

METAL LATCH

Part Numbers

- **Lock Ring**, *KODAK EKTAGRAPHIC* Universal Slide Tray, Model 2—*Kodak* Part No. **159804**
- **Latch**—*Kodak* Part No. **185837**
- **Screw** (3)—*Kodak* Part No. **851271**
- **Slide-Retainer Plate**—*Kodak* Part No. **203978**

Slide-Retainer Plate Repair Procedure

- Turn the tray upside down and remove the three Phillips screws.
- Extend a finger through the hole in the center and retract the metal latch by pushing it in the direction opposite the slide-change slot.
- Lift the slide-retainer plate from the bottom of the tray.
- Straighten it or install a new plate.
- Replace the plate by reversing the disassembly procedure.
- Check for free rotation of the plate.

Latch

- Two flat springs on the latch operate against a boss on the tray bottom to keep the latch engaged in the notches on the slide-retainer plate so the plate will not rotate when the tray is off the projector. Sometimes, mishandling can cause the latch to be pulled up so that one of the springs clears the top of the boss and prevents normal action of the latch. If this happens, push the spring back behind the boss with a small screwdriver.
- A bent latch should either be straightened or replaced (the latter is preferred). To remove the latch, first remove the slide-retainer plate, as described above. Then, with the tray oriented right side up, push the latch toward the No. 0 slide position to retract the flat tab from the space in the tray body. Grasp the latch and lift the flat tab; at the same time, withdraw the formed tab from its slot near the "0" position.
- Straighten the latch and springs or replace the part.
- To restore the latch to its position in the tray, insert the formed tab into the slot that is toward the No. 0 slide position and guide the flat springs over and behind the boss on the tray bottom. Angle the latch downward so that the tab can be inserted all the way into the slot. With the formed tab fully inserted into its slot, press down on the side of the latch opposite the tab until the latch is resting on the bottom of the tray body. Finally, slide the latch toward the No. 40-41 slide position in the tray body to insert the flat tab carefully into its slot. The springs will cause the latch to snap into operating position.
- Install the slide-retainer plate and check for proper functioning of the latch and plate.

KODAK CAROUSEL TRANSVUE 80 Slide Tray

Part Numbers

- **Lock Ring**, *KODAK CAROUSEL TRANSVUE* 80 Slide Tray (white)—*Kodak* Part No. **159804**
- **Plastic latch** (black)—*Kodak* Part No. **211946**
- **Spring**—*Kodak* Part No. **218008**
- **Screw** (3)—*Kodak* Part No. **851271**
- **Slide-Retainer Plate**—*Kodak* Part No. **211947**

Slide-Retainer Plate Repair Procedure

- Turn the tray upside down and remove the three Phillips screws.
- Lift the slide-retainer plate from the bottom of the tray.
- Straighten any small dents in the plate or obtain a new plate (preferably the latter.)
- Replace the plate by reversing the disassembly procedure.
- Check for free rotation of the plate.

Latch

- A spring on the latch keeps the latch engaged in the notch on the slide-retainer plate so the plate will not rotate when the tray is off the projector. To replace the spring on the latch, squeeze the latch pivot points together with needle-nose pliers and raise the latch from its slot. Remove the spring from the tray. Replace the spring and latch by reversing the disassembly procedure.

NOTE: Eastman Kodak Company does not make available any component parts for the *TRANSVUE* 140 Slide Tray except the lock ring (*KODAK* Part No. **185230).**

A Do-It-Yourself Slide Tester

Slide trays are sometimes blamed for slide-change failures when, in reality, the slide *mounts* are at fault. For reliable operation, the slide mounts *must* fit freely in the tray compartment slots.

NOTE: Do not use damaged slides (with torn mounts, exposed sharp glass corners or edges, or loose or sticky tape). Such slides must be repaired or remounted before they are loaded into *any* tray.

Shown here is a do-it-yourself slide tester for *KODAK* Slide Trays used most often. The tester is made of 2 pieces of glass 2 x 4 inches (approximately 51 x 102 mm) with edges ground to avoid cutting yourself, and 2 spacers $1/2$ x 2 inches (approximately 12.7 x 51 mm), $1/8$ or $1/10$ or $1/16$ of an inch (about 3.8, 2.54, or 1.59 mm) thick.

NOTE: Be sure that the spacer thickness is accurate.

Sandwich the parts together with cement or rubber bands. Hold the tester with the slot upright and insert slides (mounted in different mounts) from the top; if they *drop through* they will work in the trays for which they are intended. Use spacers of the following thicknesses for the following trays:

- Use a $1/8$ inch (3.8 mm) spacer to test slides intended for the *EKTAGRAPHIC* Universal Slide Tray, Model 2, and *EKTAGRAPHIC* Universal Deluxe Covered Slide Tray.

- Use a $1/10$-inch (2.54 mm) spacer to test slides intended for the *CAROUSEL TRANSVUE* 80 Slide Tray.

- Use a $1/16$-inch (1.59 mm) spacer to test slides for the *TRANSVUE* 140 Slide Tray.

The do-it-yourself spacer gives you the opportunity to choose the tray that you *need* for the kinds of mounts used for your slides.

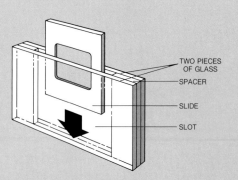

TWO PIECES OF GLASS
SPACER
SLIDE
SLOT

A Do-It-Yourself Slide Tester

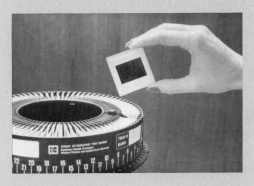

NOTE: Slide mounts with soft aluminum frames provide satisfactory service for occasional use, but they are not satisfactory for heavy-duty, long-term use. With long-term use, the soft metal wears through or develops rough areas at friction points on the sides and bottom and on the rear surface where the pressure pads in the projector gate guide the slide into the tray.

PACKAGING OF *KODAK* SLIDE TRAYS

In general, it is best to store *EKTAGRAPHIC* and *CAROUSEL* Slide Trays in the boxes supplied. These boxes, however, *are not intended to be complete shipping containers.*

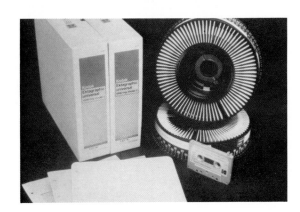

Additional packaging protection should be provided for mail, freight, or express shipments, particularly for boxes containing trays loaded with glass-mounted slides. The following procedures are suggested:

- Add a soft foam-rubber or urethane pad, about ³/₈-inch (9.5 mm) thick and 9 inches (230 mm) square, to the bottom of each box provided with the trays. This thick foam pad will provide protection against shock, breakage, and abrasion.

- Place strips of packing material around the tray as you put it into the box. This measure will help to prevent the box from splitting at the edges.

- Securely tape or tie the box cover to its base to minimize tray movement within the box. Abrasion will then be reduced at the four tray contact points on the inner sides of the box.

- Wrap each tray box on all six sides with a suitable cushioning substance, such as foam or air-cell material; and then insert the package into a larger, rigid shipping container.

- Whenever possible, make arrangements to carry trays in a vertical position (on edge).

- Place packing material around magnetic sound recording cassettes if they are to be shipped with the Universal Slide Tray, Model 2.

Some Manufacturers of Shipping Containers

Reinforced fiber or molded shipping containers serve well for mailing boxed trays. Such items are not provided by Eastman Kodak Company. However, the manufacturers listed below have indicated that they will supply shipping containers that are suitable for transporting boxed *EKTAGRAPHIC* or *CAROUSEL* Slide Trays:

Manufacturers of Shipping Containers for *KODAK* Slide Trays

Cargo Case Division
Icom, Inc.
237 Cleveland Ave.
Columbus, OH 43215

Fiberbilt Photo Products
Division of Ikelheimer-Ernst, Inc.
601 West 26th Street
New York, NY 10001

Midwest Fibre Products Co.
Box 397
Viola, IL 61486

Sirtage, Inc.
Umstead Industrial Park
P. O. Box 6417
Raleigh, NC 27628

MAINTAINING AND STORING SLIDES

The following tips concerning the care, storage, and filing of slides will help you to gain maximum life from your slide transparencies and reduce the need to replace them at frequent intervals.

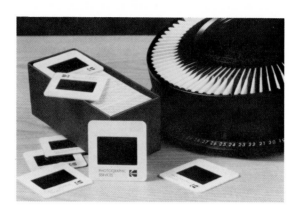

Care and Storage of Slides

The dyes used in *KODAK* Color Films are as stable as is consistent with the optical and chemical requirements of color processes. The primary factors affecting the permanency of the dyes in a color image are light, moisture, and heat. Faulty processing can hasten the deterioration of dye images. To delay dye image changes in properly processed films, store films in a dark, dry, and cool place. Avoid storage where sunlight or other stray light falls on the slides or slide trays.

Protection from Light

The projection life of a color transparency depends upon the amount of light and heat from the projection lamp falling on the slide. It also depends upon the total projection time. Avoid long projection times, if possible; make duplicate slides of the original and use them for projection purposes instead.

Avoid long projection times, if possible. Make duplicate slides of the original and use them for projection purposes instead.

Never use the projector with the heat-absorbing glass removed and never use a lamp of higher wattage than recommended. Do not restrict the flow of air to and from, or obstruct the openings in, the projector housing.

Protection from Physical Damage

Color transparencies should be kept as clean and dust-free as possible. They should never be touched with fingers except at the edges. Originals can be kept in transparent *KODAK* Sleeves, which you can buy from photo dealers, as protection against dirt and finger marks.

At relative humidities (RH) above 60 percent (not a recommended condition), shiny spots may occur on the emulsion surface of an original stored in contact with a sleeve, or, in fact, any smooth surface. These spots, as well as dirt and fingerprints, can be reduced by washing and drying the original. Use water between 65 and 75°F (18 and 24°C) and limit the washing time to a few minutes. Bathe the transparency for about 30 seconds in a solution such as *KODAK PHOTO-FLO* Solution (diluted as directed on the bottle), and hang it up to dry.

Do not store slides in the presence of moth-preventive chemicals, such as paradichlorobenzene crystals. Such chemicals tend to crystallize on the film and damage adhesives used in mounts. Gases such as nitrous oxide, hydrogen sulfide, and sulfur dioxide can cause slow dye fading.

Keep your slides away from chemical dusts; alkaline dust particles and hypo particles on the emulsion can cause dye fading after a prolonged storage period. If you use slide-mounting glass, it should be cleaned to remove contaminants before the transparencies are mounted.

Salvaging Water-Soaked Slides

Water from floods, fire-fighting, burst pipes, leaky roofs, etc, can inflict serious damage on stored transparencies. Damage can be kept to a minimum if you act quickly to salvage them.

First, keep the water-soaked transparencies and their enclosures (mounts, envelopes, sleeves, etc) *wet.* Do not allow them to dry. Immerse them completely in plastic containers of cold water, below 18°C (65°F), containing about 15 mL of Foramlin* per litre of water. The cold water and the formaldehyde will help prevent the swelling and softening of the gelatin emulsion which are the major causes of damage and the growth of bacteria.

CAUTION: Formaldehyde solutions and vapor are irritants. Keep eyes and skin from contact. Use protective gloves and glasses.

As soon as possible, carefully separate the transparencies from their enclosures and mounts and wash them for 10 to 15 minutes in water at 18°C (65°F) or lower. If necessary, the films can be swabbed, but extreme care should be taken because the wet emulsion is very susceptible to physical damage. Avoid any sudden temperature changes in the wash waters. Rinse *KODACHROME* transparencies for 1 minute in diluted *KODAK PHOTO-FLO* Solution. Rinse *KODAK EKTACHROME* transparencies for 1 minute in a working solution of *KODAK* Stabilizer, Processes E-3 and E-4.

Dry in a dust-free area and remount them.

Exposed water-soaked film should be kept wet and processed as soon as possible.

*Formalin is a 37$\frac{1}{2}$% solution of formaldehyde available from laboratory chemical supply houses.

FILING YOUR SLIDES

If you have a need to maintain a file of slides to use periodically for preparing such things as displays, presentations, and printed materials, the major considerations are safe storage, easy retrieval, and convenient viewing.

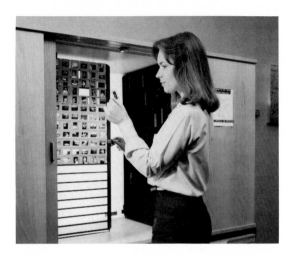

Through extensive experience, a number of audiovisual departments at Kodak have developed a rather effective slide-filing method. It has three main elements:

• A classification of categories (similar to the Dewey decimal system)

• A master slide set

• A slide file.

Using the method is easy. Establish the number for your category of interest and locate the category in the master slide set. Then, note the access code on the slide you choose, and use the code to obtain a similar picture from the slide file. Here's how the system works.

You can start classifying simply and build as required. For example, begin with whole numbers and represent major categories such as:

1. Art
2. Drama
3. Music
4. Science

As soon as any category becomes unwieldy, it can be subdivided. Thus, **Science** could be separated as follows:

4.0 Science
4.1 Biology
4.2 Chemistry
4.3 Ecology
4.4 Physics

Each of these categories can also be further subdivided as necessary. For example, **Ecology** might look like this:

4.30 Ecology
4.31 Air
4.32 Land
4.33 People
4.34 Water

Although the categories are not mutually exclusive, practicality limits extensive cross-indexing. The listing of categories is mounted on a sturdy card and placed prominently near the master slide set for ready reference.

The master slide set is composed of original transparencies that are used solely for duplicating and viewing for slide selection—*not for distribution.*

NOTE: Never take an original transparency from the master slide set for projection purposes.

A combination storage-and-viewing cabinet* houses the master set safely and conveniently. The mount of each master slide is marked with an access code (using indelible ink), such as K82-350. The "K" indicates *KODACHROME* Film (it could be "E" for *EKTACHROME*). The numbers show it was the 350th slide shot and filed in 1982. This code is used to locate a particular transparency in the slide file.

Expendable extra original (or duplicate) slides are stored in the slide file, one group for each of the slides in the master set. The slide file is situated near the master set cabinet (often directly underneath it for easy access). All file drawers are labeled serially by year and slide number and have front-to-back dividers placed about 2 inches (51 mm) apart. (Each group of similar slides is headed by a 2 x 2¼-inch card marked with the appropriate access code.)

NOTE: When you or anyone else makes a slide for the master slide set, consider the relatively inexpensive step of shooting several additional *originals* for the slide file. Otherwise, needed duplicates can be made for a little extra time and money.

The number of originals (and duplicates) required depends upon the subject matter and the judgment of the librarian. For example, a picture of a building could serve many purposes for a long period of time, whereas one of a temporary scaffolding might not.

*Suitable cabinets that hold hundreds of slides in frames, with incorporated light panels for direct viewing, are available from suppliers such as Multiplex Display Fixture Co., 1555 Larkin Williams Rd., Fenton, MO 63026, and Elden Enterprises, P. O. Box 3201, Charleston, WV 25332.

The Life of a Slide

Q. What is the useful life of slides that may run from 8 to 12 hours a day, day in and day out?

A. Consider such heavily-used slides expendable. They will eventually fade or change color balance and will need to be replaced by a new set or duplicates.

Q. How often should they be replaced?

A. We can only offer general guidelines, and such guidelines cannot be exact.

Q. Why?

A. There are too many variables, such as proper processing, adequate projector ventilation, ambient temperatures, and so on. However, the film type, if it is photographic film with dye images, does *not* make a significant difference, assuming proper processing and the projector operating at relatively normal room temperatures.

 The projector is likely to make a difference, though. The optical design of an *EKTAGRAPHIC* III or *EKTAGRAPHIC* Slide Projector is efficient. The ELH lamp in an *EKTAGRAPHIC* Slide Projector or the EXR lamp in an *EKTAGRAPHIC* III Projector (and, of course, the condenser in each projector) concentrates a great deal of light—about 95,000 footcandles—on a piece of film only a little more than one inch square in size. *Ninety-five thousand footcandles is about 15 times as bright as direct sunlight.* We are asking that little chip of film to withstand a lot of radiant energy.

Q. Then why aren't our images brighter when we project them?

A. Because the projected light is spread over a much larger area. In enlarging that little chip of film (an ordinary 24 x 36 mm transparency) to an 8 x 12-foot screen image, for example, we have increased the area about 11,000 times. That reduces the footcandles by the same factor.

Q. What other factors determine how long a slide will look good on the screen?

A. Slide subject matter is important. A high-key artwork slide will appear to change less than a full-scale slide, in which the dark-shadow areas will absorb more energy and may tend after many projections to become smoky or slightly faded and lack punch. In a high-key slide, there are either no dark areas or they are much smaller and less important, so the high-key slide

will remain satisfactory much longer than a full-scale slide. (A high-key slide will also be more visible than a full-scale slide in a projection room that has a high level of ambient light.)

A high-key artwork slide having noncritical pictorial content and fewer and less-important dark areas in the image will remain satisfactory for projection much longer than a full-scale slide and will be more visible in a room having a high-ambient light level.

Q. Are there other factors?

A. Yes. The variability in the definition of what is accepted as a "good" image. "Acceptable" to me might not be acceptable to you. We tend to be more critical about subjects with which we are most familiar. We will accept more change in the colors of a chart, for example, than in flesh tones of people.

Q. What should we consider when projecting with a high-intensity projector, such as those with a xenon-arc light source?

A. Transparency cooling is important, of course. That means that open-frame (not glass) mounts should be used. The transparency emulsion must absorb more radiant energy in a high-intensity projector no matter how well the projector is designed.

Q. And the usable slide life?

A. In general, it is roughly proportional. If you measure the light output of a high-intensity arc projector and find it is four times as great as with a regular tungsten projector, the slides will probably last only about a fourth as long.

(CONTINUED)

Q. What is an approximate figure for the projection life of a slide?

A. Keeping in mind the variables mentioned earlier, a slide can usually be projected for a few hours without objectionable changes. If a slide is high-key artwork with charts or lettering with emphasis on legibility rather than color fidelity, projection life, as mentioned earlier, can be much longer.

For most viewing purposes, pictorial slides made on properly processed Kodak color films will be acceptable through 3 to 4 hours of total projection time. This is true when the slides are used in an *EKTAGRAPHIC* III or *EKTAGRAPHIC* Slide Projector that is equipped with a tungsten-filament lamp and has unrestricted air circulation, even if the projector is operated with the power-selector switch set at HIGH.

Q. Will slides last longer if projected intermittently, for a few seconds each time?

A. No. Oddly enough, they will change somewhat less if projected continuously for a given time rather than intermittently until the same projection time is achieved.

Q. How can I determine how long a set of slides will last, particularly if different slides are projected different lengths of time?

A. Do a test, using the same lamp, projector, film type, average density, and so on that will be used in the actual program. Or make an estimate based on no more than a few hours of projection time for each slide.

Multiply the estimate by 81 (the number of slides in the tray). For color slides, you may want to replace sets more frequently. For less critical material, the slide set can probably run longer.

Q. Is it better to shoot dupes or use multiple originals?

A. If you do not project the originals, you can have additional dupes made with color balance changes, if desired. Sometimes it is less expensive to shoot several originals—such as when copying flat artwork. But saving one set of originals is still good insurance.

Q. Is it a good idea not to mix originals and dupes?

A. Yes. And better not to mix dupes made at different times or by different processes. Using similar slide types helps to reduce focus shift in projectors.

Q. Would better cooling of the projector gate make slides last longer?

A. Not appreciably. The radiant energy slides absorb can cause changes even if they are kept very cool, in much the same way that people can get sunburned on a sunny ski slope as well as in a tropical lagoon.

Q. Any other recommendations for prolonging the projection life of slides that will be continuously?

A. Let's summarize.
- Use properly processed film.
- Use open-frame mounts.
- Run the projectors in ambient temperatures that are not too high.
- Choose non-critical, high-key slides, if possible.

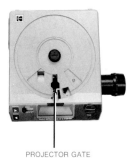

PROJECTOR GATE

Slide Fungus—Its Prevention and Removal

When transparencies are stored or kept for any length of time in an area having a relative humidity above 60%, fungus—often called mold or mildew—has a tendency to grow on them. Humidity 60% and higher is typical in tropical countries and in many sections of the United States, especially during warm summer months. (High temperatures alone without high humidity will not cause fungus growth.)

Any form of surface contamination is likely to promote the growth of fungus. Therefore, avoid leaving fingerprints on transparency surfaces. Remove any accidental fingerprints with *KODAK* Film Cleaner.

Damage caused by fungus on unexposed or unprocessed film can't be undone. A pattern of fungus filaments forms which shows up later in the processed image. The possibility of fungus damage can be reduced on unexposed films by keeping the moistureproof packaging sealed until the film is used. (Process your film as soon as possible after exposure.) Fungus can attack unprotected exposed film both inside and outside your camera.

When fungus grows on processed films, damage to the image is not immediate. If the growth is discovered in time, steps (described below) can be taken to remove it. If growth proceeds too far, however, permanent image damage can result.

The best way to prevent fungus growth is to store transparencies in a cabinet or container in which the relative humidity can be kept between 25% and 50%. Air conditioning with fully automatic relative-humidity control provides the most desirable situation for storage under exceptionally humid conditions.

If the prevailing relative humidity is above 60%, dry your transparencies with silica gel before storing them in cans, jars, or bags. Silica gel lasts indefinitely, but it must be reactivated periodically to remove the moisture. Heat the gel at 300° to 400°F (149° to 204°C) for about 30 minutes and allow it to cool in a closed metal container. If it is not to be used immediately, seal the container. One ounce of silica gel will protect about 50 *KODACHROME* Slides.

When you want to keep a small quantity of transparencies dry under humid conditions for just a short time—in transit, for example—place them in a container along with silica gel and then close and seal the container. (Neither silica gel nor other desiccants are recommended for permanent installations.)

Considerable protection can be provided by storing your transparencies in metal, polyethylene, or styrene rather than wood or cardboard. (One way to dry slides is to *project* them occasionally.)

If transparencies need protection from fungus growth, apply film lacquer. A lacquered surface is more readily cleaned, and in cases of minor fungus damage, restoring the surface is possible by removing the old lacquer and applying the new.

Do not use water to remove fungus from color or black-and-white films. Fungus growth on the emulsion usually makes the gelatin soluble in water. Water *will damage* the image.

Most surface fungus on *unlacquered* transparencies can be removed by wiping the transparencies with a soft plush pad, absorbent cotton, or a chamois moistened sparingly with *KODAK* Film Cleaner. (Kodak processing laboratories stopped lacquering *KODACHROME* transparencies in 1970. Kodak never lacquered *KODAK EKTACHROME* Films.) Remove the transparencies from their mounts before cleaning, and use new mounts after cleaning.

If there is fungus growth on *lacquered* transparencies, remove the lacquer as follows:

- Add 15 mL (about a tablespoon) of nondetergent cloudy or clear household ammonia to 240 mL (about 8 fluidounces) of denatured alcohol. (Wear cotton gloves to avoid touching the film.) Use shellac-thinning alcohol—*not rubbing alcohol.*

- Agitate the film in the solution for no longer than 2 minutes at room temperature. (Longer times may change the color in areas of minimum density.)

- Hang the transparencies up to dry and then mount them in *new* mounts—*not* the original ones. Be sure the transparencies and mounts are *dry;* warm the transparencies and mounts for ten minutes at 10° above room temperature.

To clean slides on a large scale, use an ultrasonic cleaner, the type sold for cleaning small metal parts and surgical and dental instruments. A cleaner of 1-pint capacity should be adequate for cleaning slides individually.

PART IX
Offbeat Applications for *KODAK* Slide Projectors

INTRODUCTION

Our slide projectors are normally used for projecting 2 x 2-inch slides onto a screen for some communications task. Occasionally, however, we hear of nonstandard but still utilitarian uses.

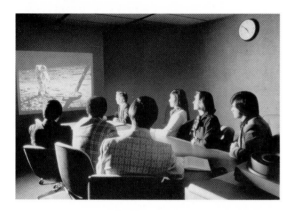

1. Making Large Wire and Cable Spools

A company in Indiana used a projector to optimize the process of making spools for wire and cable. The projector was placed overhead with a slide of a circular image in the gate. The light beam was aimed at a 45-

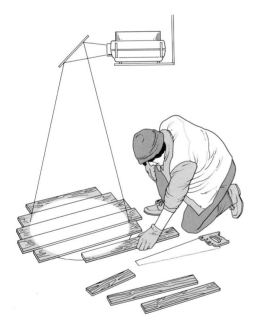

degree angle downward toward a mirror that reflected the image of the circle toward the work area. Wire spools were then assembled from scrap wood using the circle as a guide. It let the men make the best use of the wood. (Each piece had to extend across the diameter of the circle.) The men were able to assemble the shortest pieces of wood that would do the job, and thus use it economically.

2. Researching Dolphin Learning Behavior

A professor in Florida used projectors for research into the behavior of dolphins. The projectors were placed in a water-tight glass box equipped with a rear-projection screen and two large contact switches on the outside of the box next to the screen. The dolphins received a reward if they could distinguish between the vertical

and horizontal lines on the image. They were taught to push one switch for vertical lines, and other switch for horizontal lines to learn how well they could see. Originally, the reward was a fish, but the dolphins liked the game so much, their reward became having the slide change for another try.

3. Pain Relief

A dentist installed a projector in his office. A mirror reflected the light beam toward a ceiling screen that his patients watched while undergoing treatment. The

patient changed the slides at will with a hand-held remote control. The dentist reported that his patients were more relaxed, happier (and thus easier to work with), and required less anesthetic.

4. Simulated Golf

Some time ago, the Golf-A-Tron and similar outfits were popular. They projected an image onto a screen of the scene that a golfer would see from a particular tee on a particular golf course.

When the golfer hit the golf ball into the visual equivalent of the net, the more sophisticated units would immediately project a slide corresponding to a right, left, or straight shot, and project that scene for the next attempt until the whole "course" was played.

New Projector Line-Up Announcement!
(With New Three-Year Warranty!)

At presstime, Kodak announced two new *EKTAGRAPHIC* III Projectors—the III ATS and III AM Projectors, available August 1984.† These new models, plus slightly changed III E, B, and A Projectors, will have a new 3-year warranty. The new line-up of projectors offers customers a more cost-effective, convenient selection. (NOTE: The technical descriptions in *The Source Book* of specific projector features are accurate for both the old and new models. See chart below.) .

NEW!

KODAK EKTAGRAPHIC III
ATS Projector

Features	Model				
	ATS	AM	A	B	E
Focus: Remote and Automatic	●	●			
Remote only				●	
Automatic only			●		
Autofocus ON/OFF switch	●	●	●		
Solid-state variable timer (3 to 22 seconds)	●				
Built-in viewing screen	●				
Seven-pin accessory receptacle (remote control)	●	●	●	●	●
Eight-contact special-application receptacle including shutter switch and zero-position switch	●	●	●	●	●
Illuminated control panel	●				
Vertical and horizontal slide registration	●	●	●	●	●
KODAK EC Remote Control furnished with projector (EC Model No.)	3	3	1	2	1*

*Not furnished with the III E Projector.
†Projectors having the new 3-year warranty can be identified by the black plastic power-cord retainer on the bottom of the projector and the single-color nomenclature on the control panel.

INDEX

OTHER HELPFUL SOURCES OF INFORMATION

KODAK Publications

We have listed below a selection of informative Kodak publications that will help you use audiovisual techniques to communicate your message more effectively. All of these titles—and many others—along with complete descriptions, photographs, and ordering instructions, appear in the current issue of *The Communicator's Catalog from Kodak* (*KODAK* Publication No. S-4). To learn more about any or all of these titles, order your one free copy of the *Catalog* from Eastman Kodak Company, Department 412-L, 343 State Street, Rochester, NY 14650. If you need current information on Kodak audiovisual equipment, you can also request one free copy of the *KODAK* Audiovisual Products Catalog (*KODAK* Publication No. V1-11).

Literature Packets

Code No.	Title
S-100	*Slidemaker's Packet*
S-200	*Multi-Image Production Packet*
S-400	*The Audiovisual Omnibus* (The largest, most complete collection of audiovisual information ever assembled.)

Single Publications

Code No.	Title
S-3	*Audiovisual Projection*
H-23	*The Book of Film Care*
S-12	*Images, Images, Images—The Book of Programmed Multi-Image Production* (Third Edition)
S-29	*Self-Contained Projection Cabinets*
S-30	*Slides—Planning and Producing Slide Programs*
S-49	*Projection Distance Tables and Lamp Data for KODAK Slide and Motion Picture Projectors*
S-60	*Presenting Yourself*
T-90	*The Best of Audiovisual Notes From Kodak*

TECHNICAL SUPPORT PERSONNEL

In addition to providing consistently high-quality products and the publications that support these products, Kodak fields a world-wide team of skilled sales and engineering representatives, able to answer any question you may have concerning the use of our audiovisual products and services. For prompt, personal service, select from the listing below the Motion Picture and Audiovisual Markets Division Sales Office nearest you. Then, contact them concerning your questions.

Atlanta, GA 30318: 1775 Commerce Dr. NW (P. O. Box 4778, Federal Annex 30302) Phone: (404) 351-6510

Dallas, TX 75235: 6300 Cedar Springs Rd., Phone: (214) 351-3221

Hollywood, CA 90038: 6706 Santa Monica Blvd. (P. O. Box 38939, ZIP 96817), Phone: (213) 464-6131

Honolulu, HI 96819: 1122 Mapunapuna St. (P. O. Box 17007, ZIP 96817), Phone: (808) 833-1661

Montreal, PQ H3E 1A1: Kodak Canada, Inc., 2 Place du Commerce, Ile des Soeurs, Phone: (514) 761-3481

New York, NY 10036: 1133 Avenue of the Americas, Phone: (212) 930-8000

Chicago/Oak Brook, IL 60521: 1901 West 22nd St., Phone: (312) 654-5300

San Francisco, CA 94109: 3250 Van Ness Ave. (P. O. Box 3145, Rincon Annex 94119), Phone: (415) 928-1300

Toronto, ON M6M 1V3: Kodak Canada, Inc., 3500 Eglinton Ave. West, Phone: (416) 766-8233

Washington, DC Arlington, VA 22209: 1555 Wilson Blvd. Phone: (703) 527-2000

West Vancouver, BC V7T 1A2: Kodak Canada, Inc., 100 Park Royal South, Phone: (604) 926-7411

Outside the United States of America or Canada, please contact the Kodak company in your country or International Photographic Operations, Eastman Kodak Company, Rochester, New York 14650, U.S.A.

KODAK EQUIPMENT SERVICE CENTERS

For further assistance in using your projector, contact a dealer in Kodak audiovisual products. They are listed in the Yellow Pages of your telephone directory under Audiovisual Equipment and Supplies. For service on your projector, return it directly to one of the Kodak Equipment Service Centers listed below or to a dealer in Kodak audiovisual products; the projector will then be forwarded to a Kodak Equipment Service Center for servicing. To help the Equipment Service Center return your projector promptly, please enclose a note giving details of the problem, date of purchase, and your complete name and address.

Eastman Kodak Company Equipment Service Centers

Atlanta/Chamblee, GA 30341:
5315 Peachtree Industrial Blvd.

Chicago/Oak Brook, IL 60521:
1901 W. 22nd St.

Country Club, Carolina PR 00630:
Kodak Caribbean, Ltd.
Campo Rico Ave. & 246 St.

Dallas, TX 75234:
2800 Forest La.

Rochester, NY 14650:
800 Lee Rd.

Toronto, ON M6M 1V3:
Kodak Canada, Inc.
3500 Eglinton Ave. W.

Whittier, CA 90606
12100 Rivera Rd.